VEGAN ART

A Book of Visual Protest

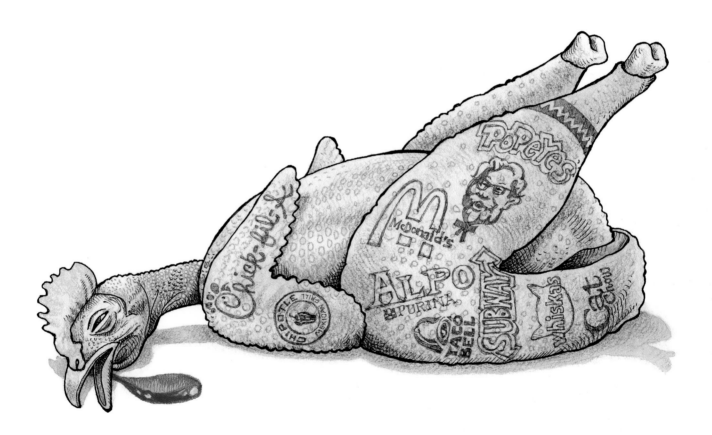

HENI Publishing, London

VEGAN

n. [vee-guh n]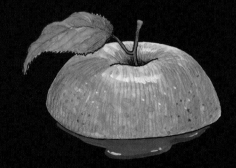

1. A person who is asked all day everyday how they get their protein.
2. A mass murderer of thousands of innocent fruits and vegetables.

See also: *sane, wise*

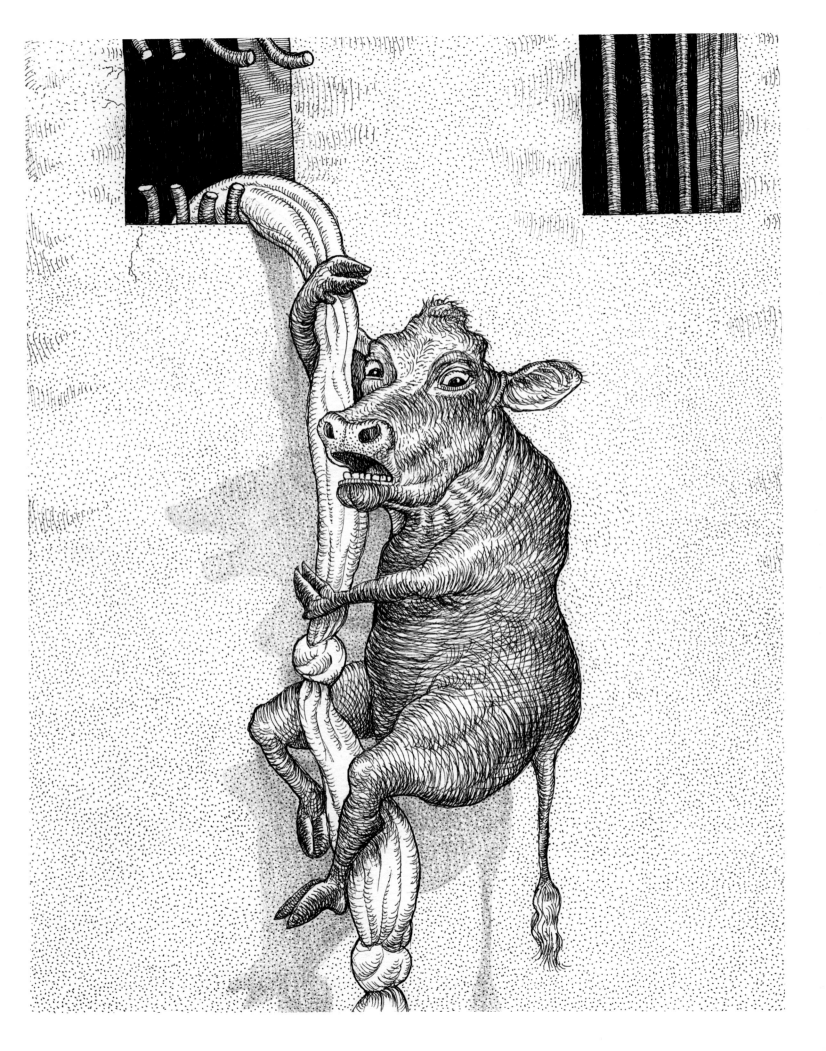

CONTENTS

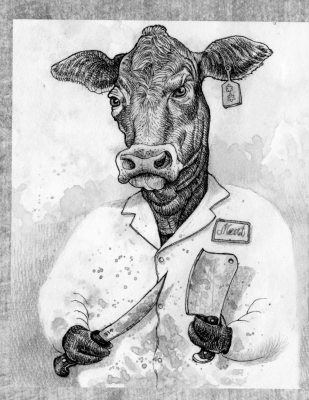

Preface

Sometimes when I post my vegan artwork online, I get emails from people telling me that they have recently become vegan themselves or have reduced the amount of meat and dairy that they consume. They say that it was my work that put them over the edge. Most of these individuals were probably close to converting anyway—it's not like I have super vegan powers or anything. But there is something about visualizing a fact that gives it extra power, and that's what I can do as an artist. I once made an illustration of a beautiful cooked shrimp on a fork heading for someone's mouth, except it had fishing line tangled around it and was dragging a ton of dead bycatch along with it. Months after I posted the work, people still wrote to me to say that they couldn't eat shrimp anymore because that image was stuck in their head. I'm evil like that.

I'm not the only one. On the internet, I discovered like-minded artists from all over the globe—painters, photographers, cartoonists, and illustrators. The talent that they possessed and the messages that their art projected blew me away. I began to fantasize about doing a book where all this vegan propaganda could live together in one place. A kind of antimeat, never-dairy bible, if you will. A big hardcover volume with which to whack carnivores over the head (figuratively speaking, of course). I picture parents showing this book to their kids instead of Dr. Seuss; grandparents gifting it for grandchildren's bar mitzvahs and bat mitzvahs; and impressionable youths tearing off the wrapping paper on Christmas morning, or after blowing out the candles on a vegan birthday cake, to reveal the perfect sweet-sixteen present. There is nothing like some good old blood and guts to scare the daylights out of the next generation. After all, a new potential vegan is born every four seconds somewhere around the world. It's our job to try and make a difference.

Here's to a better future.

Tommy Kane

Photo: Jeorge Napoleon

"I choose not to make a graveyard of my body for the rotting corpses of dead animals."

George Bernard Shaw

FOREWORD

Never before in the history of publishing has an unborn child been asked to write the Foreword for a book. I love the fact that it's an art book; seeing as I won't be able to read for a few years, I can visualize the story of animal cruelty to feed the population. Hopefully, people will be moved by being exposed to these photographs, paintings, cartoons, and illustrations. So if you find yourself the owner of this fine book, please show it to as many fellow humans as possible. I'll be born in a few weeks so I can pick up the torch from there. It turns out I'm not the artistic type. I may have to push myself towards politics. Ugh, what an awful thought to contemplate, but the planet is so full of ineffective leaders being controlled by money. Real change is going to take more than clever clichés on bumper stickers. So you better get prepared to see me all over your social media feeds in the future, crusading for a global awakening.

Unfortunately, the world I'll pop into is looking more and more hopeless. Year-round hurricanes, massive forest fires, landfill mountains of single-use plastic, oceans on life support, and now you can throw in pandemics. The worst part is that this is now the new normal. So picture me extending my miniscule middle finger up in the amniotic fluid and aiming it at all of you wankers. Thanks for screwing up the earth for yours truly. In mom's womb without a view, I fell in love with certain foods. Green veggies mostly. Baby carrots, baby beets, and baby zucchini to name a few. That's an infant joke. My very first joke actually. One needs a sense of humor to become human, especially since I had no say in being conceived. The first order of business upon arrival will be to declare myself a vegan.

I want to do something that will have maximum impact. My generation will be forced to roll up our sleeves and act quickly. I get the feeling I'm a type A personality.

When Covid-19 first hit, I heard on the TV that the pork slaughterhouses in America got slammed with cases. That's right, I could hear television in the prenatal chamber. It was a bit muffled but I got the gist of what was being said. All restaurants closed down and as a result no one ordered any more meat. All the factory farms were forced to slaughter their existing pigs and piglets and then dump the carcasses somewhere. Dead for no reason at all. Sadly that number turned out to be like a zillion pigs. What kind of sick people are all of you? As the restaurant business began to reopen, people went right back to their stupid habits. I knew at the third trimester that I'd be meat and dairy free for the duration of my life ahead.

There's a quote from the famous environmentalist, Greta Thunberg: "You say you love your children above all else, and yet you're stealing their future in front of their very eyes." As Greta frets that meat is stealing her future, you can let her know that I'm coming to steal it back.

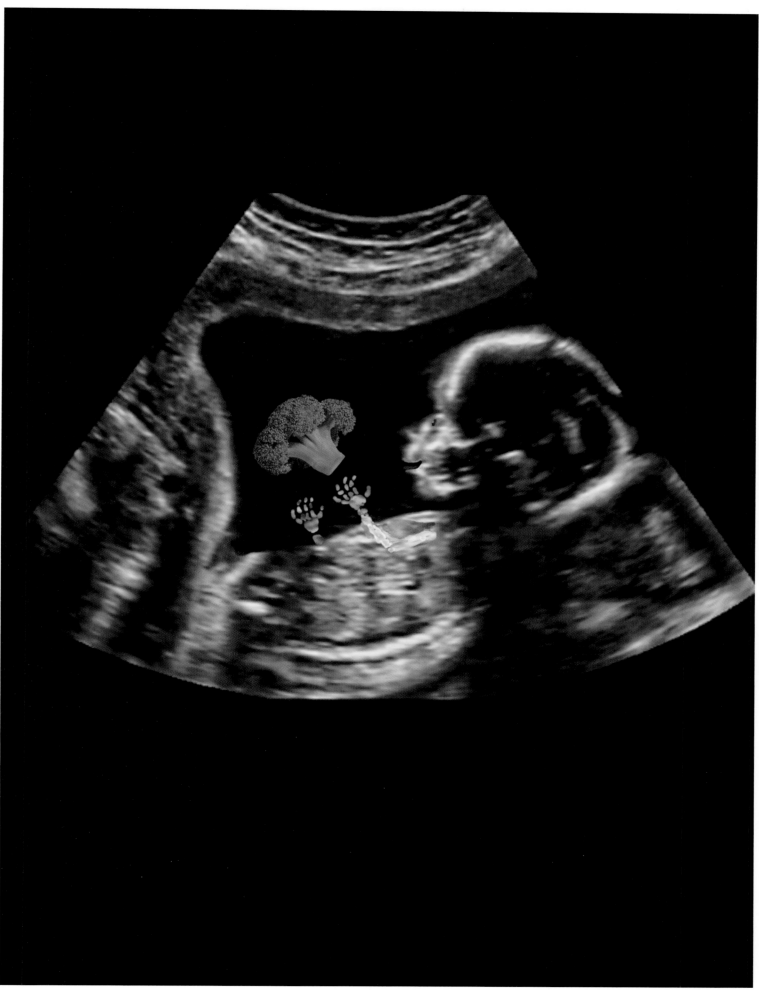

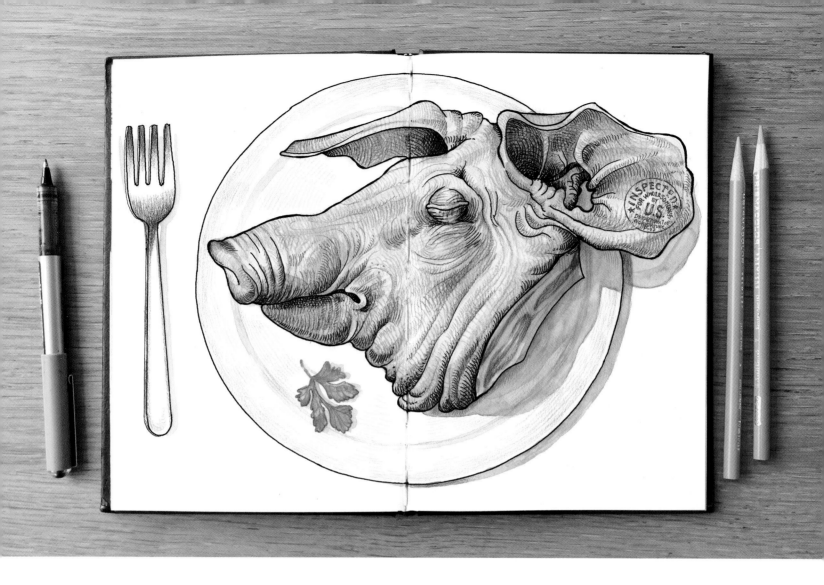

TOMMY KANE

A few years ago, someone suggested that I watch the documentary *Cowspiracy: The Sustainability Secret*. As the final credits rolled, I knew at that moment that I had become vegan. The realization that I had been clueless about the food industry and its negative impact on the world was profound. The shift to vegan happened in an instant. All it took was for the veil to be lifted from my eyes for me to see clearly the extent to which animals and the Earth were being exploited in the name of profit. I had spent more than three decades in advertising. And I have seen the power that great marketing can have on consumers. The champions of marketing have long been the meat and dairy industries. Milk, cream, and butter are hidden in practically every item in the supermarket. "Lean meat," "white meat," the "other white meat," turkey bacon, the "keto diet," the "paleo diet," and the other latest high-protein diets are all packaged as some new health craze. Cute corporate mascots like Ronald McDonald, the Burger King, and cuddly Colonel Sanders are like drug pushers selling

us triple-meat, extra-bacon-and-cheese, heart-attack happy meals on sesame-seed buns. The United States Department of Agriculture (USDA) food pyramids are written by the meat and dairy lobbyists. The industrial farming complex grows stronger, meaner, and less sanitary with each year. Yet consumers falsely believe that the meat they buy comes from some small family-owned, organic, green-acres farm straight out of a Walt Disney movie. They also think that their fish is line-caught by some salty, old, bearded fisherman who happens to look like Jacques Cousteau.

Ninety-nine percent of all meat now comes from factory farms. Yet one hundred percent of my carnivore friends tell me that they get theirs from a local "Old MacDonald" petting-zoo farm that feeds its animals on organic grass and treats them like family. Really? It seems that years of great marketing have convinced them to buy into that tale. But a newly informed army of advocates are fighting back, with artists like us doing our small part. Let's keep spreading the word.

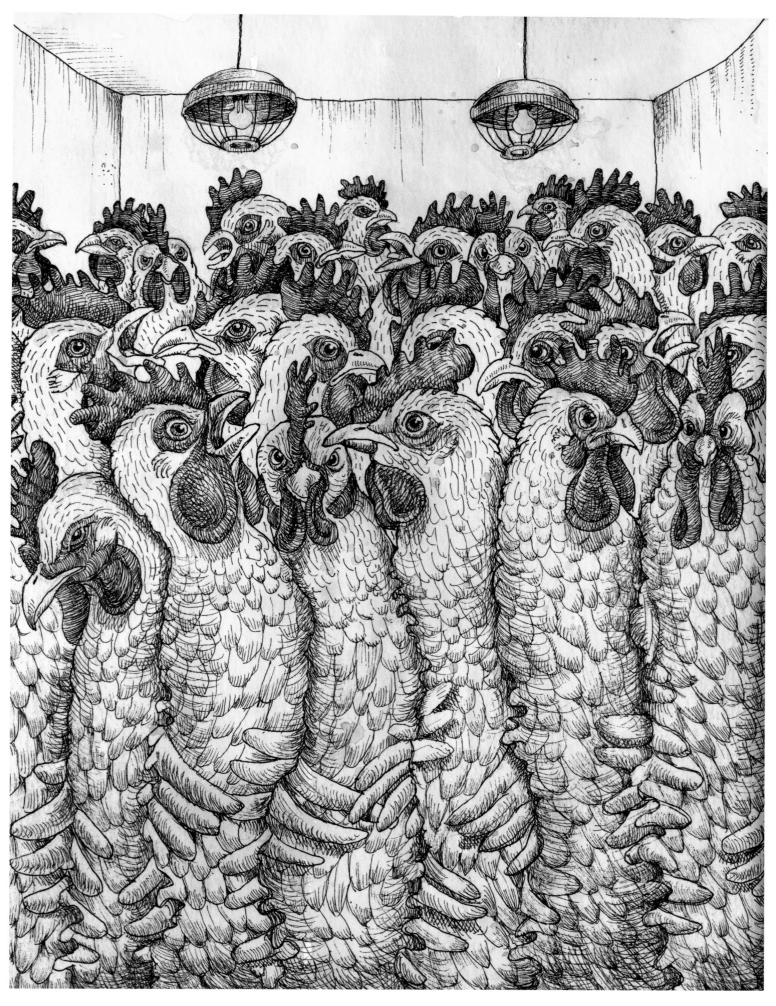

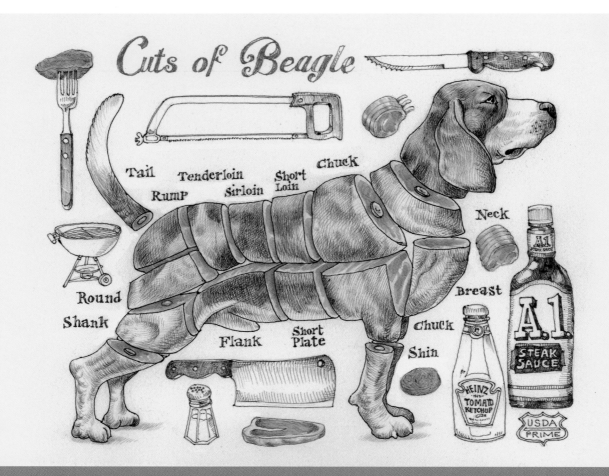

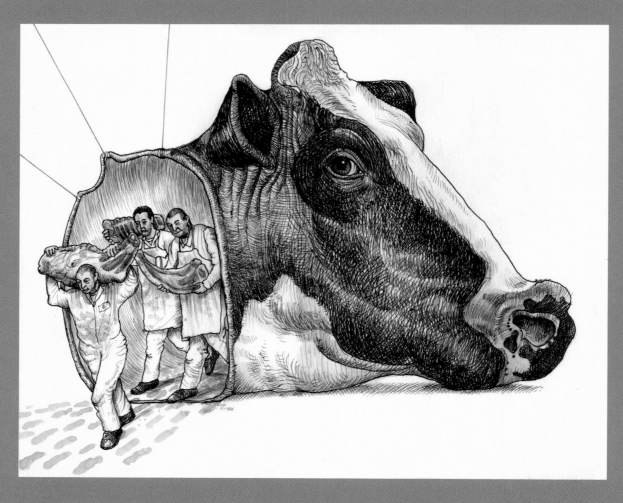

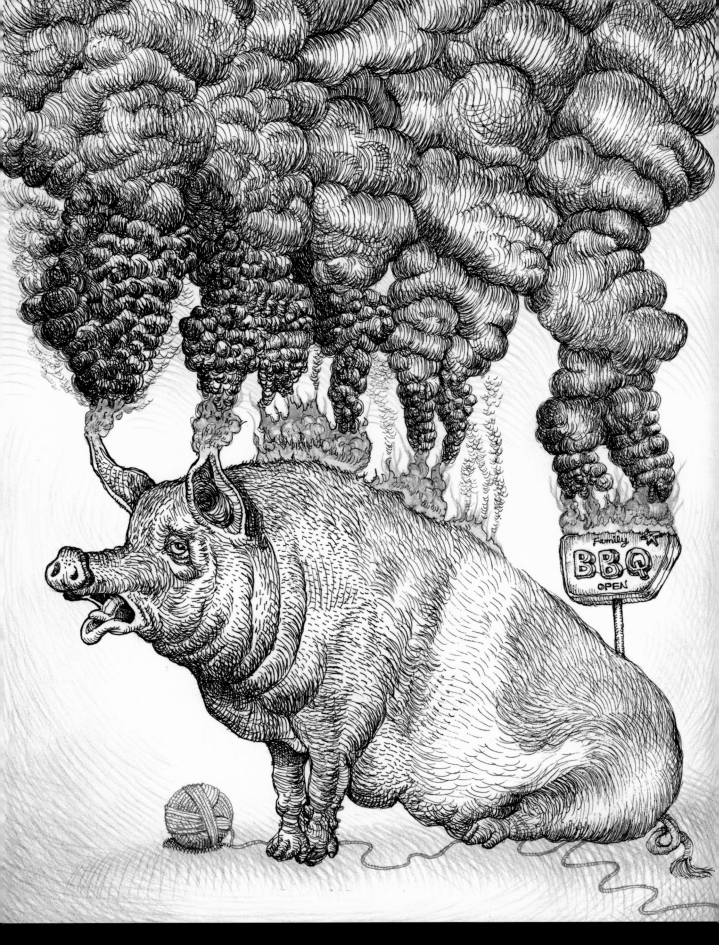

Pigs have been found to be mentally and socially similar to dogs and
chimpanzees. So maybe it would be a good idea not to barbecue them.

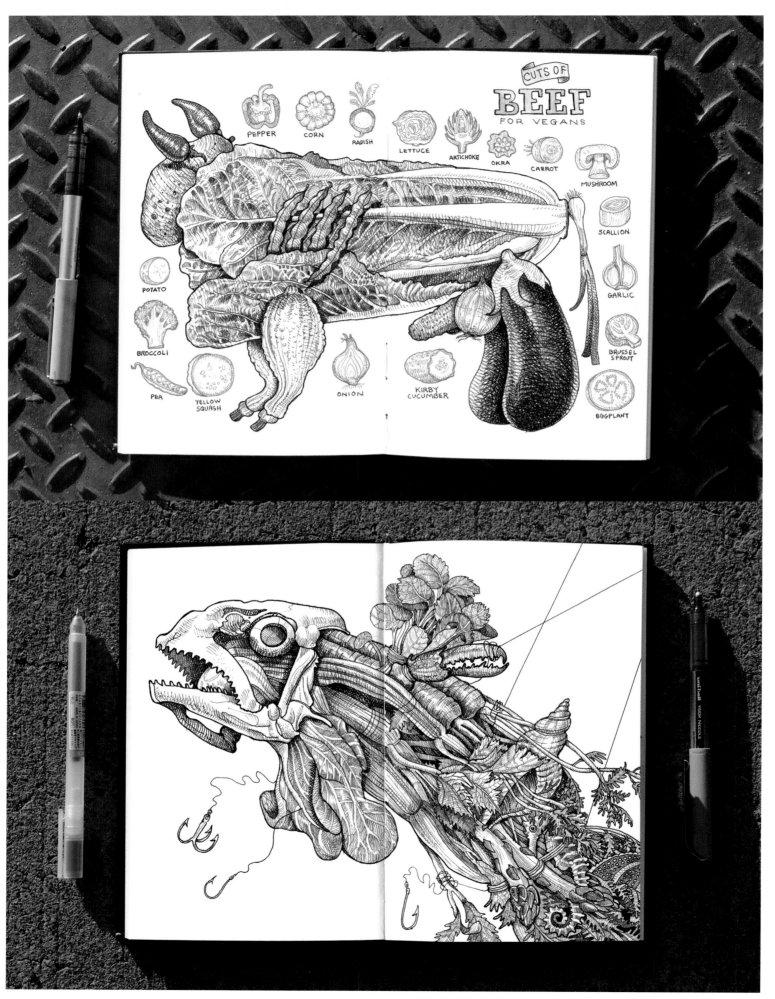

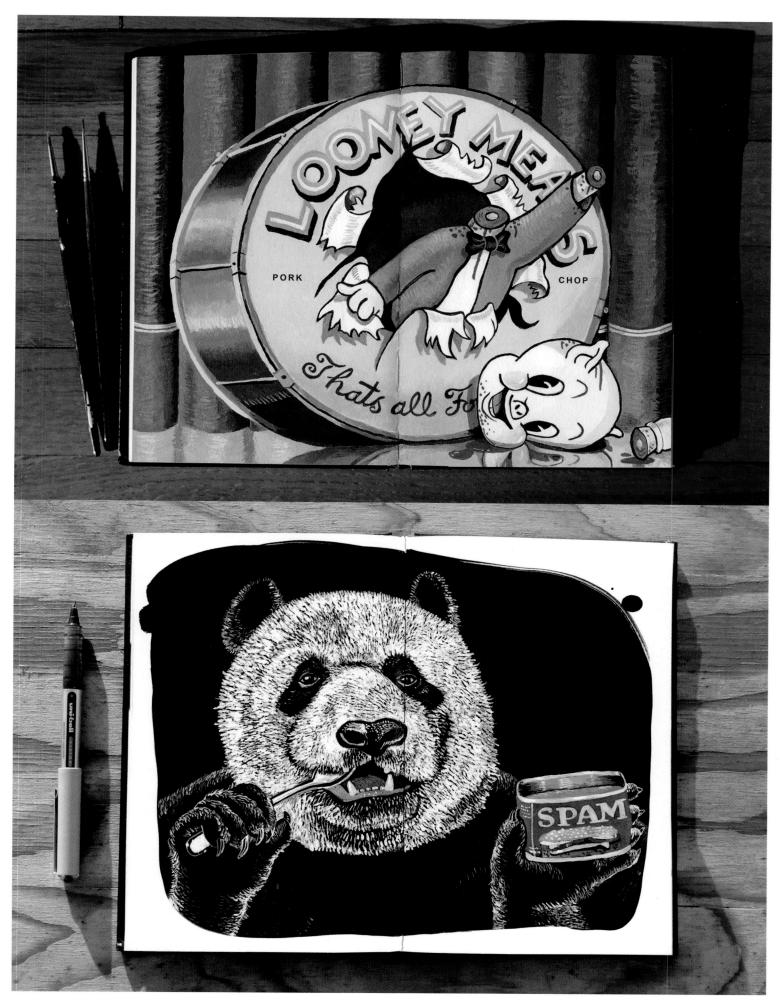

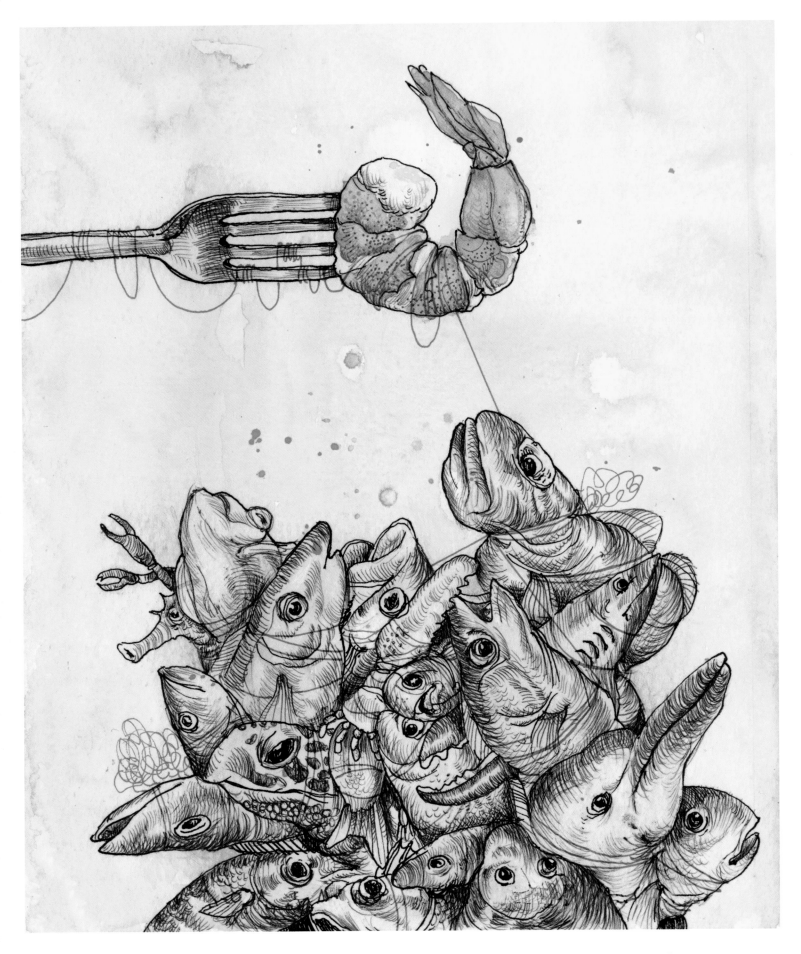

The average shrimp-trawling operation throws eighty to ninety percent of the sea animals
it captures overboard, dead as bycatch. Shrimp account for only two percent of global
seafood by weight, but shrimp trawling accounts for thirty-three percent of global bycatch.[1]

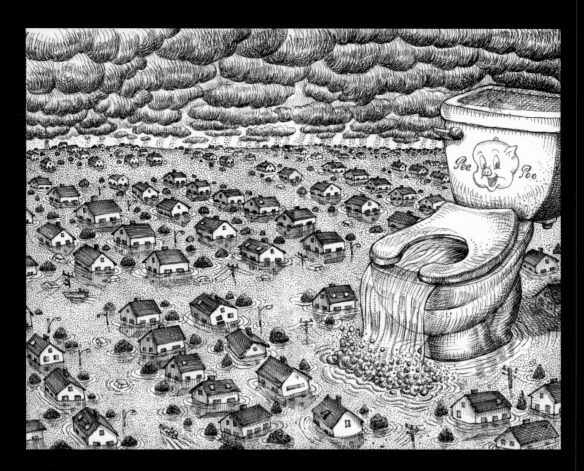

More than one hundred lagoons of pig waste overflowed into the
water system after Hurricane Florence in September 2018.[2]

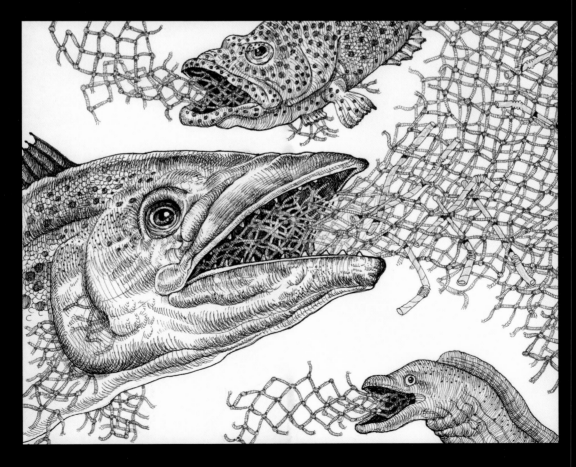

Forty-six percent of ocean plastic comes from discarded fishing nets.[3]

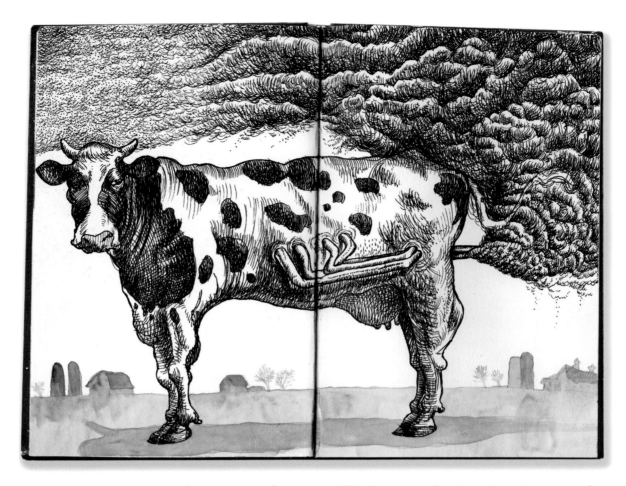

Livestock and their byproducts account for at least 32 billion tons of carbon dioxide per year.[4]

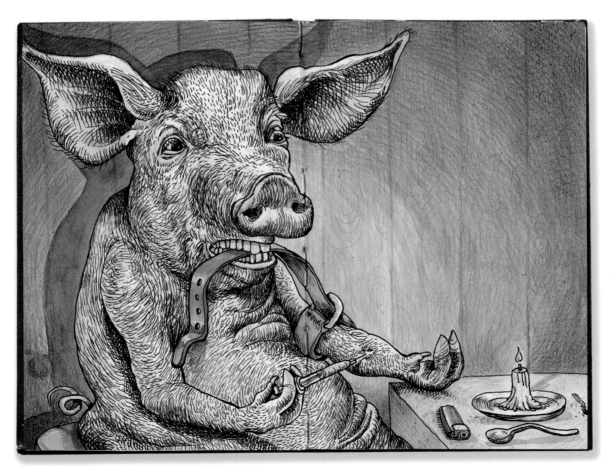

Eighty percent of all antibiotics in the United States are used on livestock.[5]

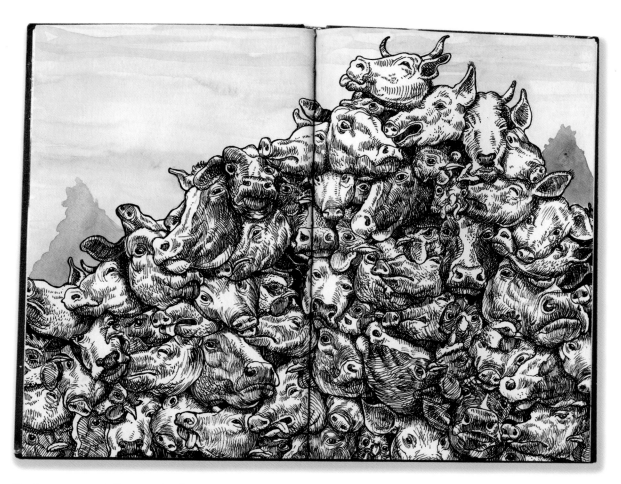

Each year, meat thrown in the garbage equates to twelve billion animals slaughtered for no reason.[6]

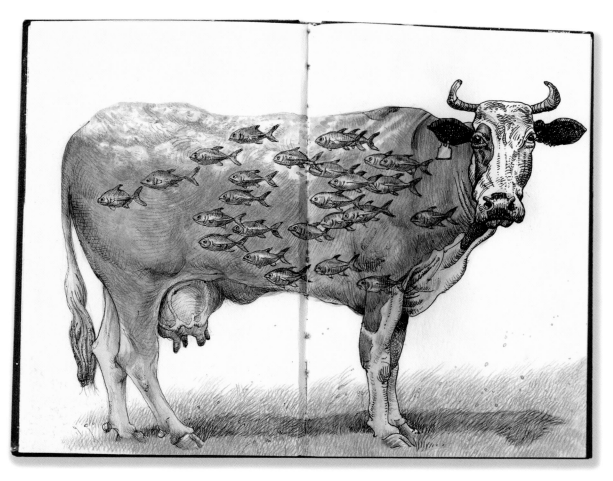

Animal agriculture is the leading cause of species extinction, ocean dead zones, and habitat destruction.[7]

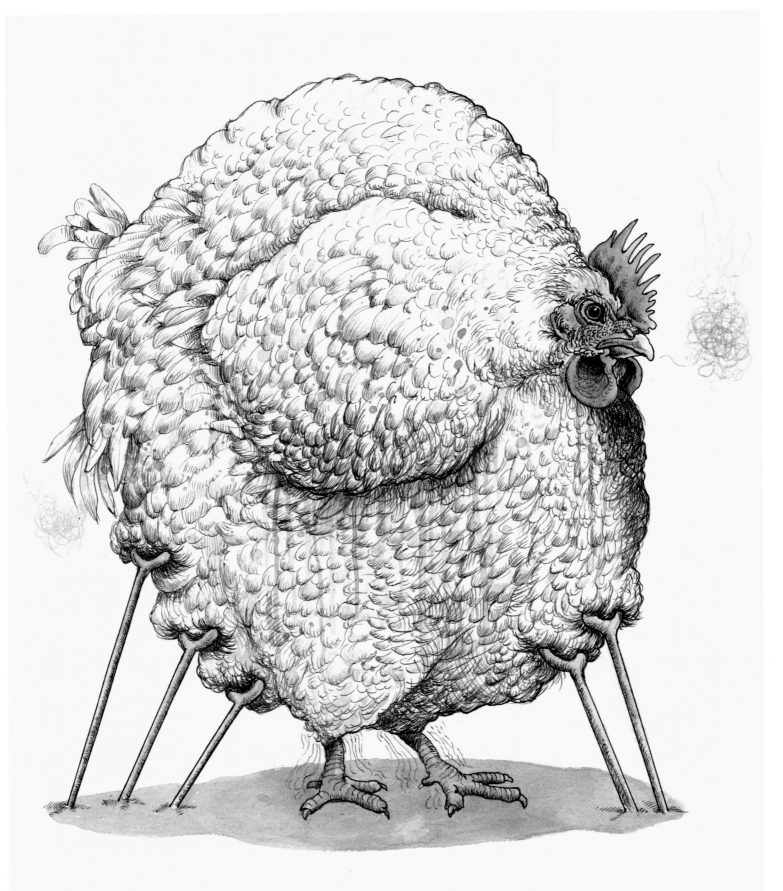

Chickens bred for meat are arguably the most genetically manipulated of all animals, forced to grow sixty-five times faster than their bodies normally would, and the industry continually seeks to increase their growth rate. Their daily growth rate has increased roughly four hundred percent.[8]

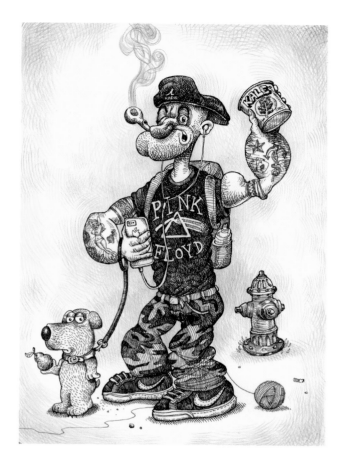

Most people are unaware that
Popeye the Sailorman is vegan.

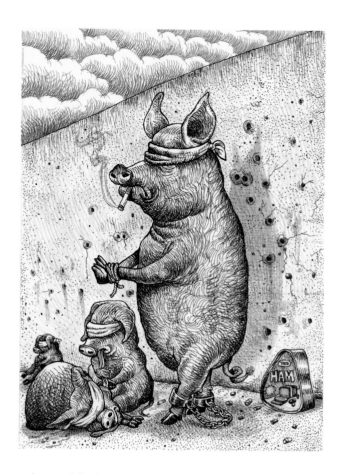

Around forty-seven pigs are slaughtered every
second globally, almost 1.5 billion each year.[9]

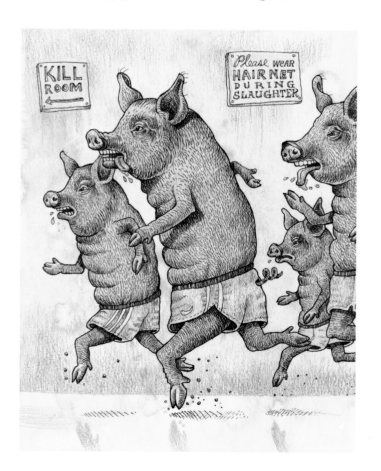

Pigs are slaughtered at speeds of up to 1,100
animals per hour in the United States.[10]

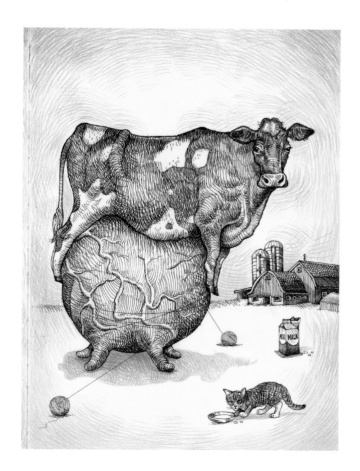

Dairy cows have been modified to produce up to
ten times more milk than they would naturally.[11]

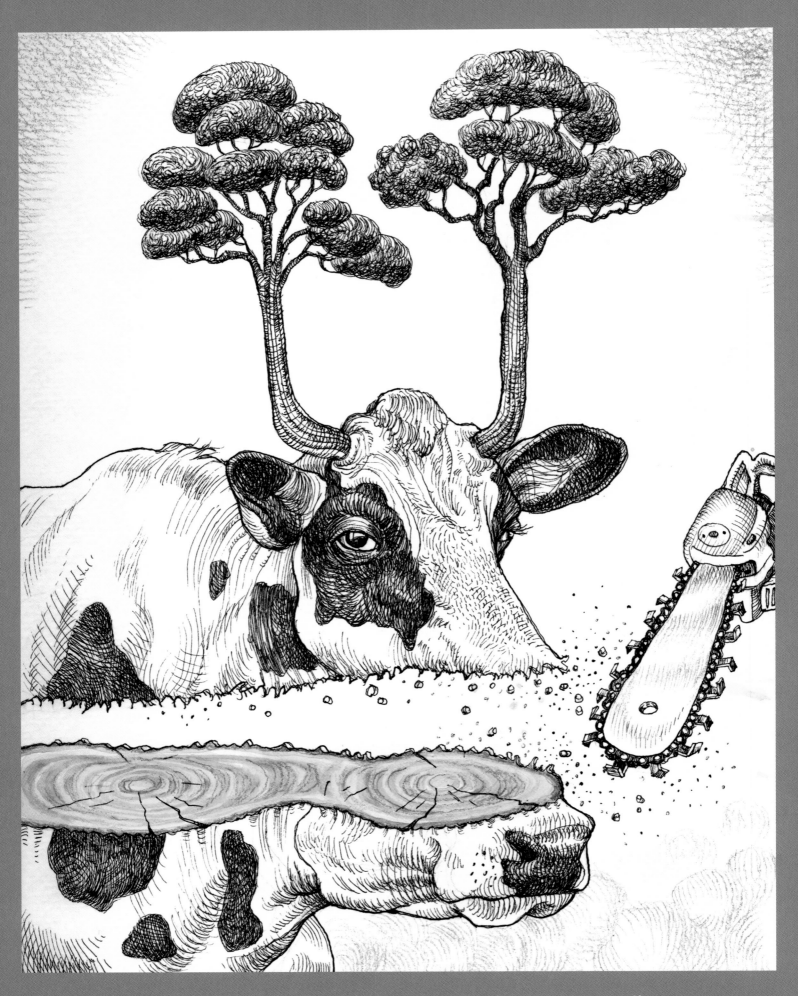

Animal agriculture is responsible for seventy percent of Amazon destruction.[12]

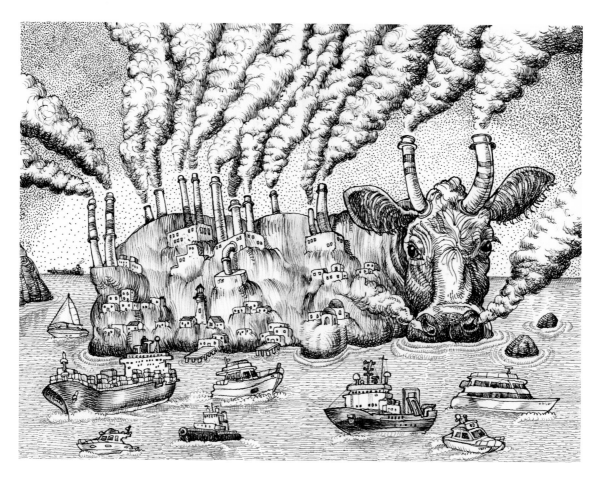

If cows were a country, they would be the third largest greenhouse gas emitter on the planet.[13]

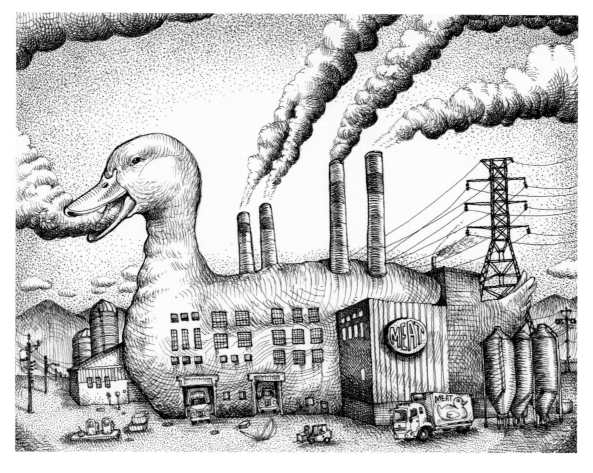

Almost all duck meat in supermarkets and restaurants comes from factory farms.[14]

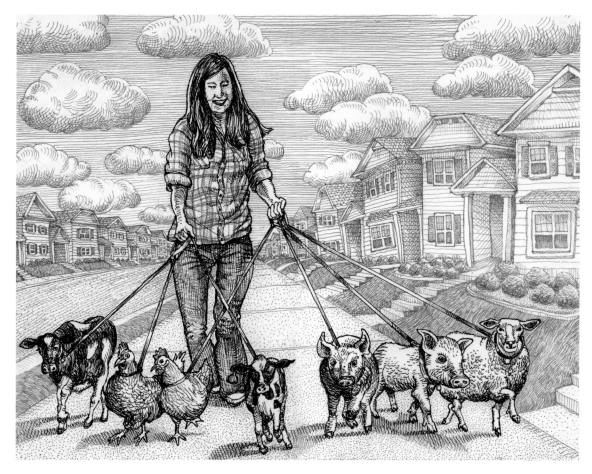

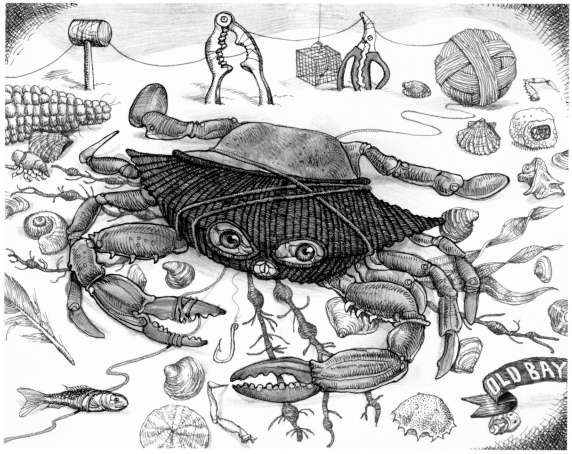

A certain company sold a whopping 398,000 pounds of blue crab mixed with cut-rate crab, which was not even the same species, and labeled it as an American product. A recent report found that nearly forty percent of crab cakes tested contained cheap imported meat.[15]

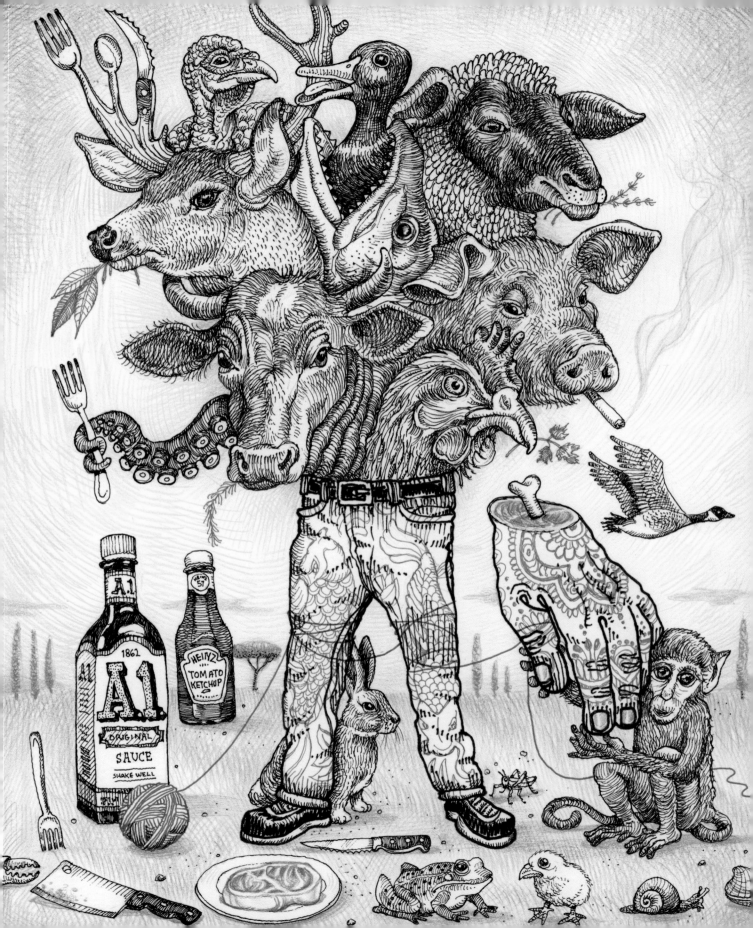

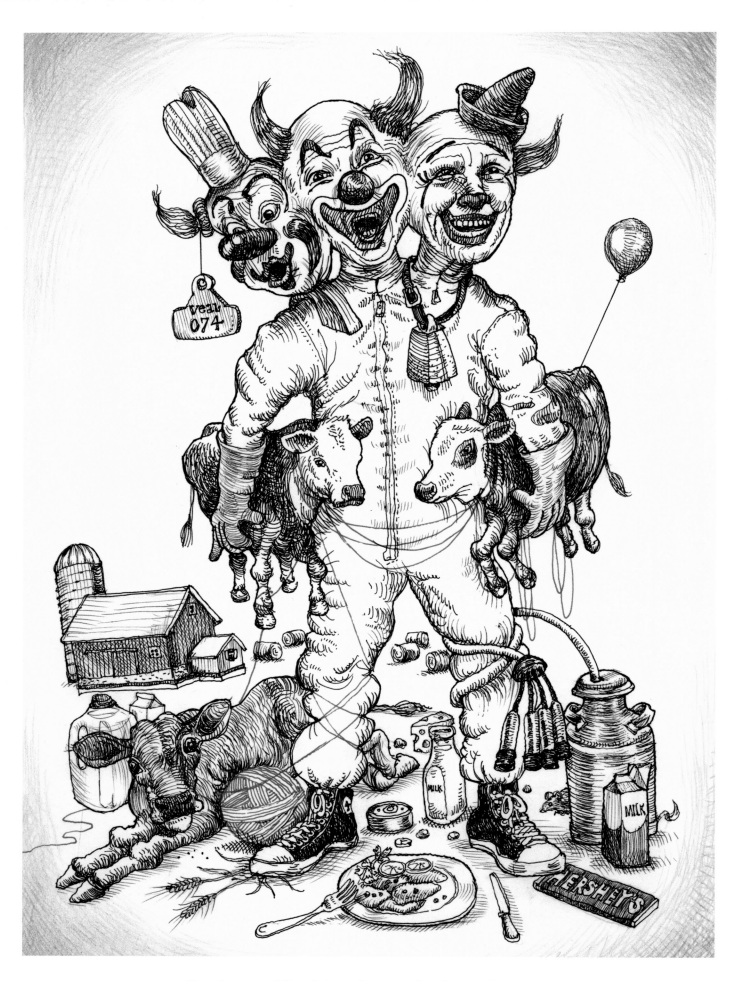

Twenty-one million dairy calves are slaughtered for veal or
cheap beef every year globally. Another reason to be vegan.[16]

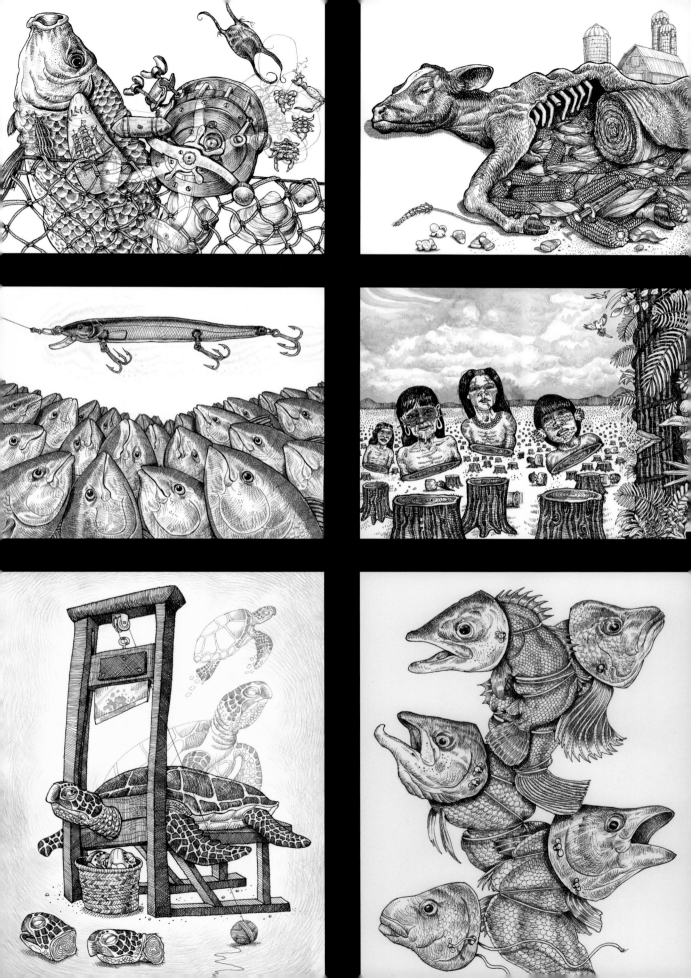

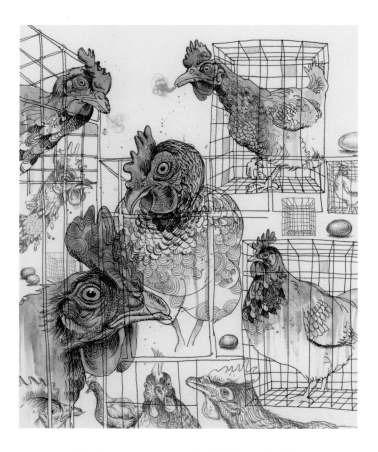

Ninety-seven percent of all eggs in the United States are from hens in battery cages with no way to roam outside.[17]

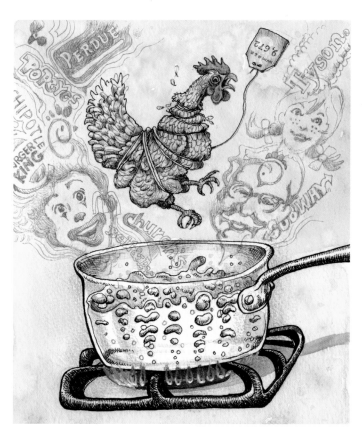

The U.S. government estimates that approximately 1 million birds are scalded alive at slaughterhouses each year.[18]

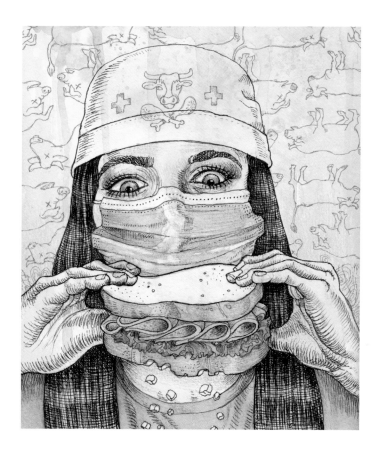

The World Health Organization has classified cured meats as Group 1 Carcinogens, the same as asbestos.[19]

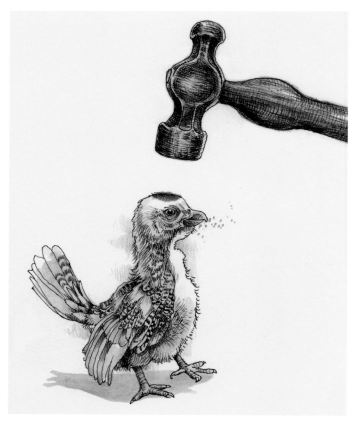

All baby male layer chickens are destroyed (250 million a year in the United States).[20]

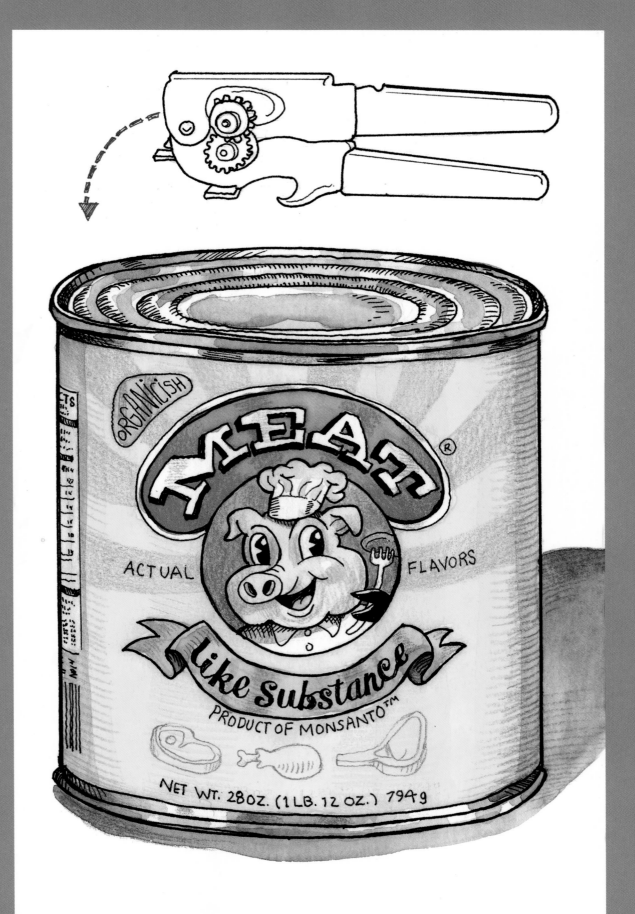

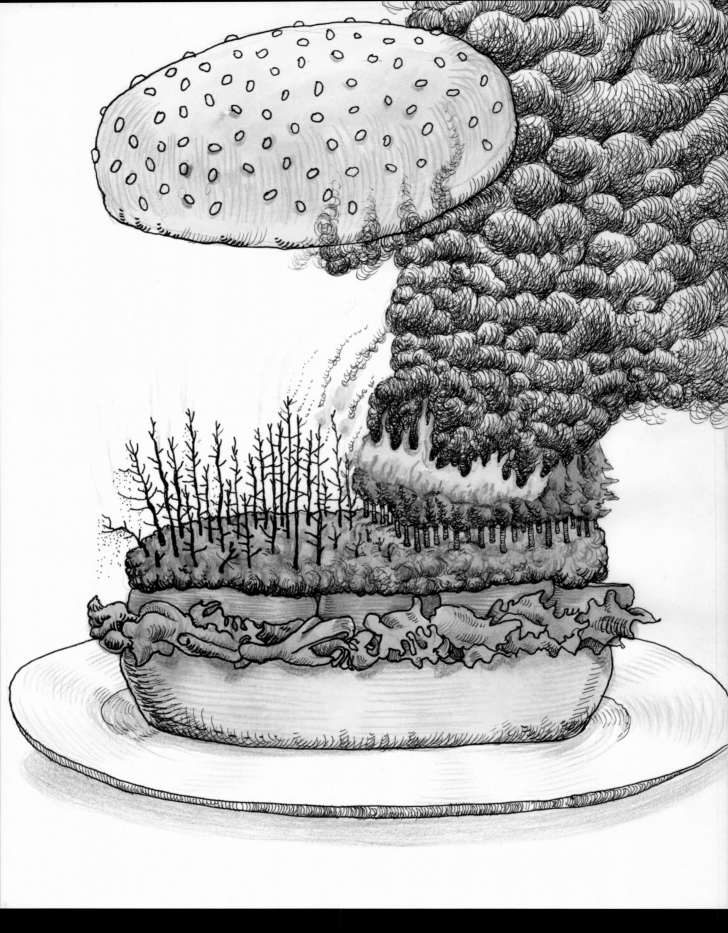

Basically, eating hamburgers is what's
causing the Amazon to burn to the ground.

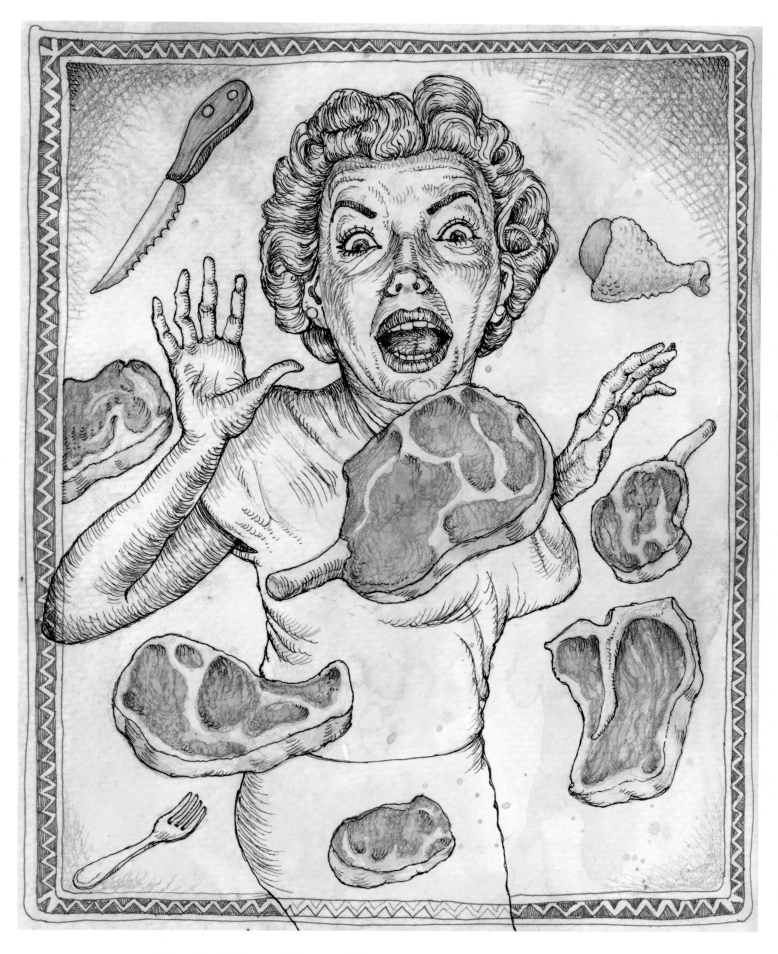

A *New York Times* article stated that a recent survey found that "vegans are viewed more negatively than atheists and immigrants, and are only slightly more tolerated than drug addicts." I say, "can't we all just get along?"[21]

HELEN BARKER

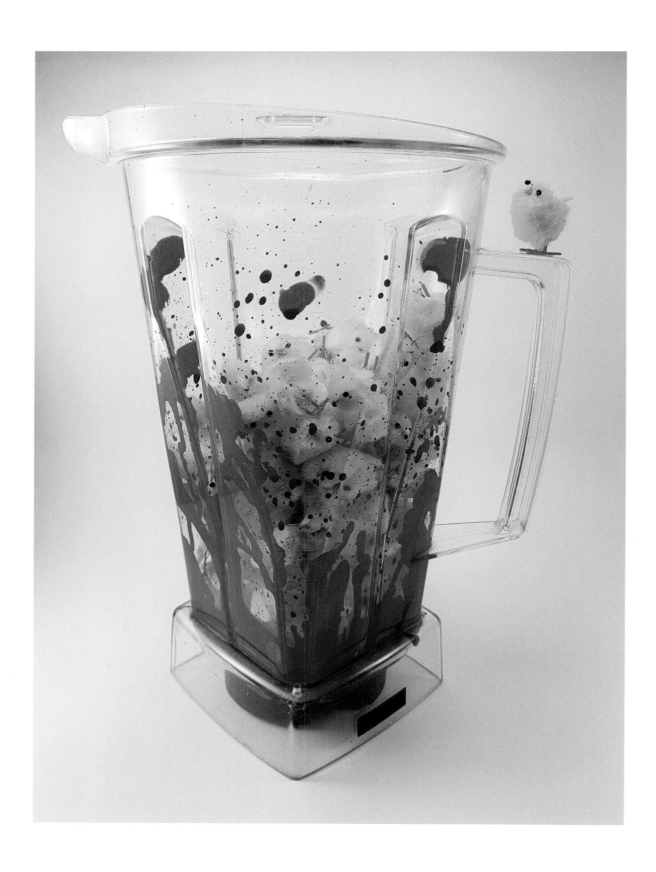

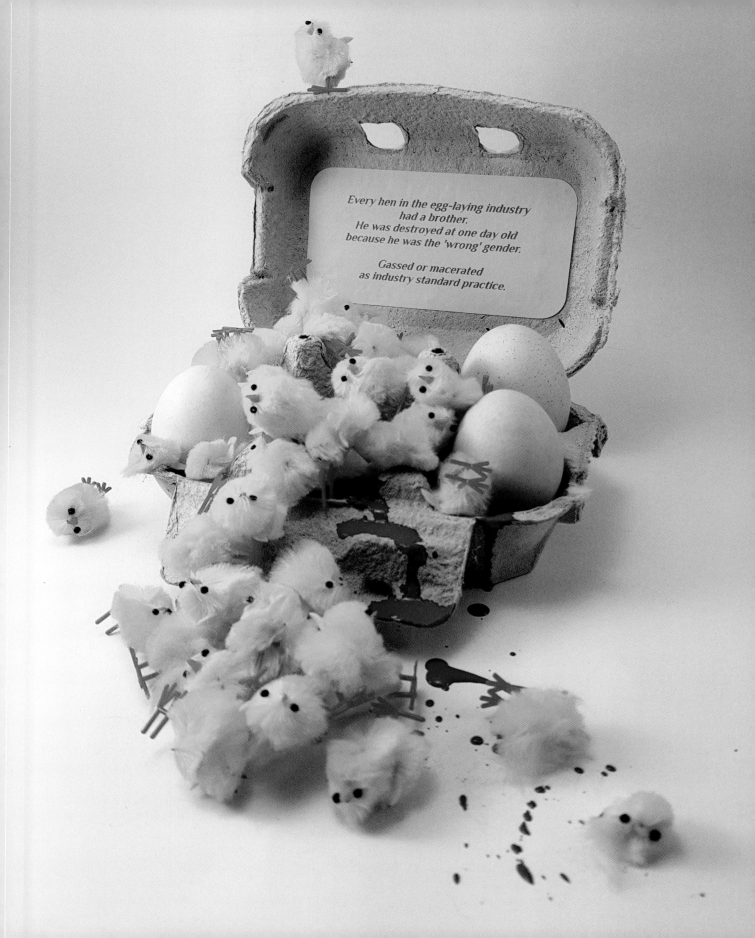

Every hen in the egg-laying industry
had a brother.
He was destroyed at one day old
because he was the 'wrong' gender.

Gassed or macerated
as industry standard practice.

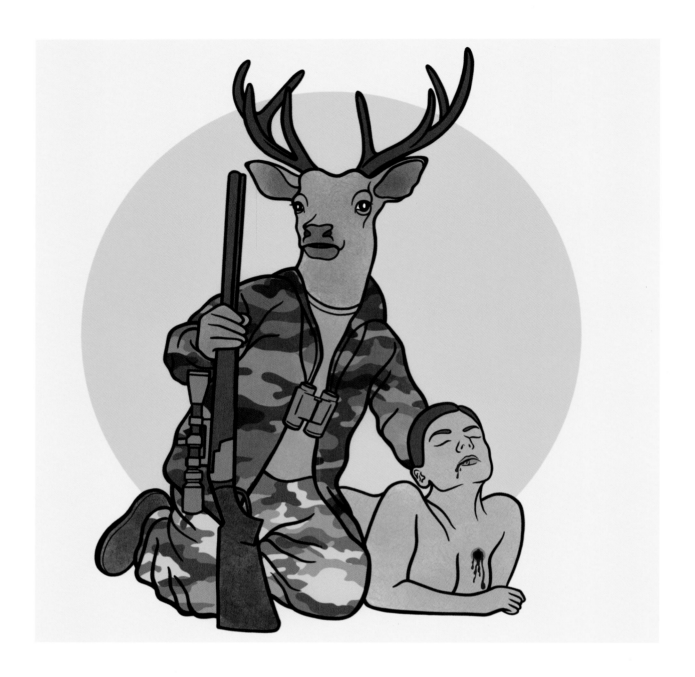

MELINDA HEGEDUS

I have always loved to draw and paint, but what eventually fueled me to create these vegan-themed illustrations is all the frustration that I feel as I live as a vegan in this mad meat-eating world. Luckily, I found a creative way to channel all the anger and resentment that I felt and to transform those feelings into something with value for the world and that can help destroy carnism and bring about positive change in people's minds. The pictures use bold colors and humor. Strong, bright colors help to grab attention; humor simultaneously distracts and instructs viewers. It distracts them from the seriousness of the topic, while guiding them to think about the messages behind the art. Because of the humor, nonvegans can

glance at these vegan images and maybe even reflect on them, instead of instantly blocking them out like other vegan-related messages. The drawings display animals in an anthropomorphic shape. Anthropomorphism is the attribution of human traits, emotions, or intentions to nonhuman entities. I hope that looking at these anthropomorphic animals will help my fellow humans see that, despite anatomical differences, animals are just like us. We all fear pain and death, and we all try to avoid suffering. We are all sentient beings living together on this planet. I hope my images help humans to think about the reality behind eating meat. We are one. We are the same. Make the connection and go vegan!

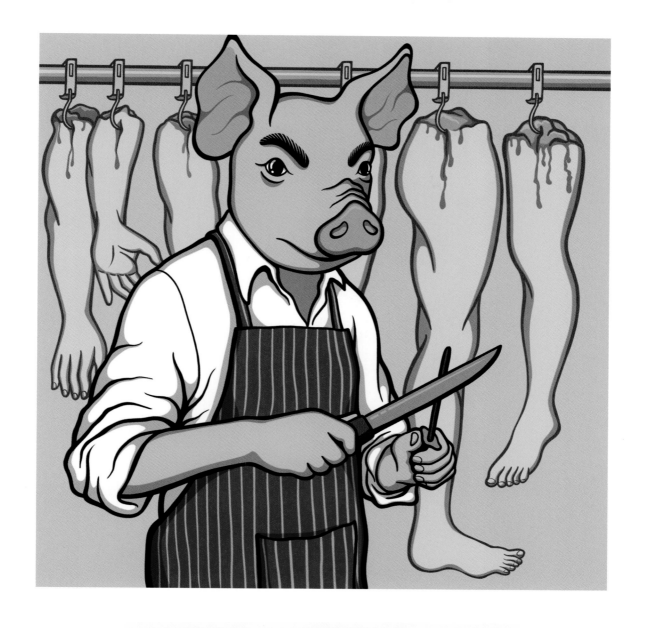

FRESHFlesh

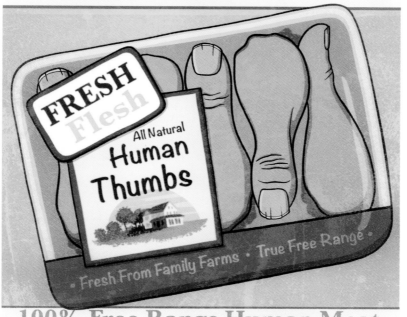

100% Free Range Human Meat

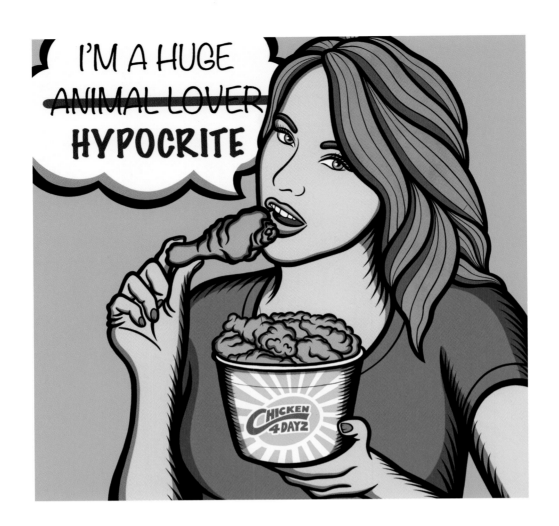

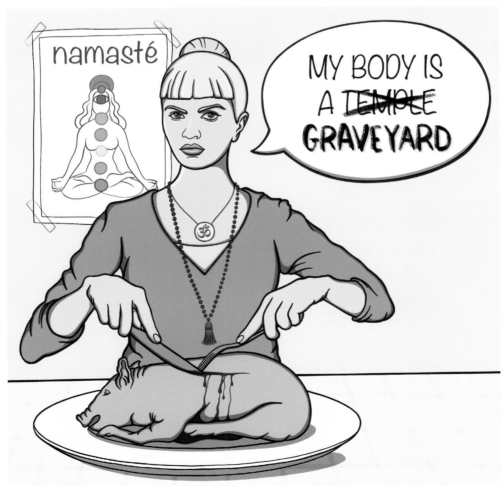

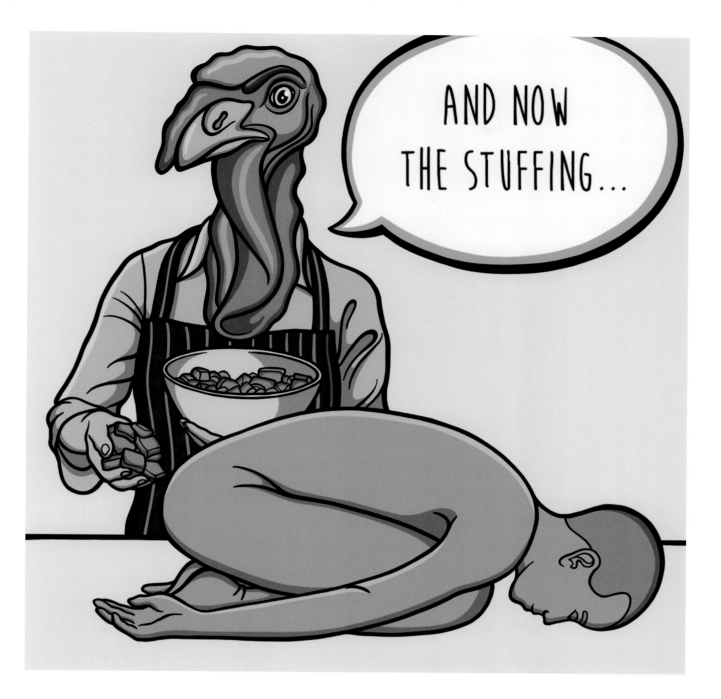

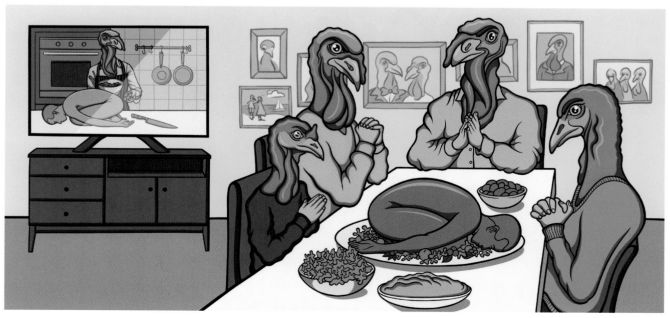

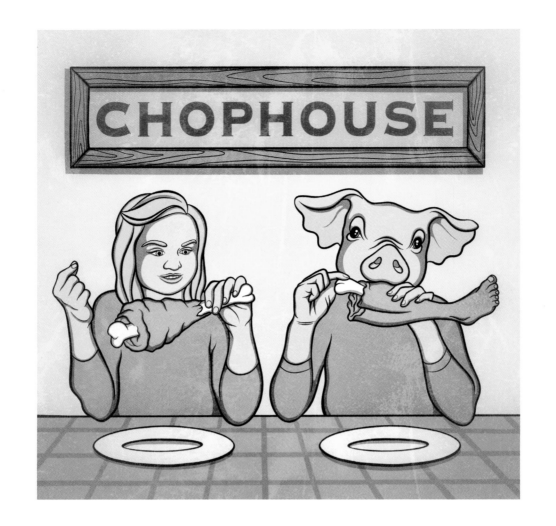

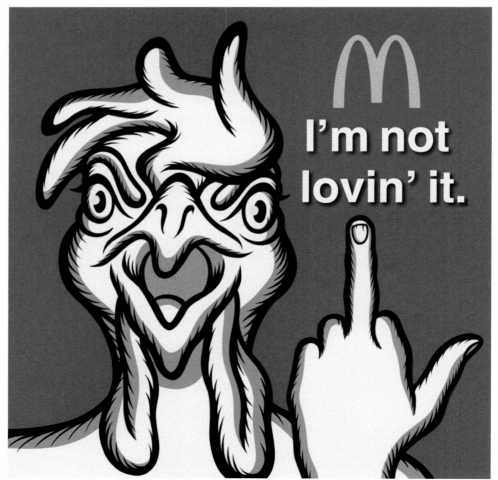

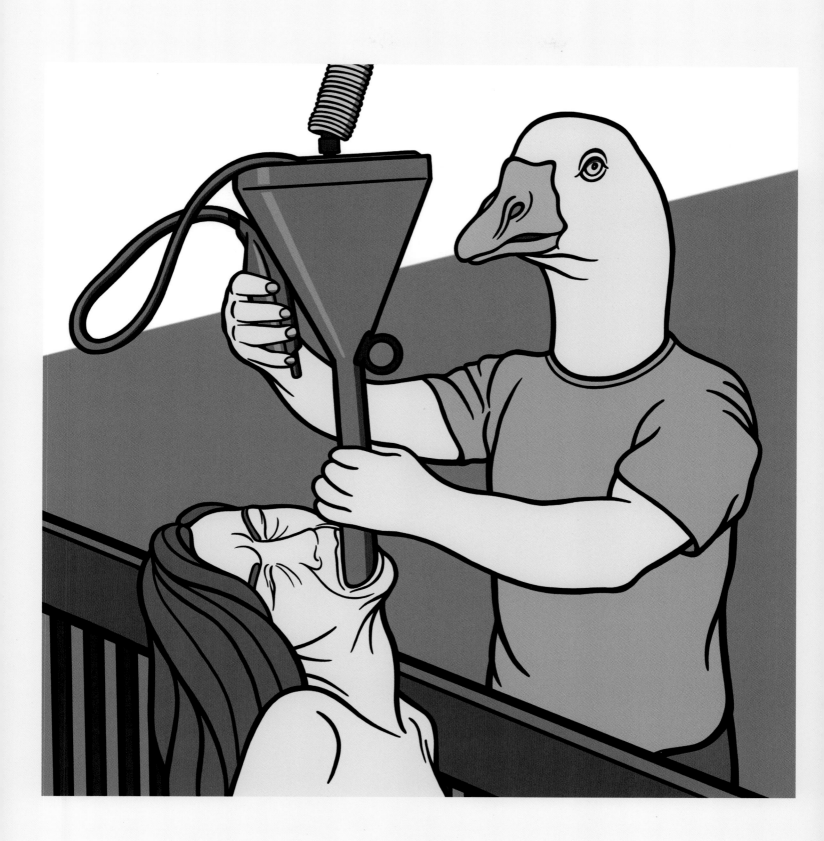

PHILIP McCULLOCH-DOWNS

I became vegetarian as a teenager, immediately after having a close encounter with a truck transporting sheep to the slaughterhouse. But like most people would, I then deployed an unhealthy dose of cognitive dissonance to avoid confronting the more complex issues of dairy, eggs, leather, and vivisection. Wearing these blinders worked perfectly well for sixteen years until I volunteered at a local animal-rights organization, and then I finally saw clearly. The facts that were presented to me were unavoidable, unforgettable, and unacceptable. So my vegan lifestyle began. Although my novels, poetry, and painted canvases were from then on predominantly concerned with environmental and vegan issues, it was almost a decade before my art caught up with my ethics. I read the book *We Animals* by the photojournalist Jo-Anne McArthur and was so moved by it that I painted the author and emailed her the portrait as a surprise gift. After the incredible response that this one piece of artwork (p. 47) received on social media (and from Jo herself), my life changed literally overnight, and my course as an "artivist" was set.

I isolated myself from the all-too-human egos around me and made a pact with the animals with which I felt such empathy. Using photographic evidence from undercover investigators—the real heroes of the animal-rights movement—I chose to record accurately the suffering and sorrow of farmed animals, to portray their individual characters with dignity, and to make the viewer feel profoundly (and rightly) disturbed by what they were seeing.

Since the painting of Jo-Anne in 2014, my animal art has been created as an "act of controlled fury"—a violently emotional reaction to the casual, "acceptable" cruelty of our everyday world, and to the lies and deceit employed by the meat and dairy industries. Whether thought-provoking, shocking, or satirical, "activist art" holds a mirror up to our society. It speaks eloquently to the viewer in a language that transcends borders and cultures. It alters perceptions and changes minds. In the future, I hope that my contribution to this movement is nothing more than a beautifully grotesque record of what once was.

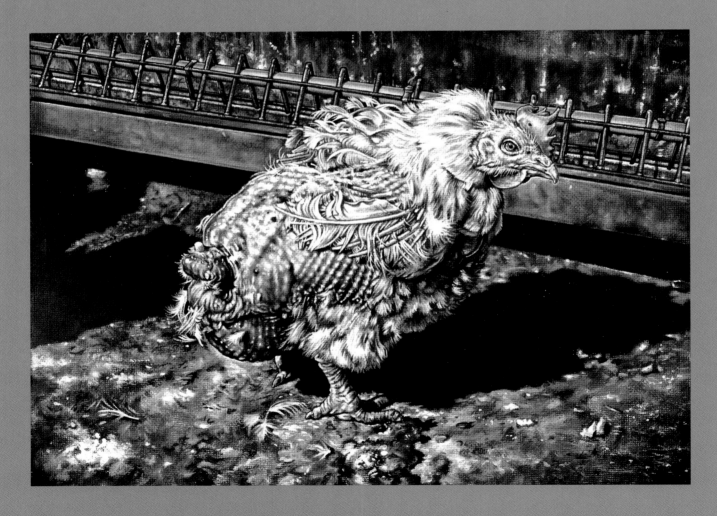

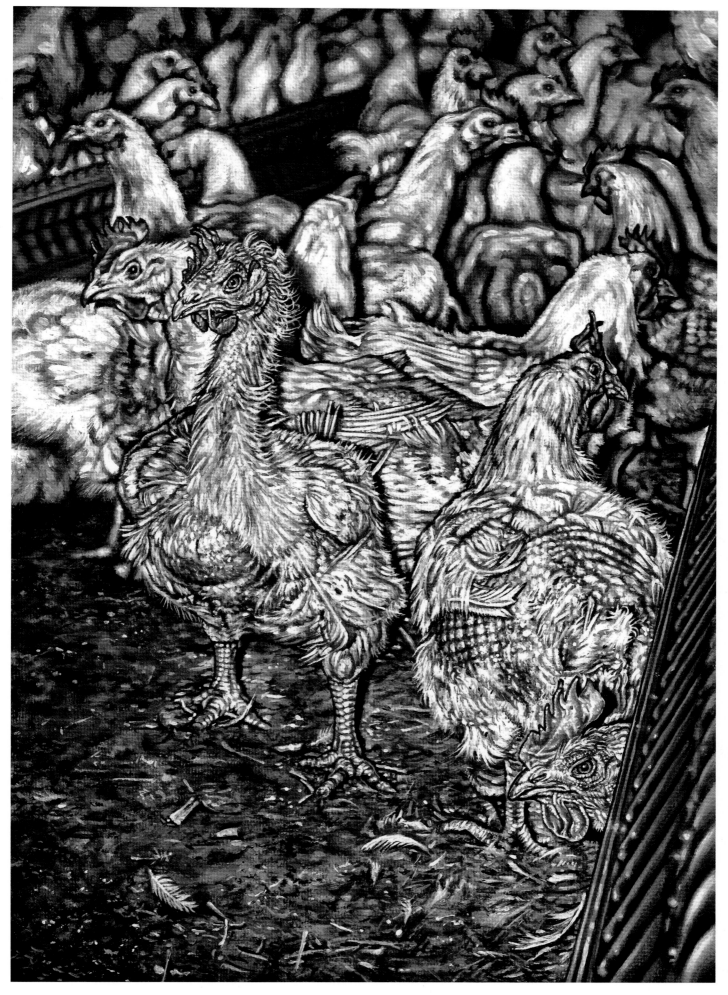

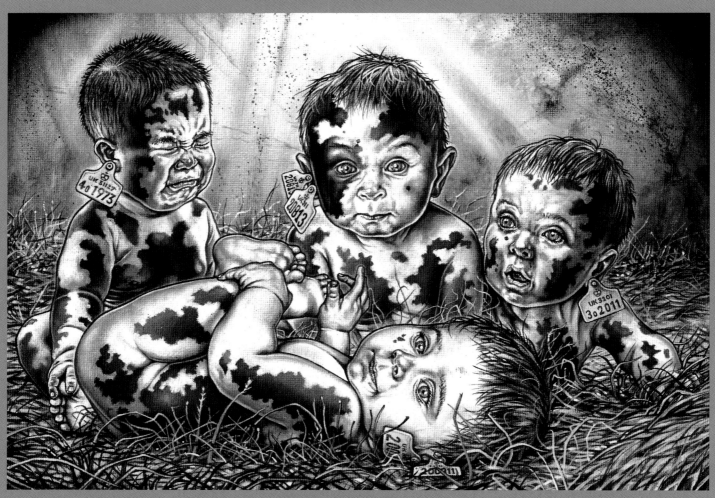

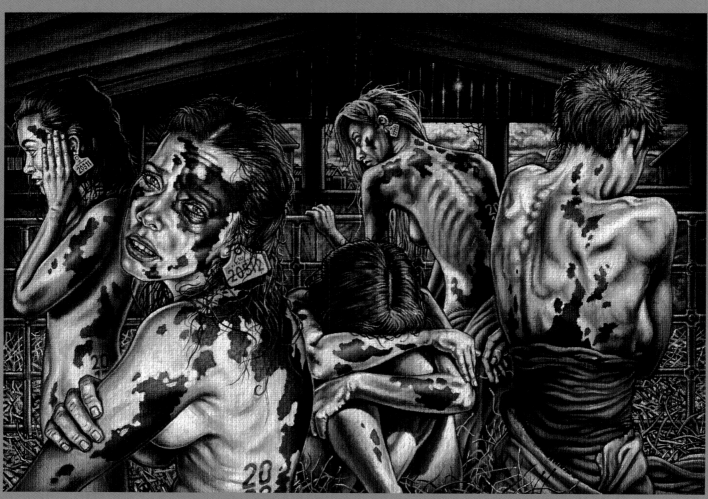

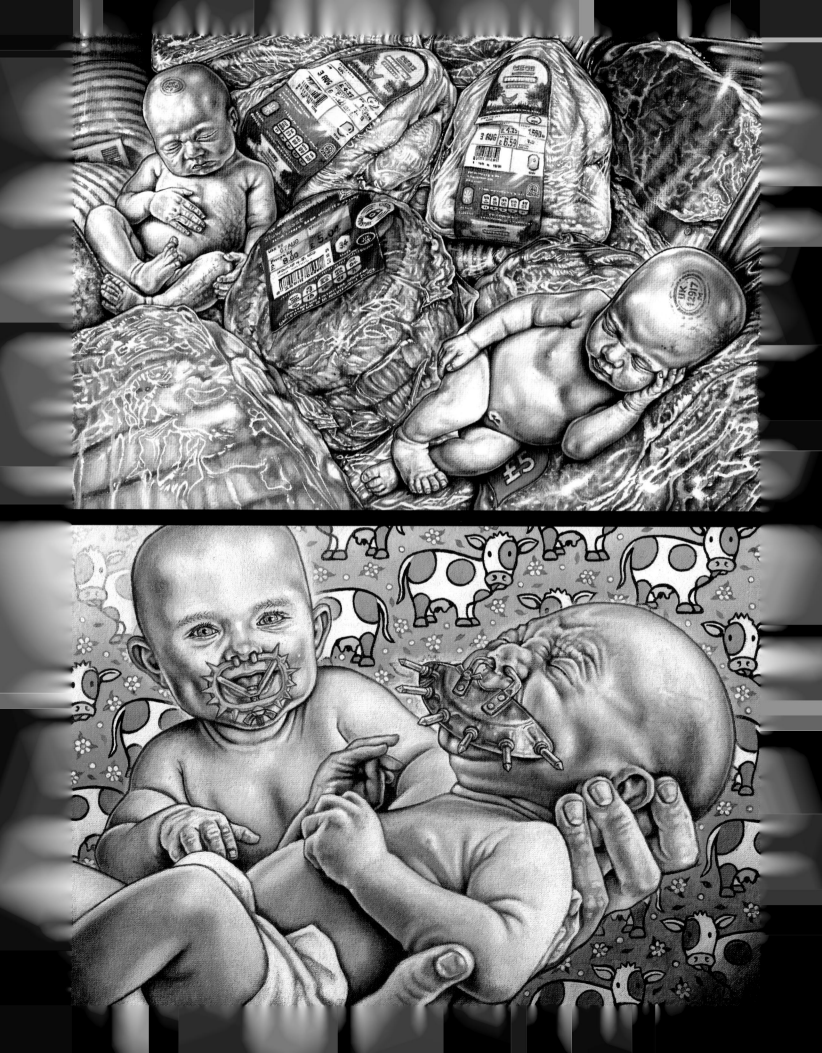

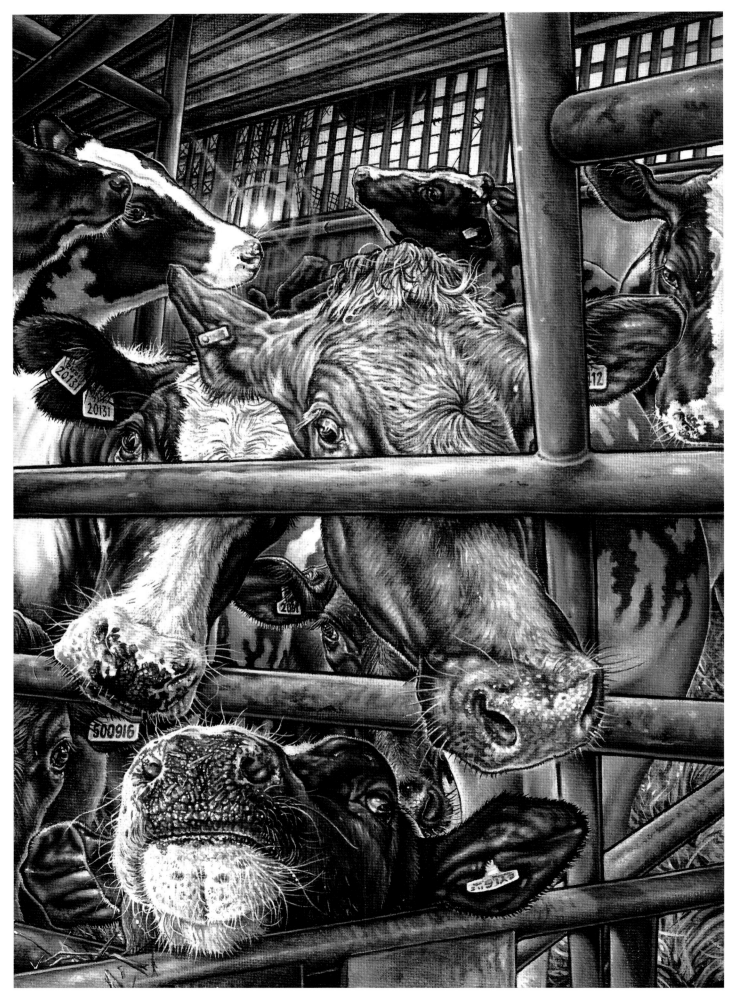

44

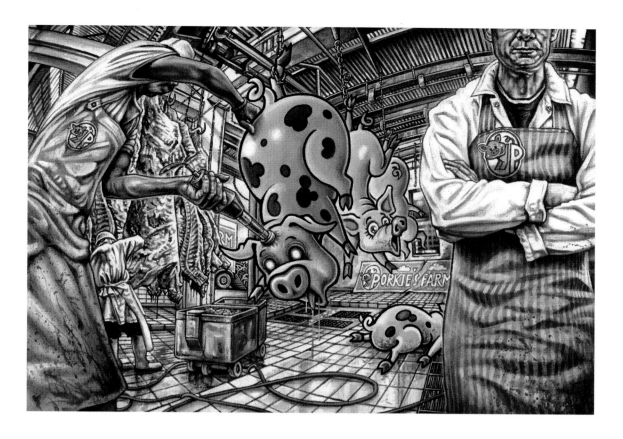

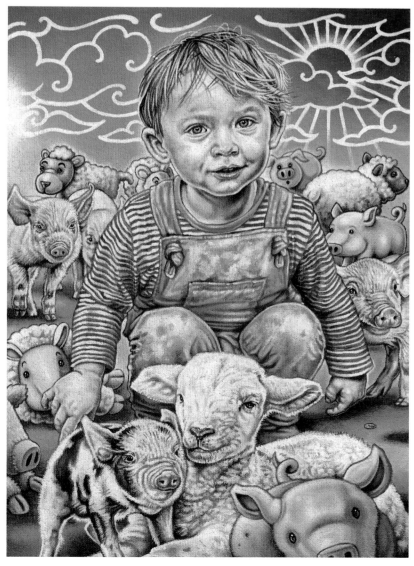

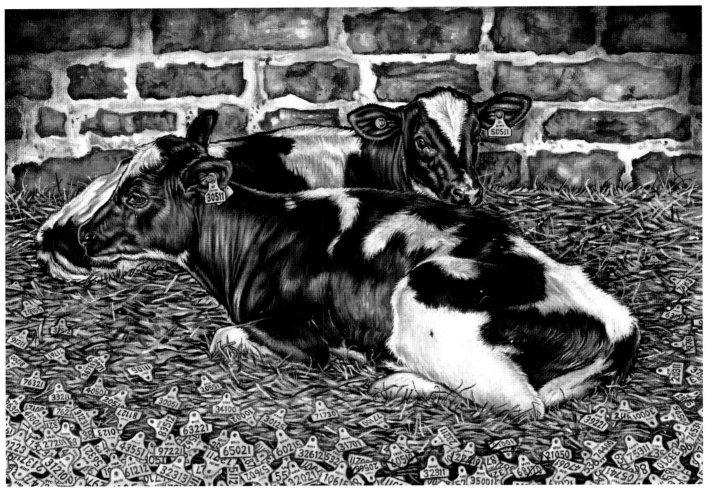

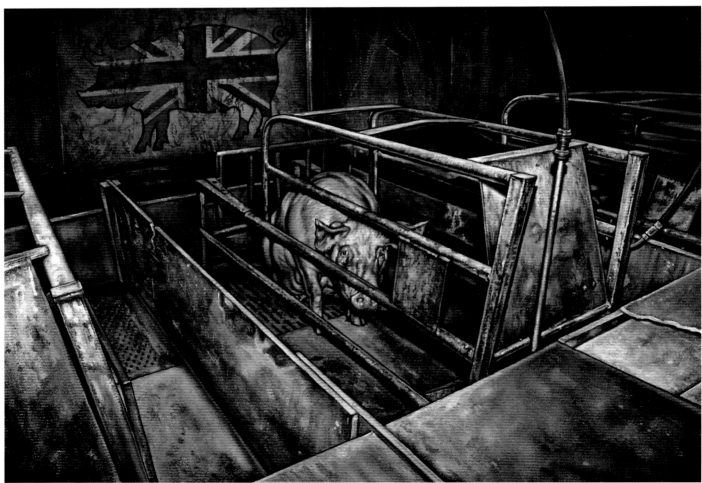

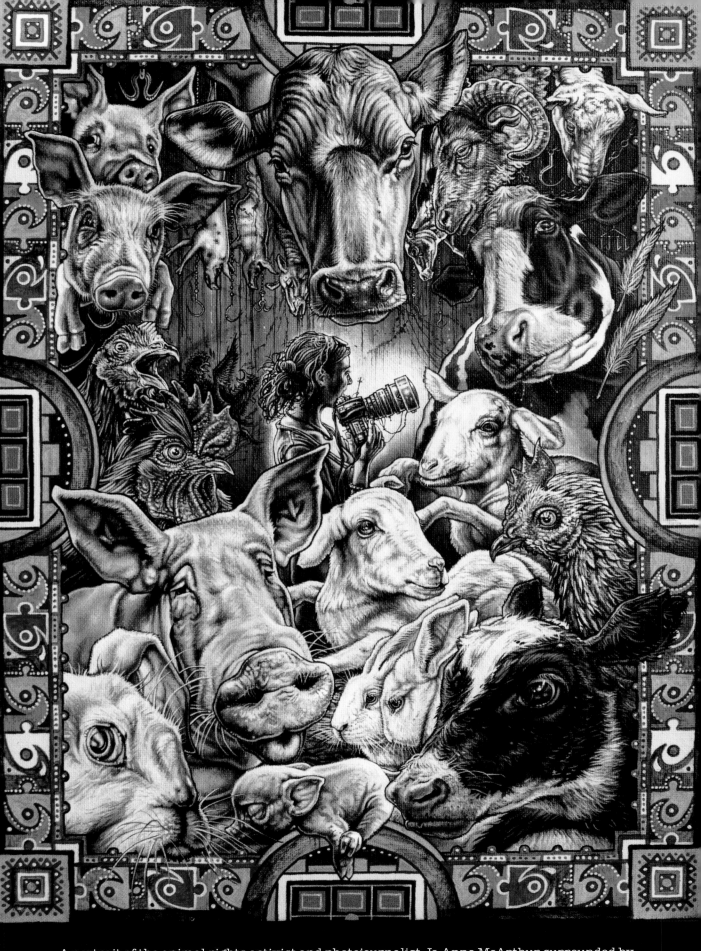

A portrait of the animal-rights activist and photojournalist Jo-Anne McArthur surrounded by some of the individual animals (both rescued and lost) that she has photographed.

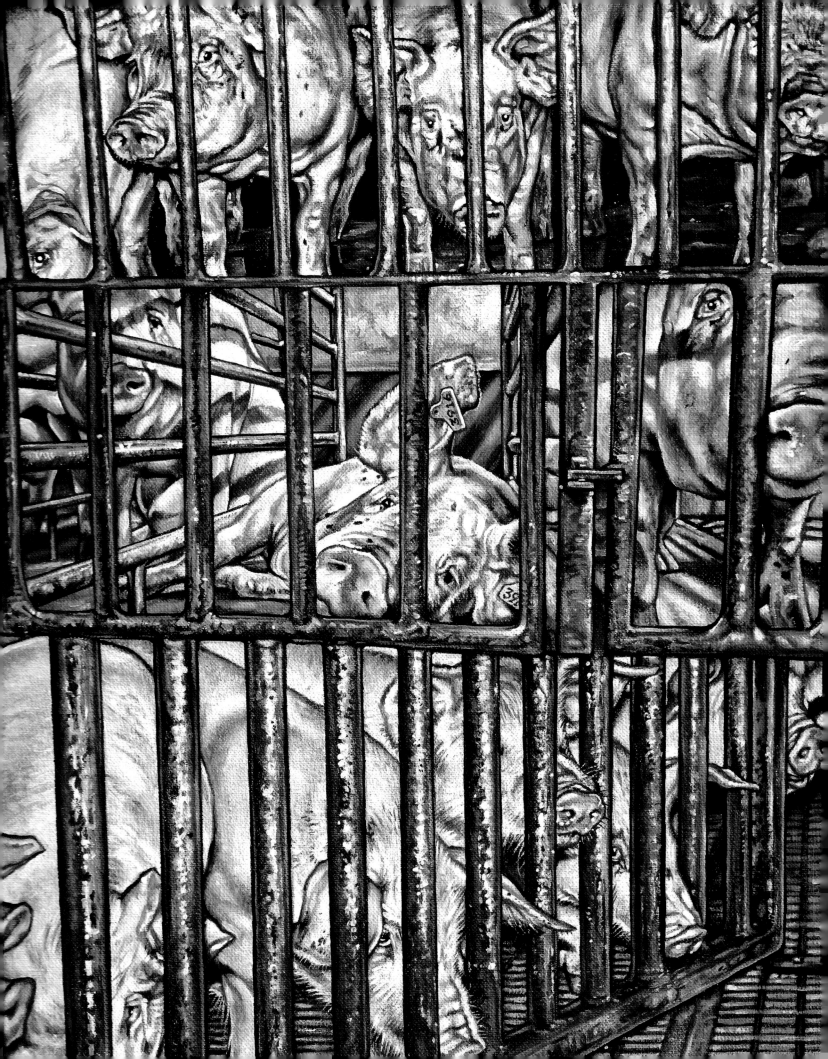

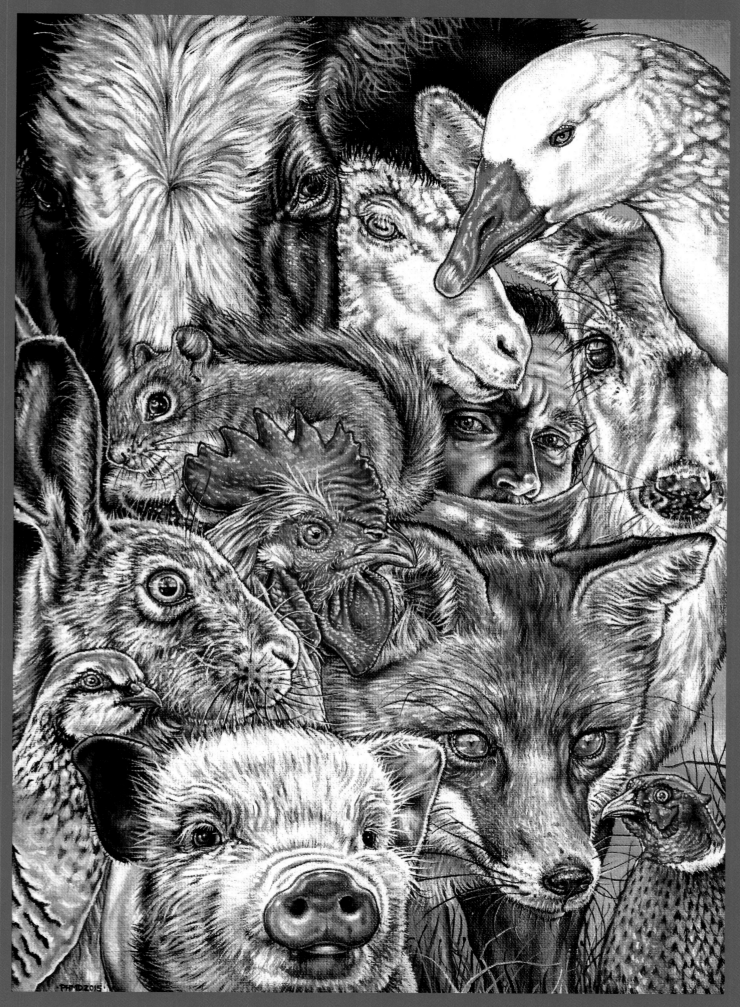

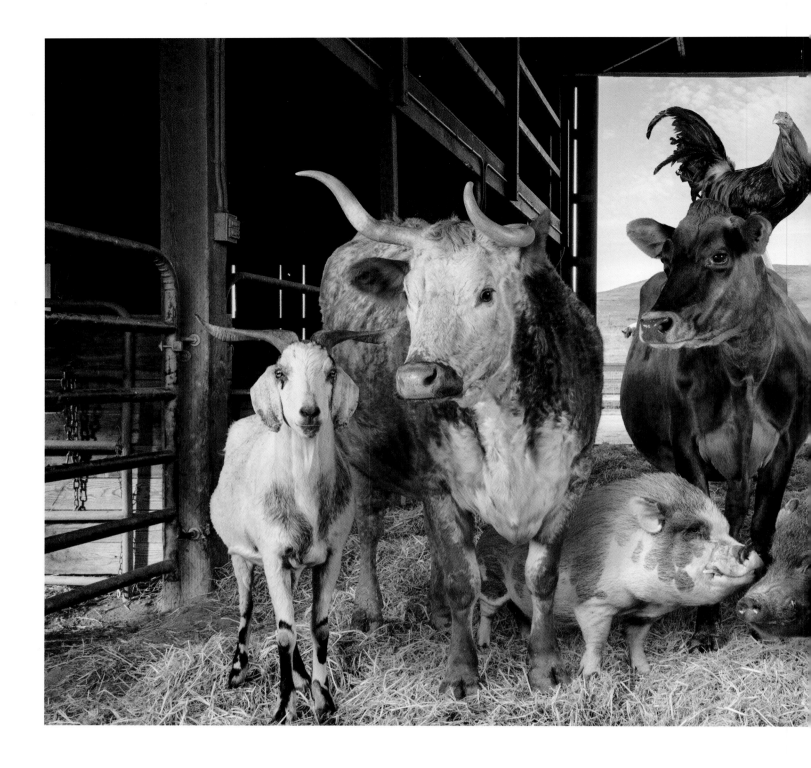

ROB MacINNIS

I make photographs of farm animals using methods designed to intoxicate the viewer and overwhelm them with sympathy. They are designed to make us question our own impulse to eagerly accept the reality that we desire, even while knowing it cannot be true.

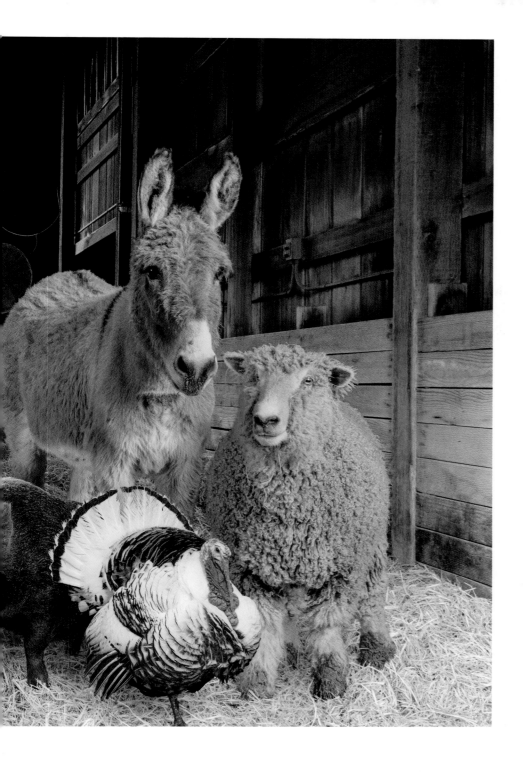

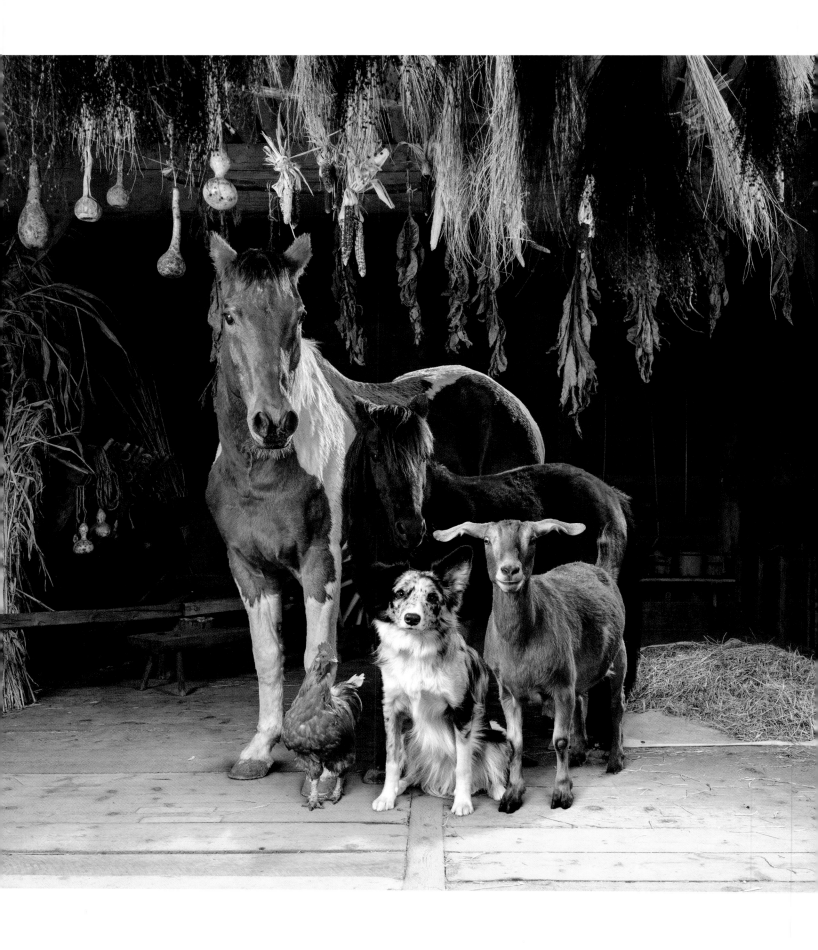

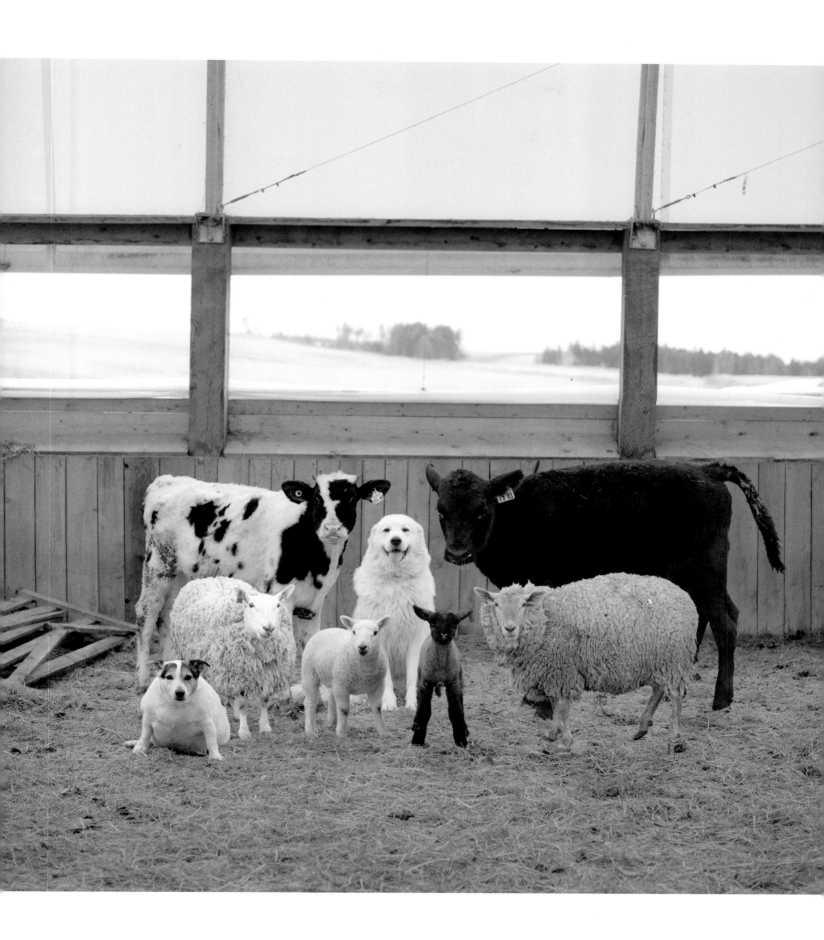

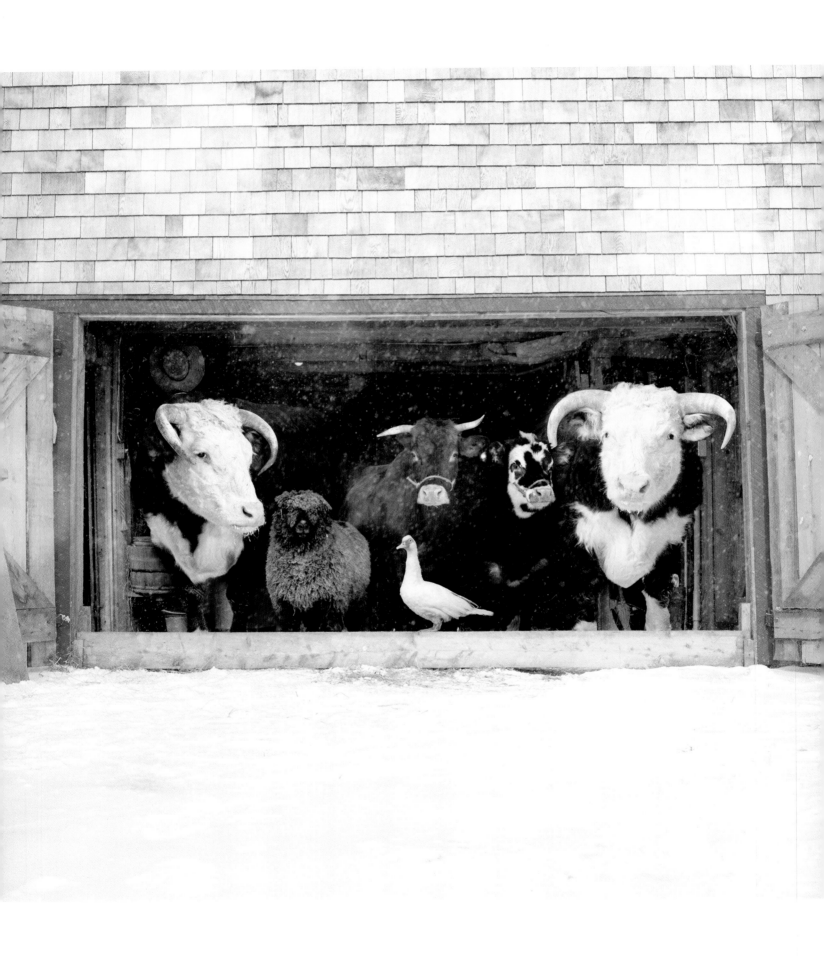

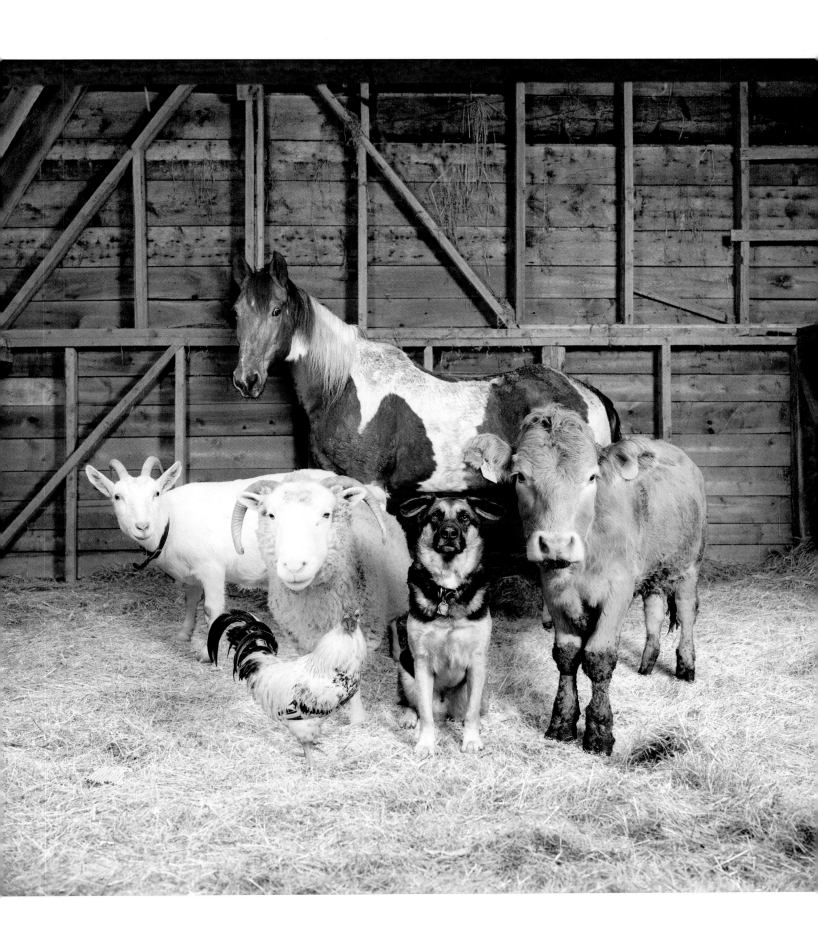

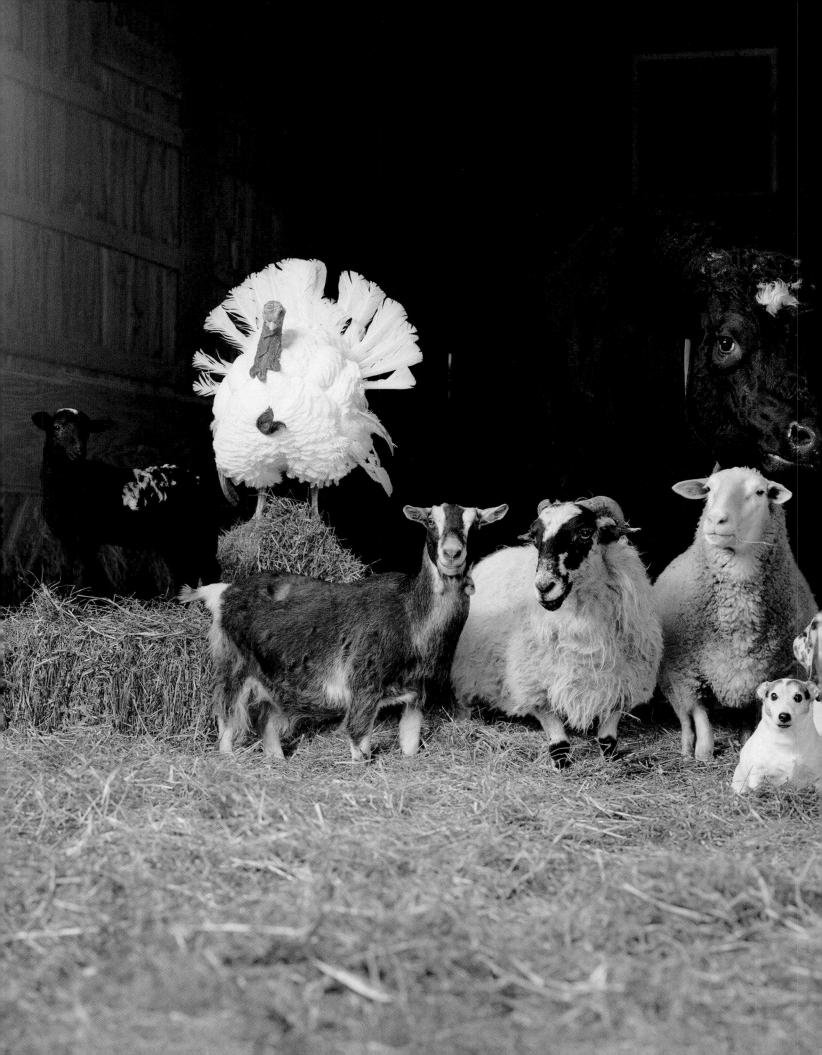

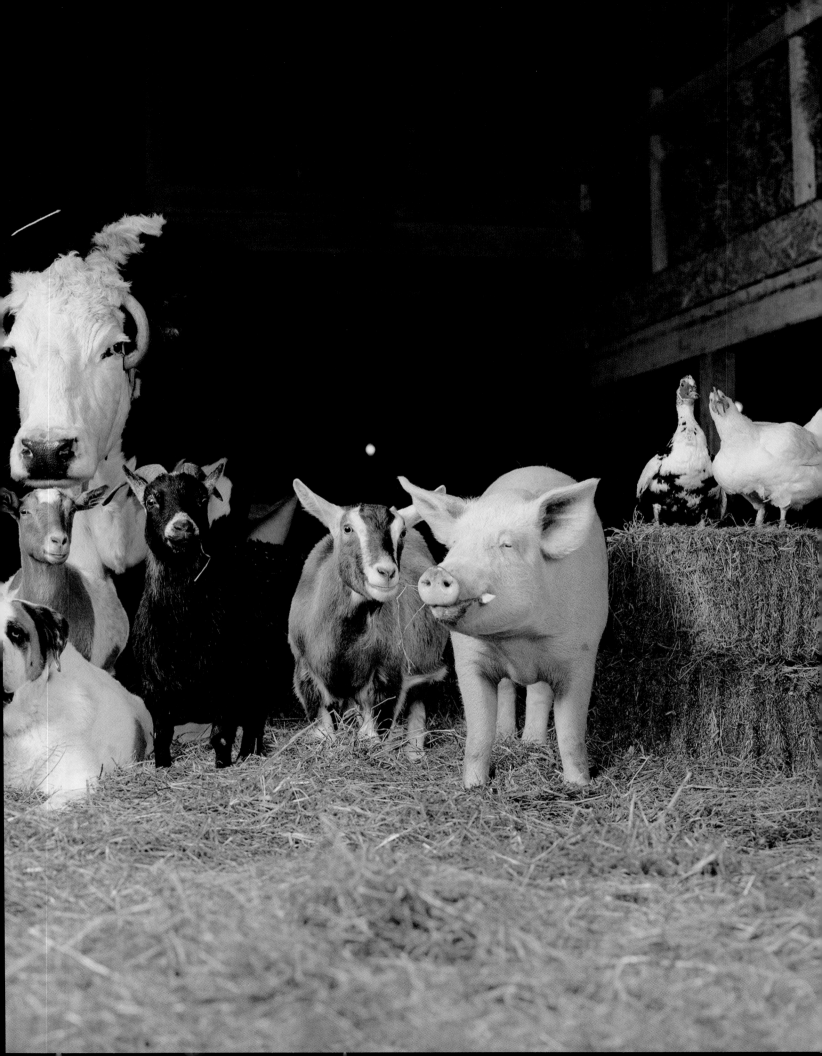

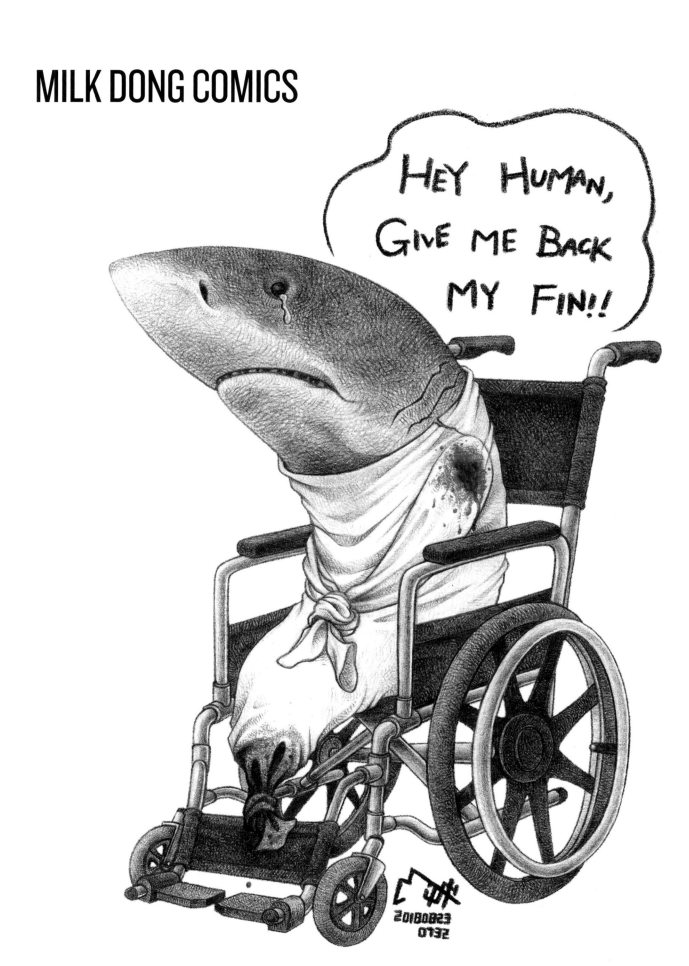

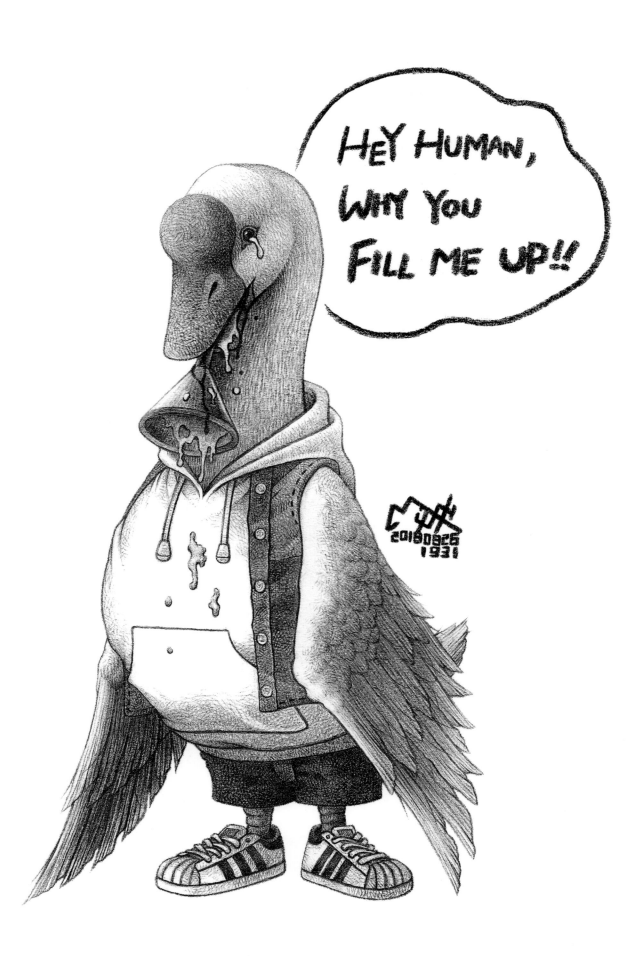

DAN PIRARO

Dan Piraro is an American artist, illustrator, writer, and cartoonist, best known for his comic strip *Bizarro*, which since its debut in 1986 has been syndicated in hundreds of publications across North and South America, Europe, and Asia. Describing himself as "liberal and progressive," he has often addressed political issues through his work.

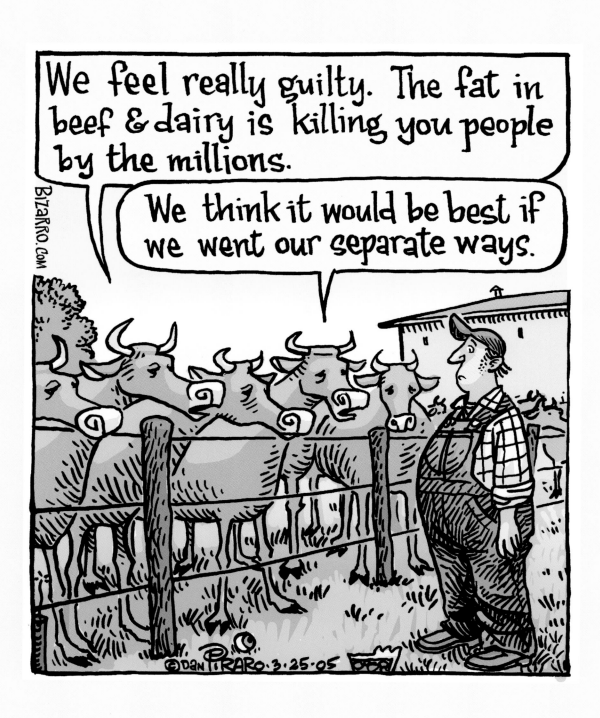

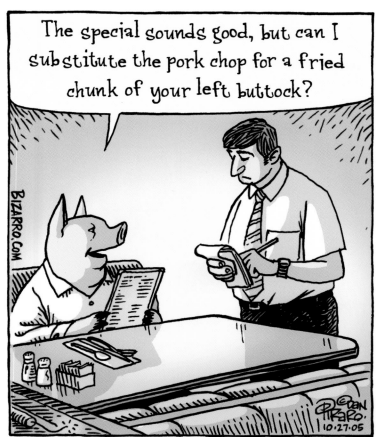

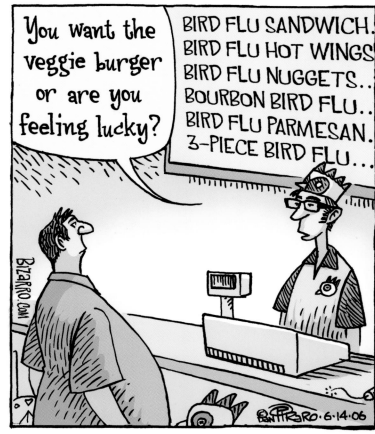

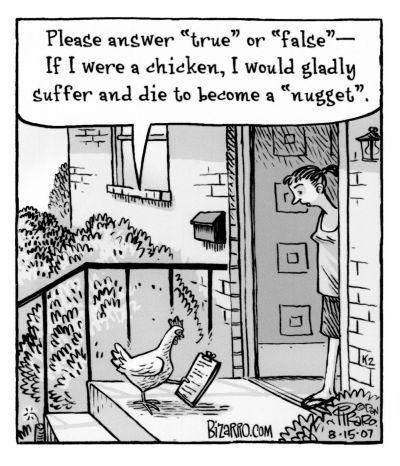

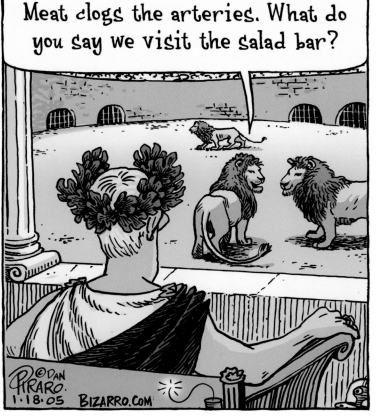

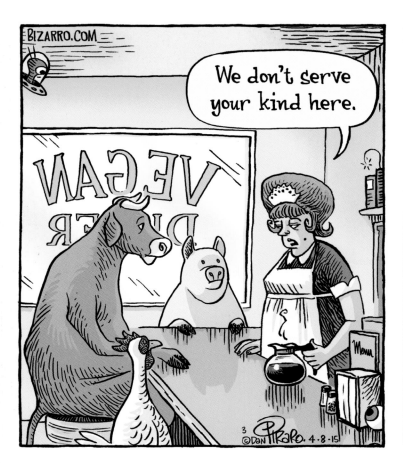

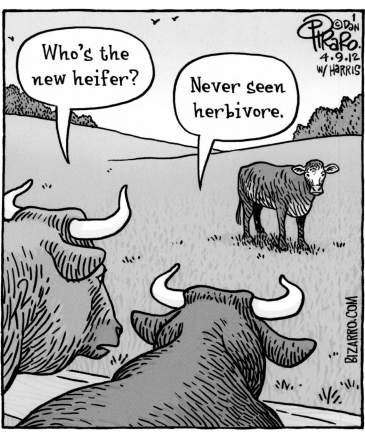

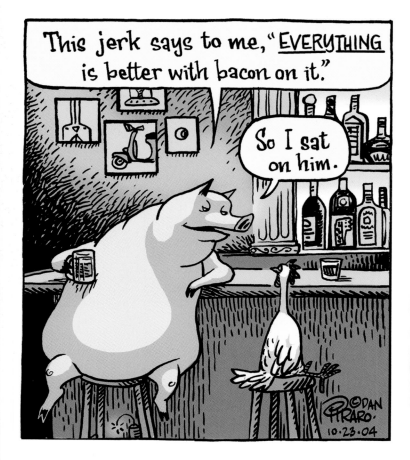

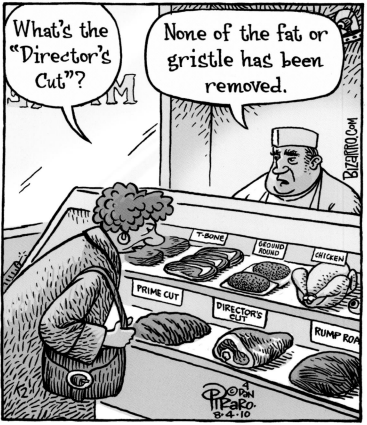

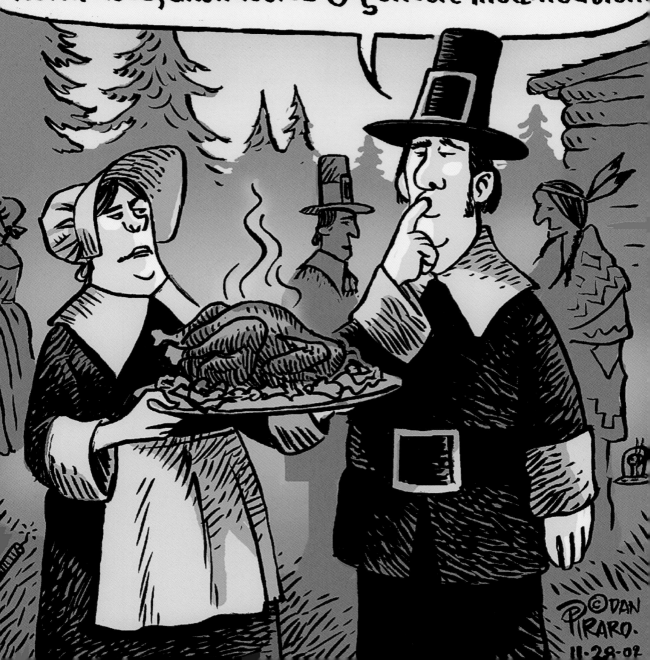

SUE COE

As the philosopher Theodor Adorno wrote, "Auschwitz begins whenever someone looks at a slaughterhouse and thinks: 'they're only animals'." When I was born, food rationing from World War Two was still in effect. On the outskirts of London, evidence of bombing remained. Entire houses were rubble. The school was quickly assembled in tin shacks. We lived opposite a hog farm and down the street from a slaughterhouse and a memorial to World War One. The hogs would be screaming all night, as they were loaded into the abattoir. From the slaughterhouse to my house, where the cheapest "food" was white lard on white bread. One day, I watched a pig escape the abattoir and the men with bloodied aprons chase it through traffic to catch it. People thought it was funny. But I had a feeling of knowing dread and walked into the slaughterhouse, following the captured pig. As a child and a neighbor, I was allowed inside to witness the slaughter. Since then, I have been in some forty slaughterhouses to draw, and I have dedicated my work to the animals. To care when so many are indifferent is to live in an alternative universe. Going vegan is not enough, but it is the one simple act of nonviolence that we can all do today.

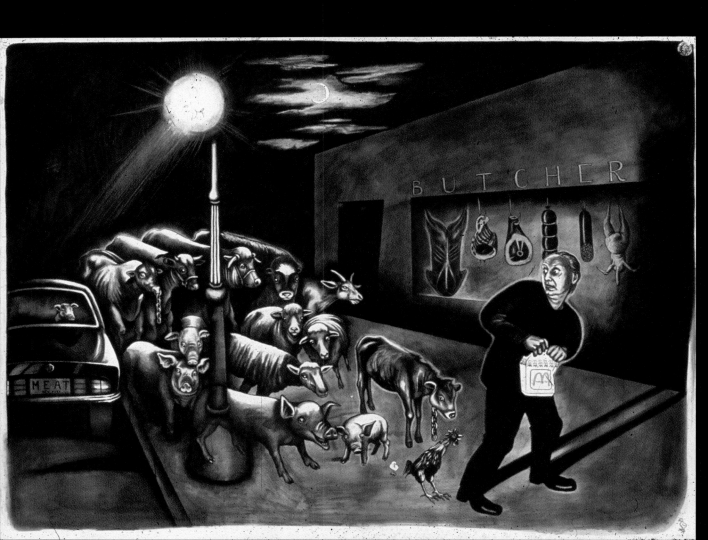

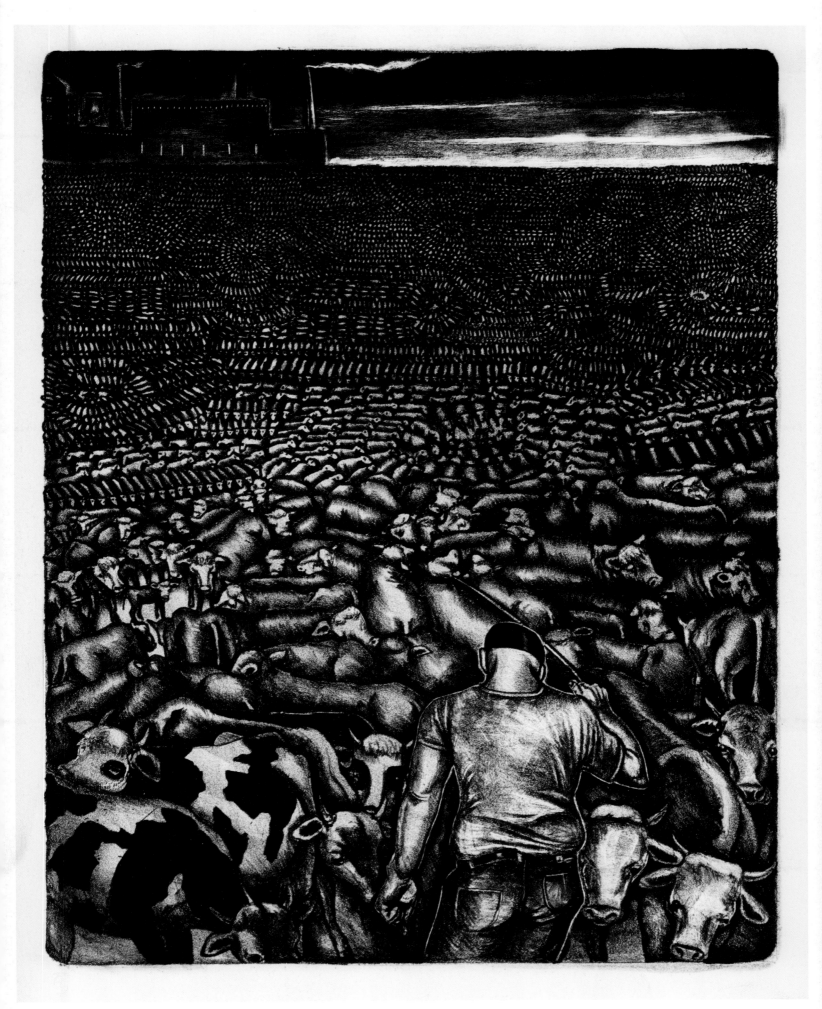

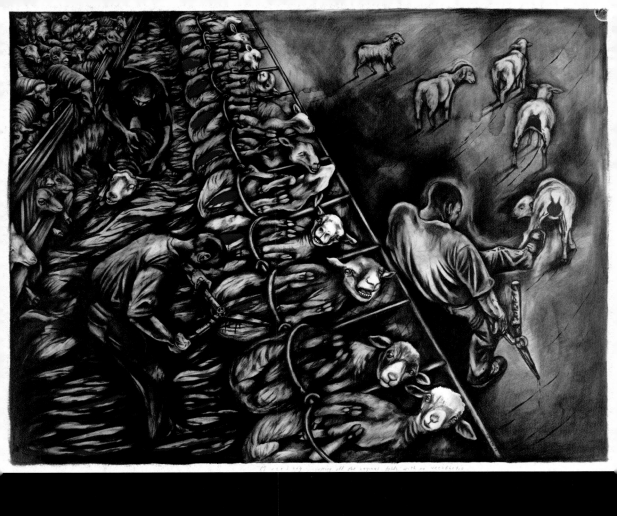

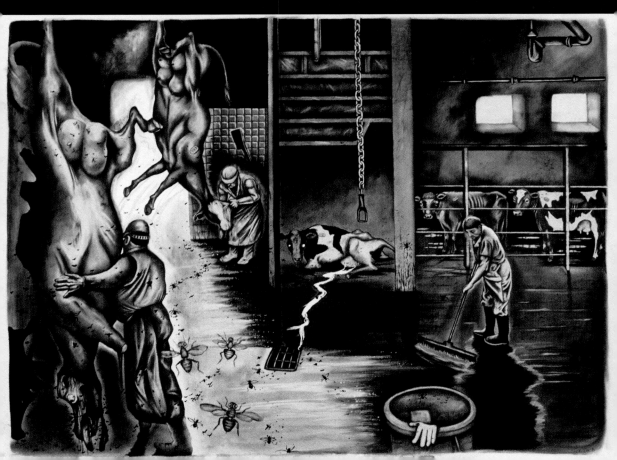

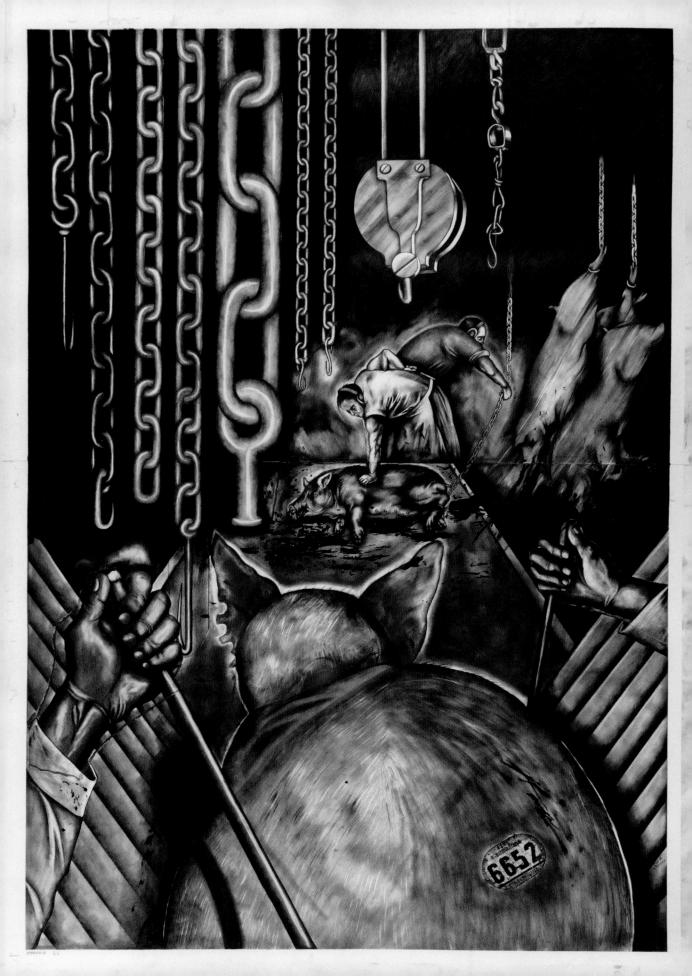

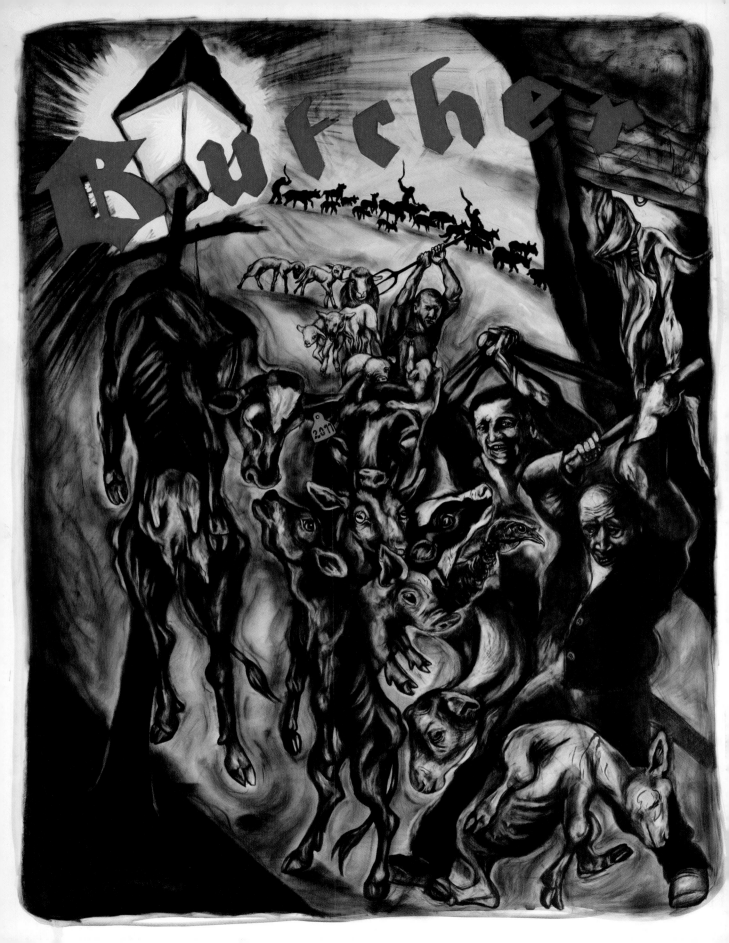

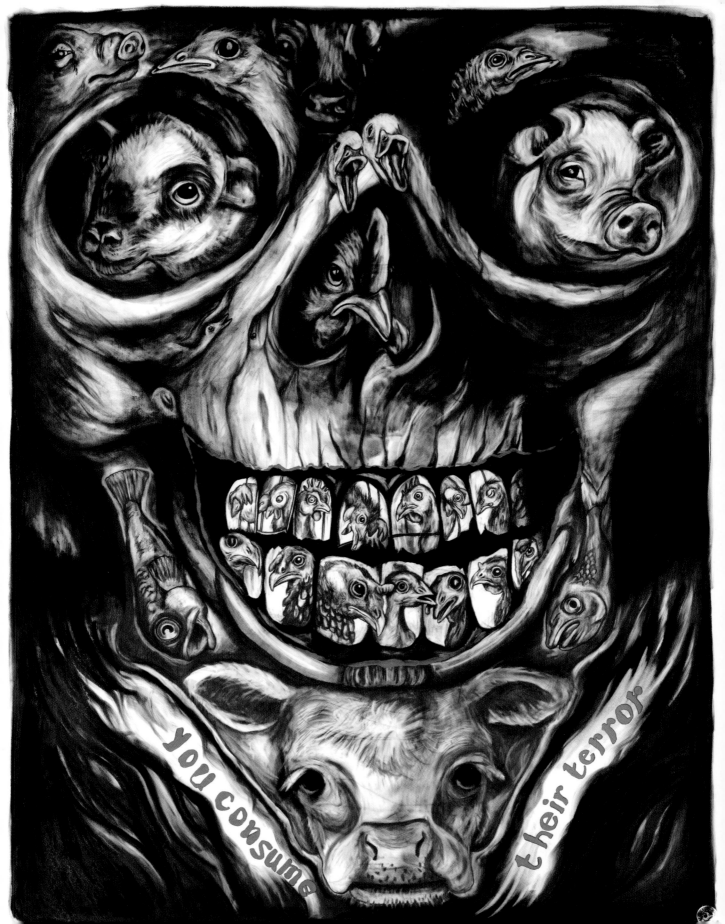

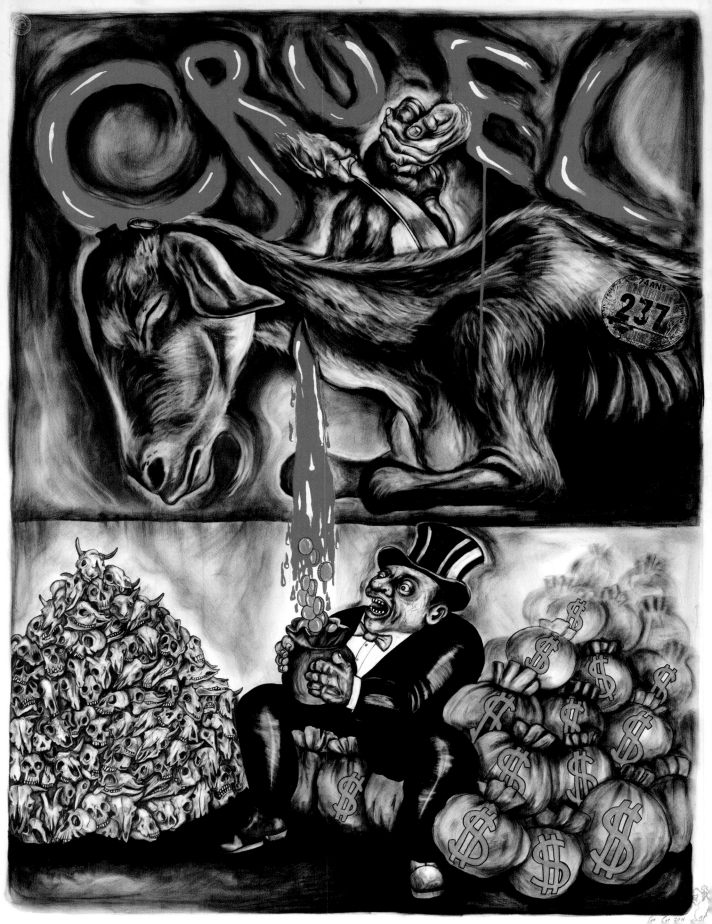

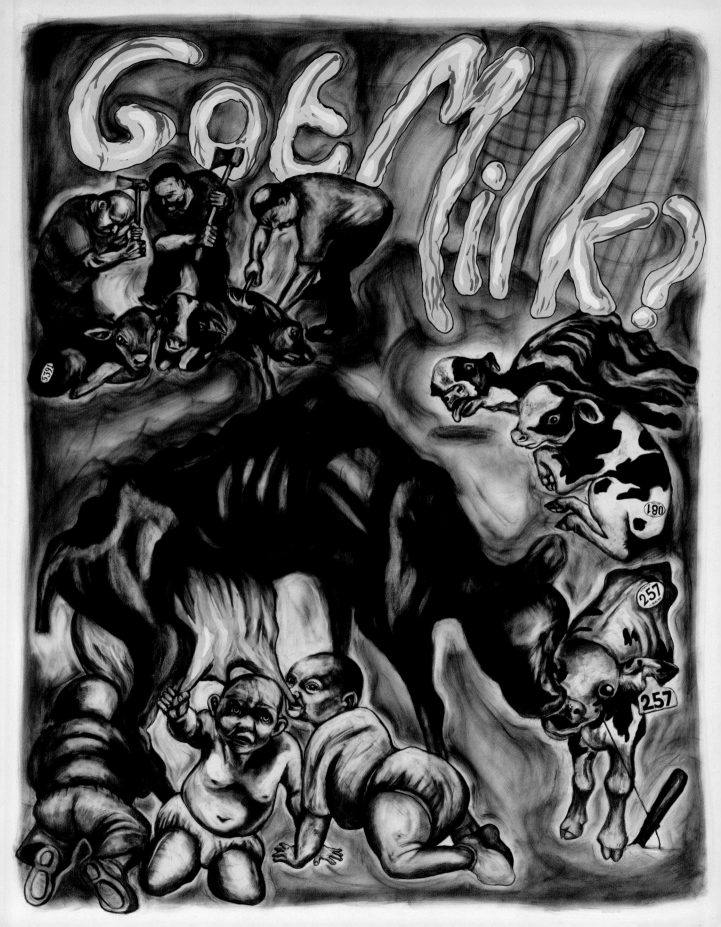

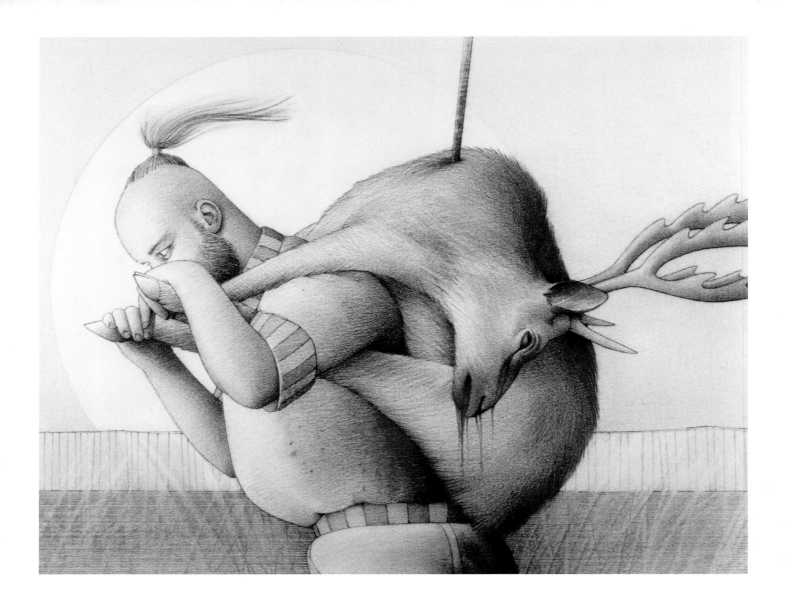

JANE LEWIS

In April 2015, at the age of sixty-two, I watched the documentary film *Earthlings*. It shocked and shook me to the core, and from that moment I knew the very least that I could do was become vegan. I say the very least because a year later I had to acknowledge a dissonance between the images that I continued to make as an artist, for which I had an established audience and career, and my ethics about animal rights. My passions have always informed my work, and so I began to give visual expression to the tragedy of the lives of all non-human animals in a humancentric world, and in doing so found a different audience (and a reduced income!). I have come to believe that it is important to express the radical and political through art, even if it makes exposure of such images in the conventional art world difficult. At the moment, all my ideas are to do with

animals and veganism. Until there is positive change in the world, I see no reason to alter the narrative of my art.

Having lived a long time as a nonvegan, I recognize that the majority of people have a deep fear of change, and becoming vegan is about profound personal change. Acknowledging the awful truth of animal agriculture will naturally bring feelings of anger, shock, and sadness. But I am living proof that it is never too late to choose compassion. Change will not come from governments but from the grassroots, from ordinary people living compassionately and ethically and demanding products and lifestyles that are not dependent on the suffering and death of animals. I would like to see a time when the kind of work I am doing now is redundant, just a terrible reminder of an appalling time in history.

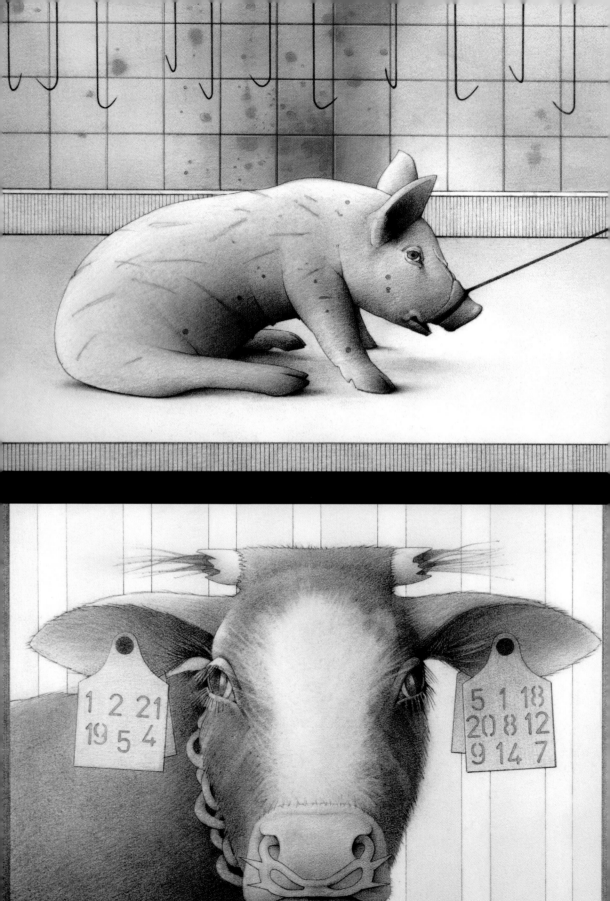

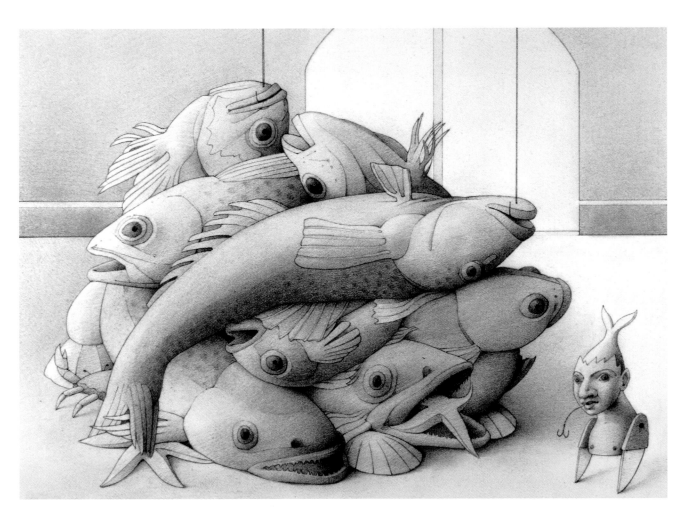

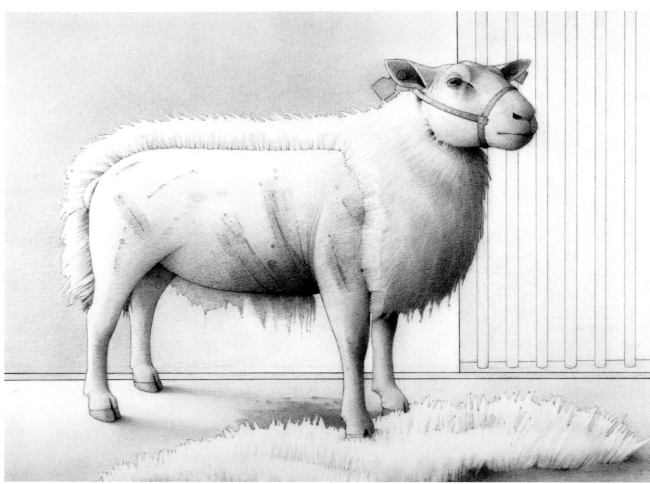

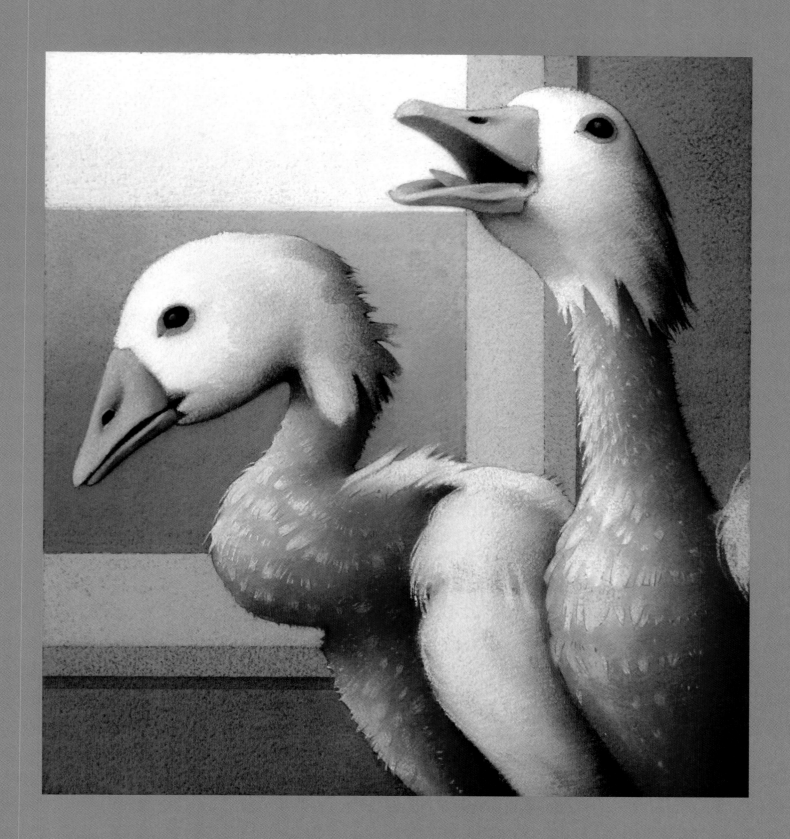

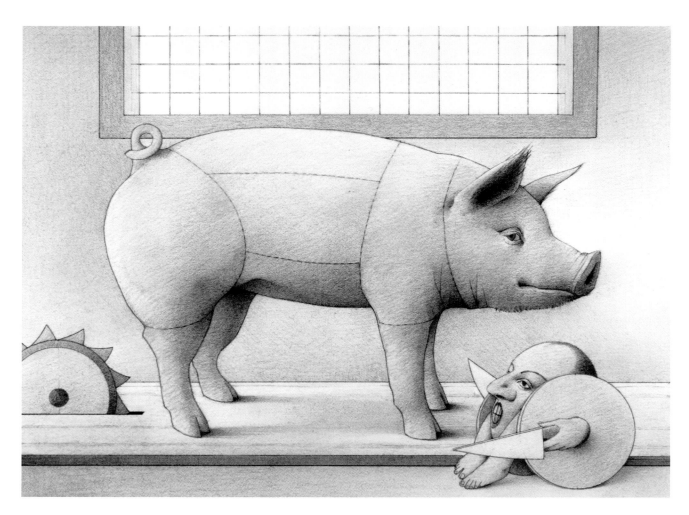

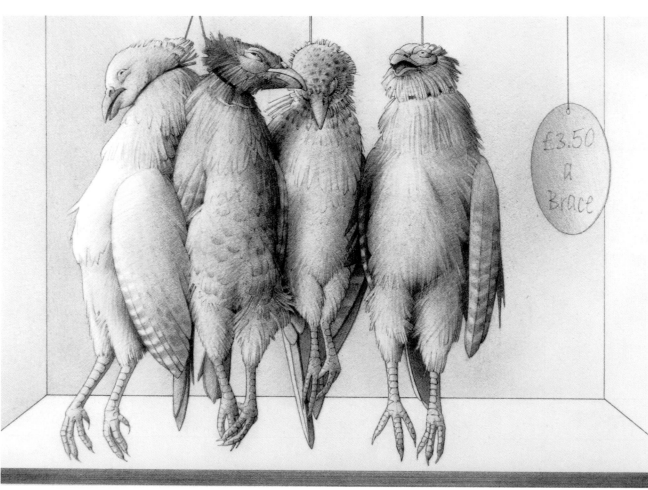

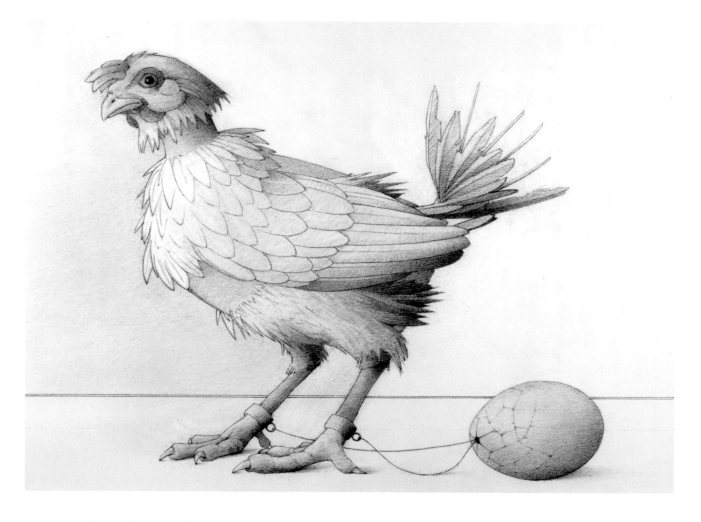

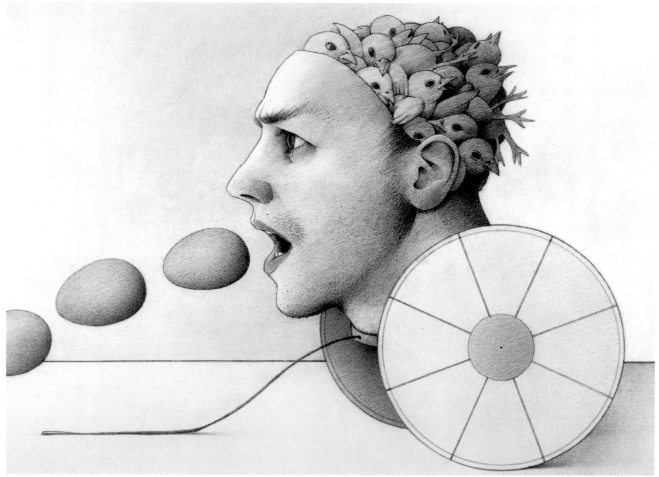

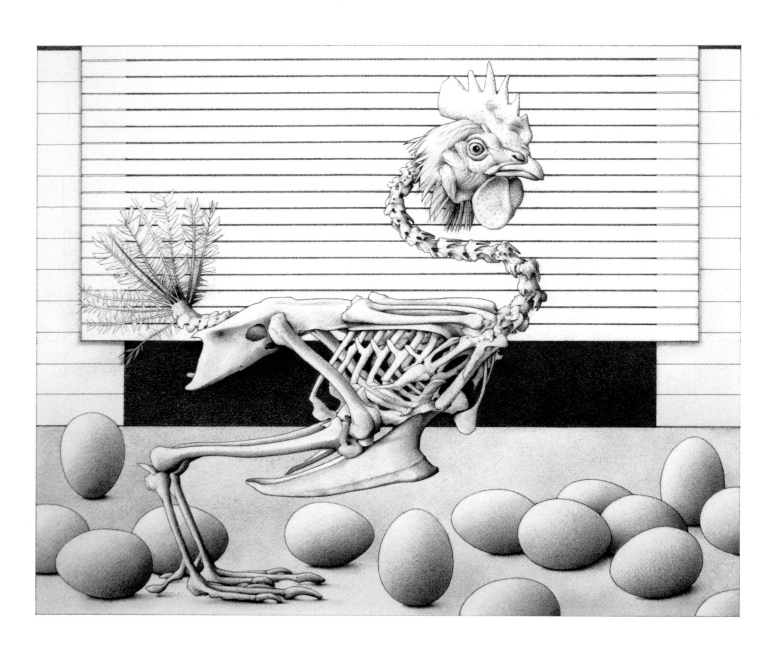

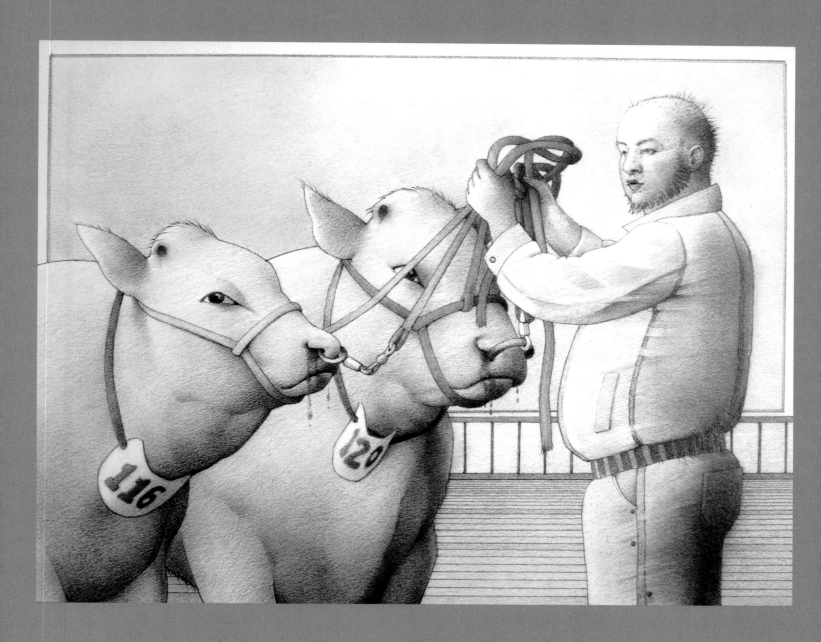

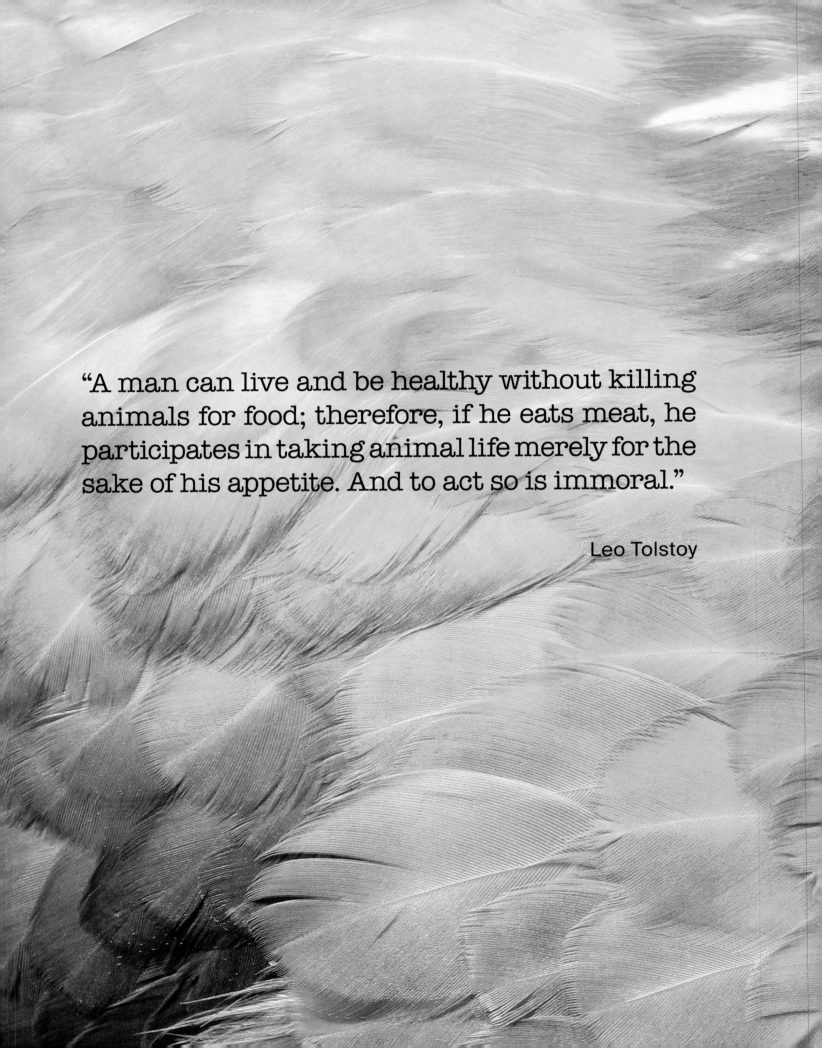

"A man can live and be healthy without killing animals for food; therefore, if he eats meat, he participates in taking animal life merely for the sake of his appetite. And to act so is immoral."

Leo Tolstoy

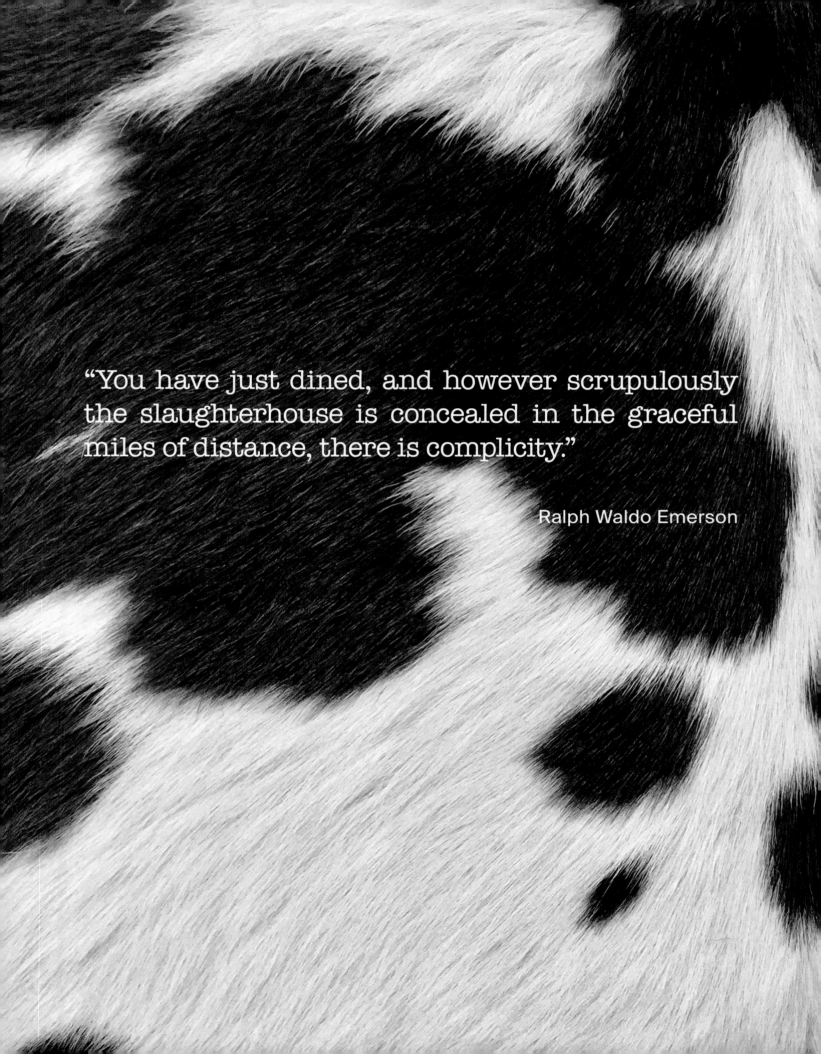

"You have just dined, and however scrupulously the slaughterhouse is concealed in the graceful miles of distance, there is complicity."

Ralph Waldo Emerson

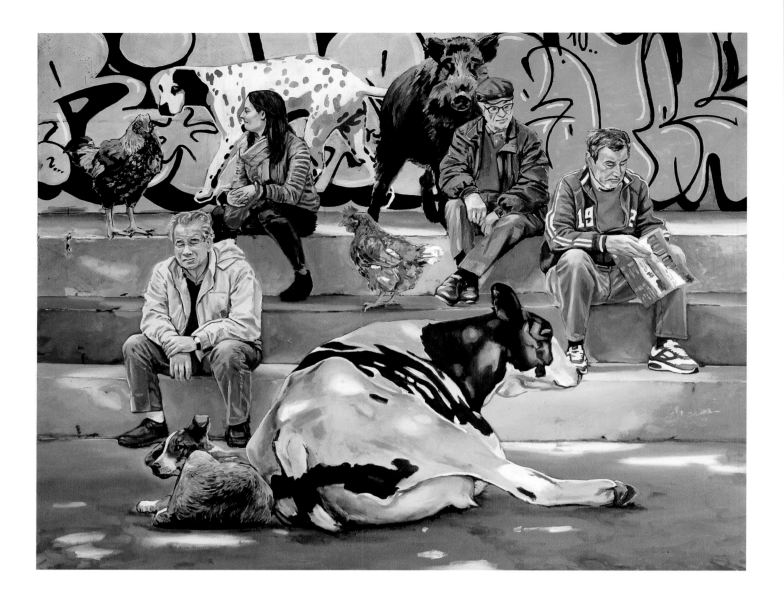

HARTMUT KIEWERT

In our society, animals are bred, caged, and killed in numbers of astronomical proportion. The meat, diary, eggs, and fishing industries are turning a profit from commodifying nonhuman animals. Capitalist modes of economic organization are also destroying the habitats of wild animals and eventually our whole planet.

The exploitation of animals and nature is legitimized by an ideology that separates humans from animals and culture from nature. Yet humans are animals and part of nature too. And other animals have culture as well. Since 2008, I have been dealing with the relationships between humans and animals in my imagery, living and painting vegan. Given that the social status of animals has played a role in the visual arts since early cave paintings, I think that art can be a tool for us to renegotiate our relations with other animals. It can show new perspectives on animals and help to lift the ideological veil of speciesism.

By moving so-called "farm animals" out of gestation facilities and slaughterhouses into streets, parks, and living rooms, or by presenting them against the backdrop of the ruins of former meat-industry buildings, I want to stimulate the viewer and offer an opportunity to question common perceptions of these animals. By showing nonhuman animals as individuals and as subjects of their own life, I try to anticipate a world free from animal exploitation in which humans encounter other animals on an equal footing. Evoking a perception of animals shaped by compassion, this imagery poses a counternarrative to the animal-exploiting industries and the everyday practice of consuming animal products. Furthermore, the paintings invite one to think about a world in which any kind of dominion is overcome. A world beyond slaughterhouses, battlefields, cages, and borders in which all are free.

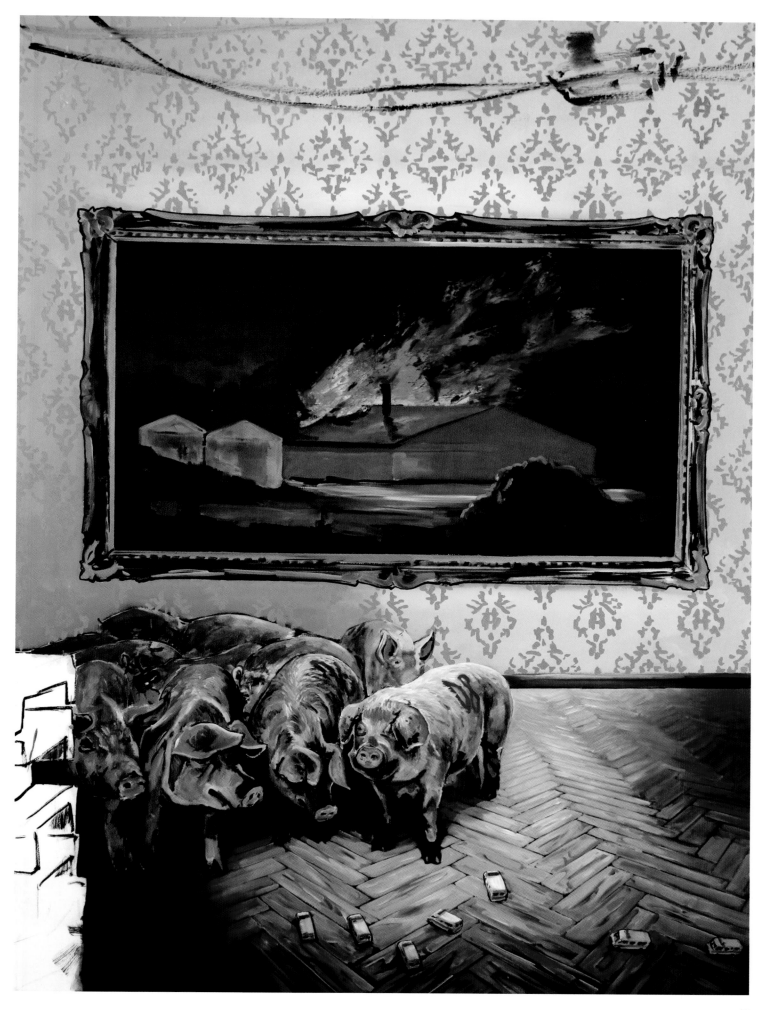

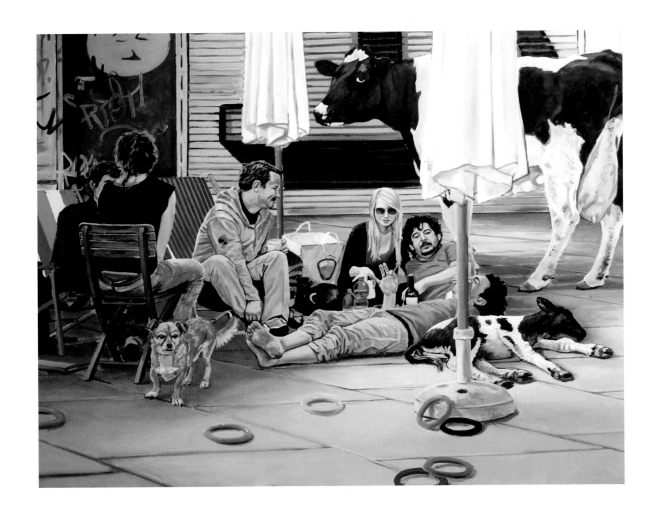

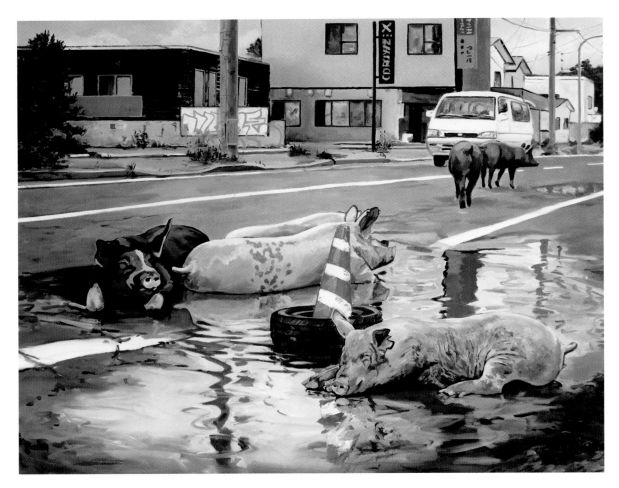

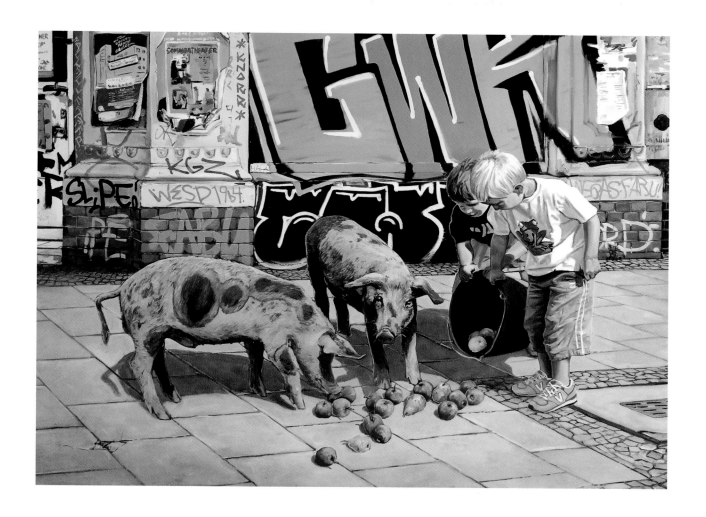

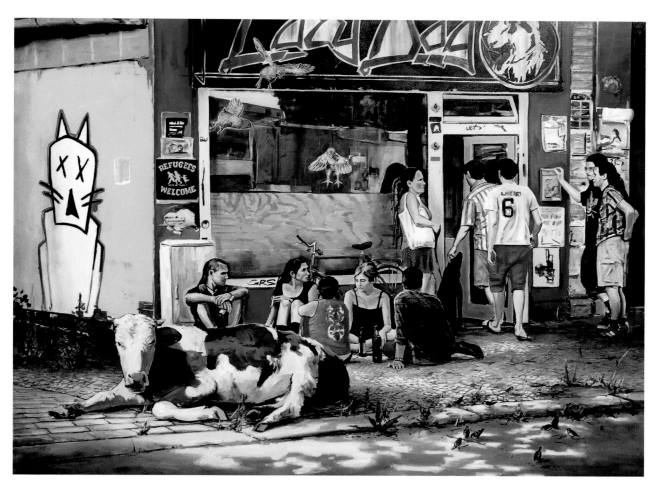

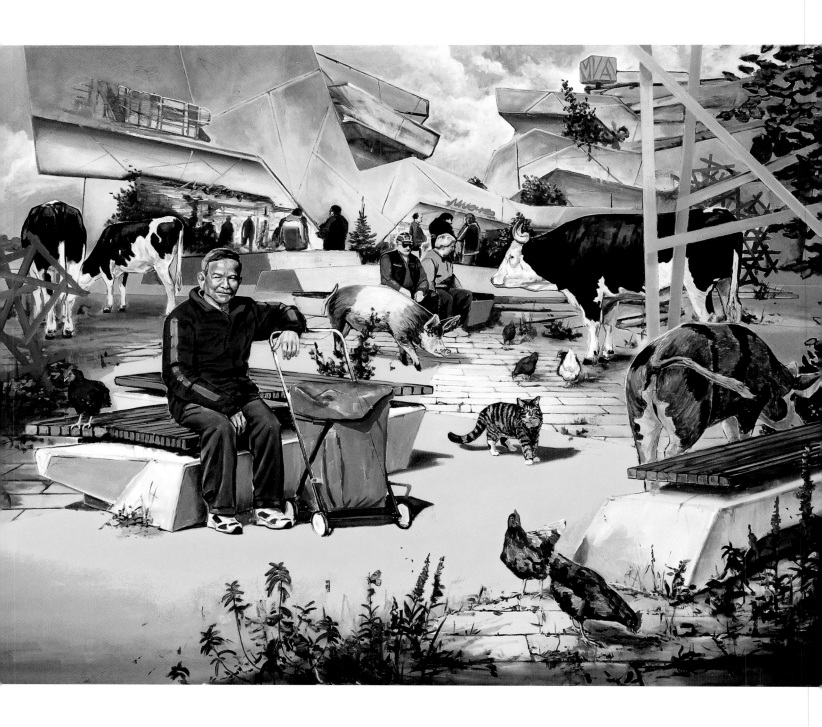

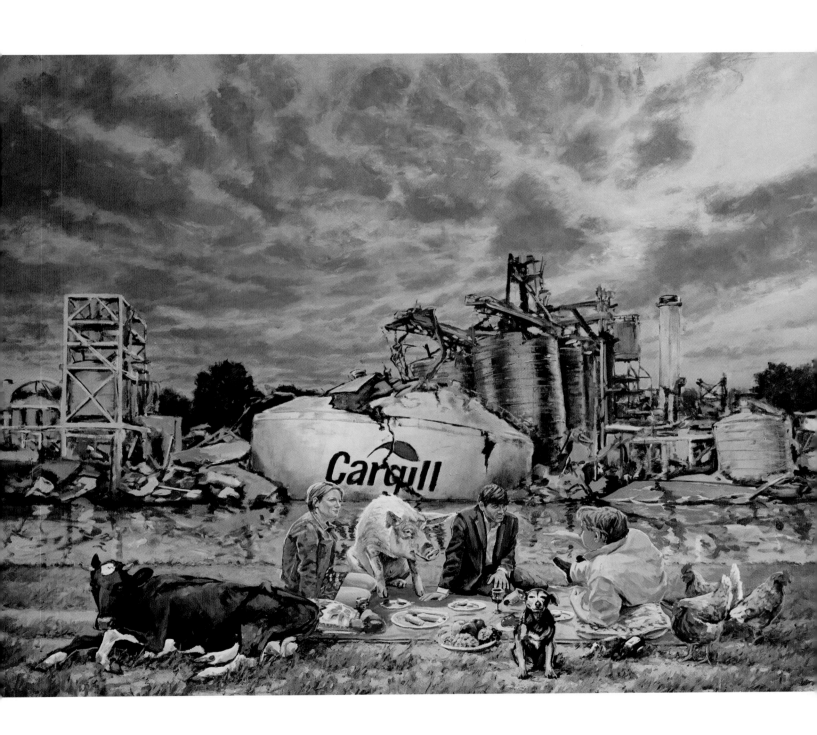

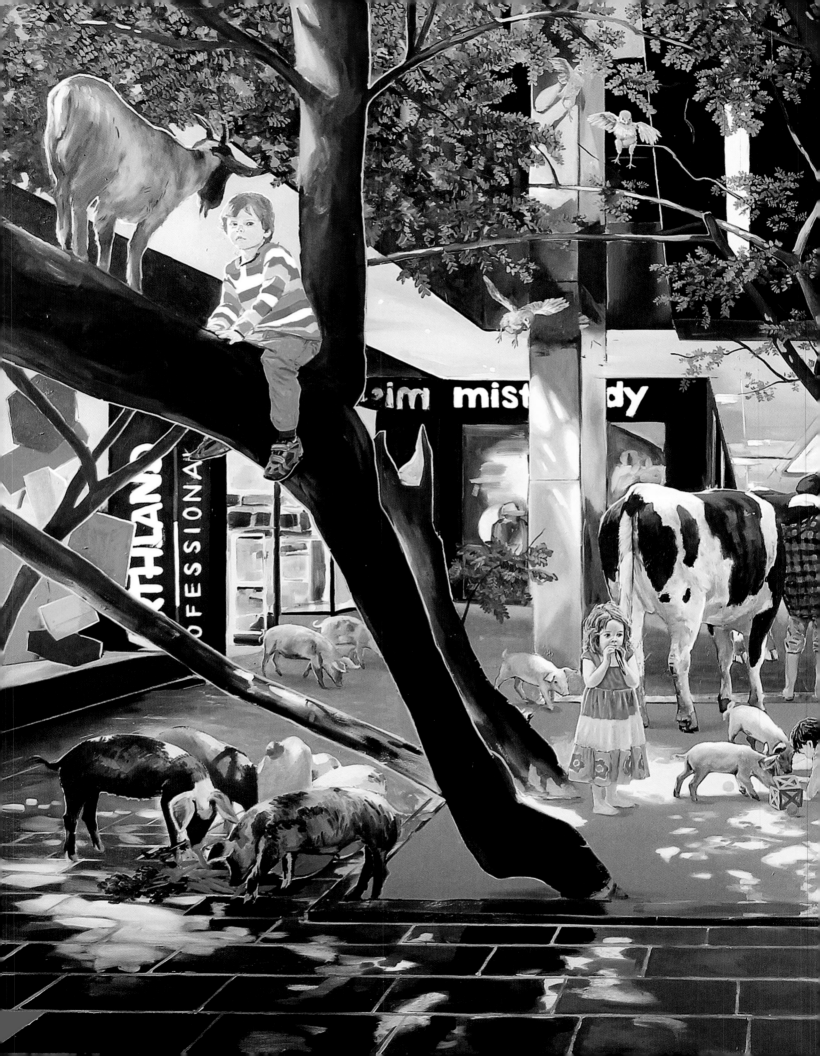

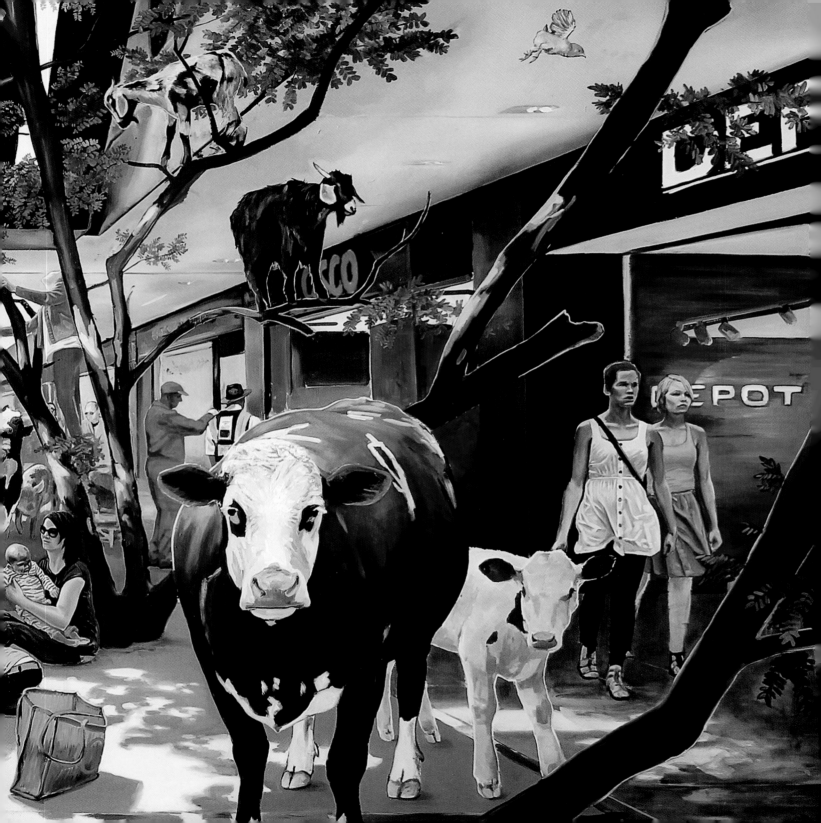

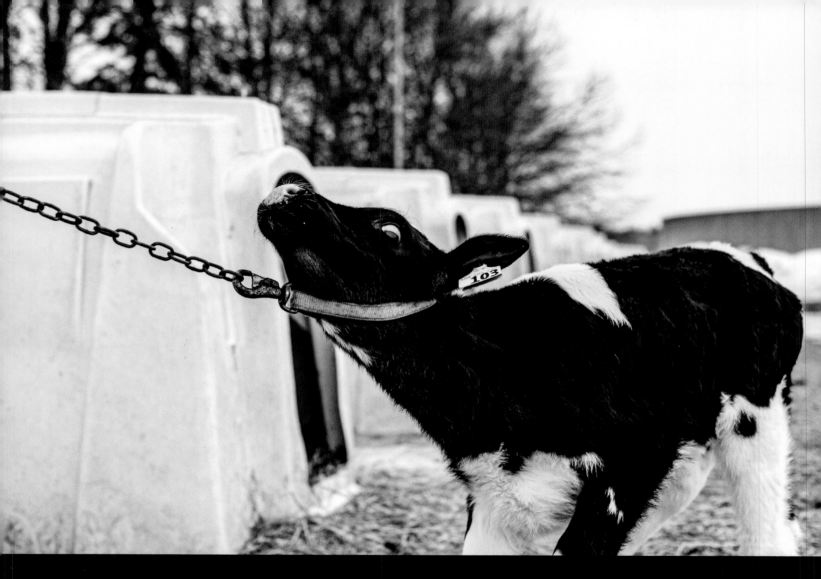

JO-ANNE McARTHUR

Images of our complex and often violent relationship with animals are not easily published or even seen. For the most part, they are met with averted eyes and anger. To face animal use in its many forms is to face our complicity in those uses. Every day, billions of animals are raised, kept, bred, transported, and slaughtered for human use. I record our industrialization of animals, but

more importantly, the animals themselves, as they exist within industries, so that we can glimpse and understand but a fraction of what their experiences might be. Images from the "We Animals" project are for the examination of anyone who will look, and they are for the history books. After almost two decades and travel to sixty countries, the work chronicles what is and what should never again

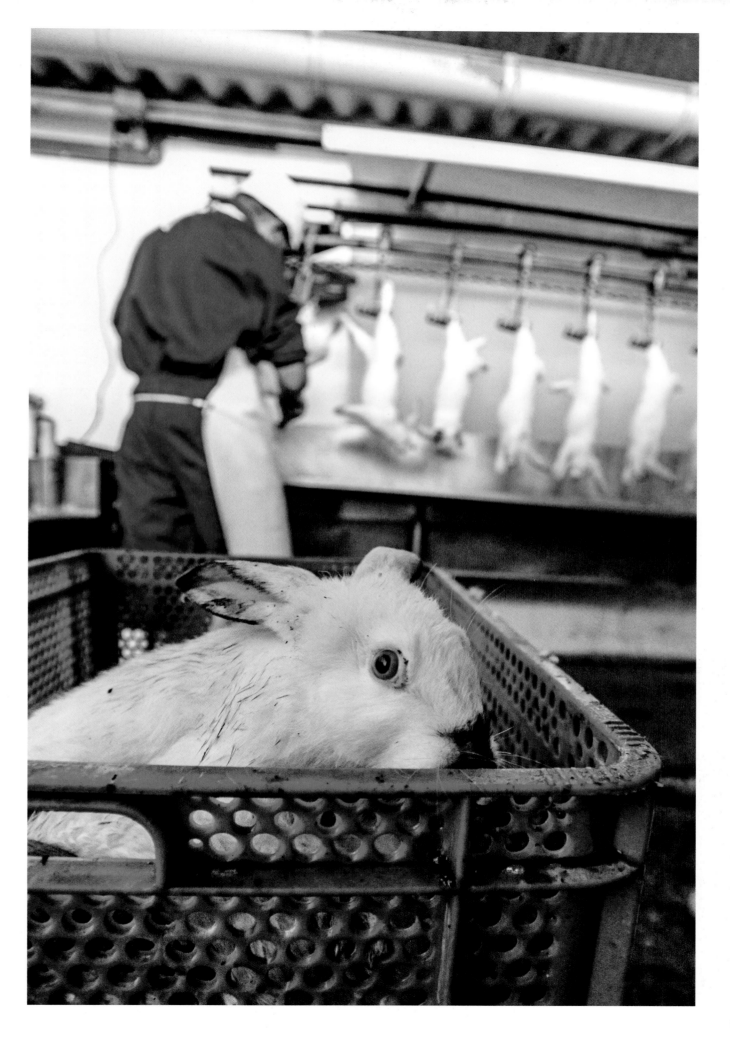

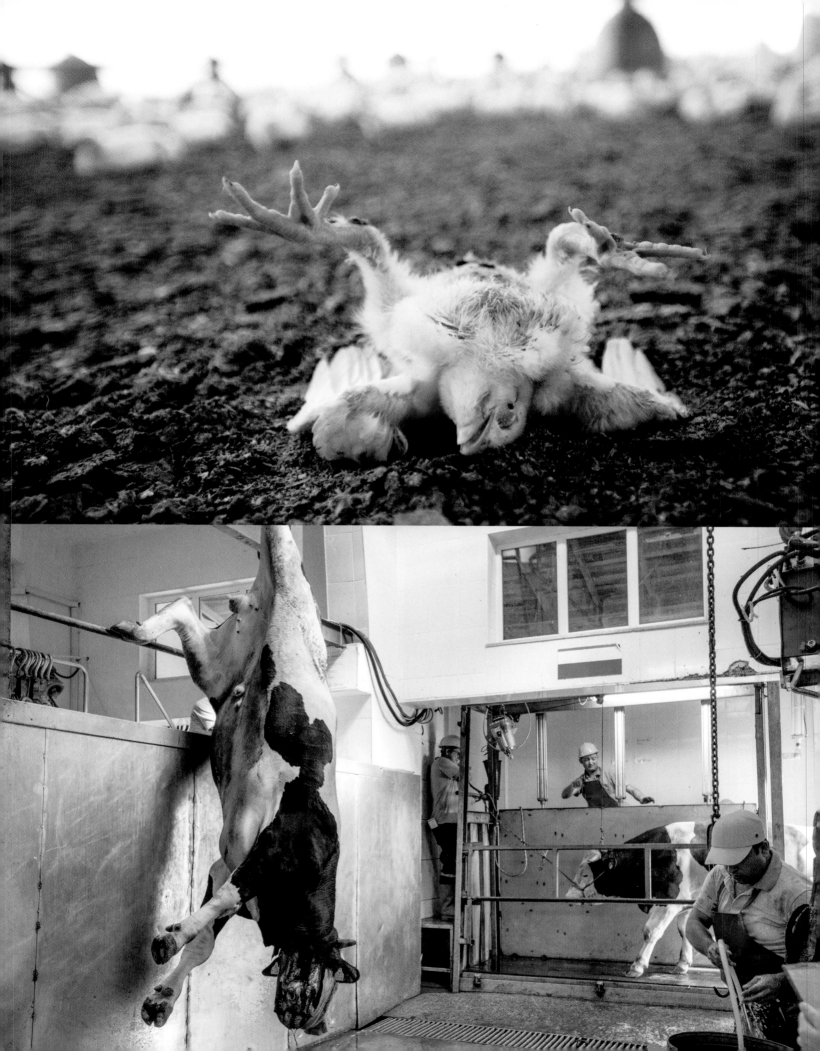

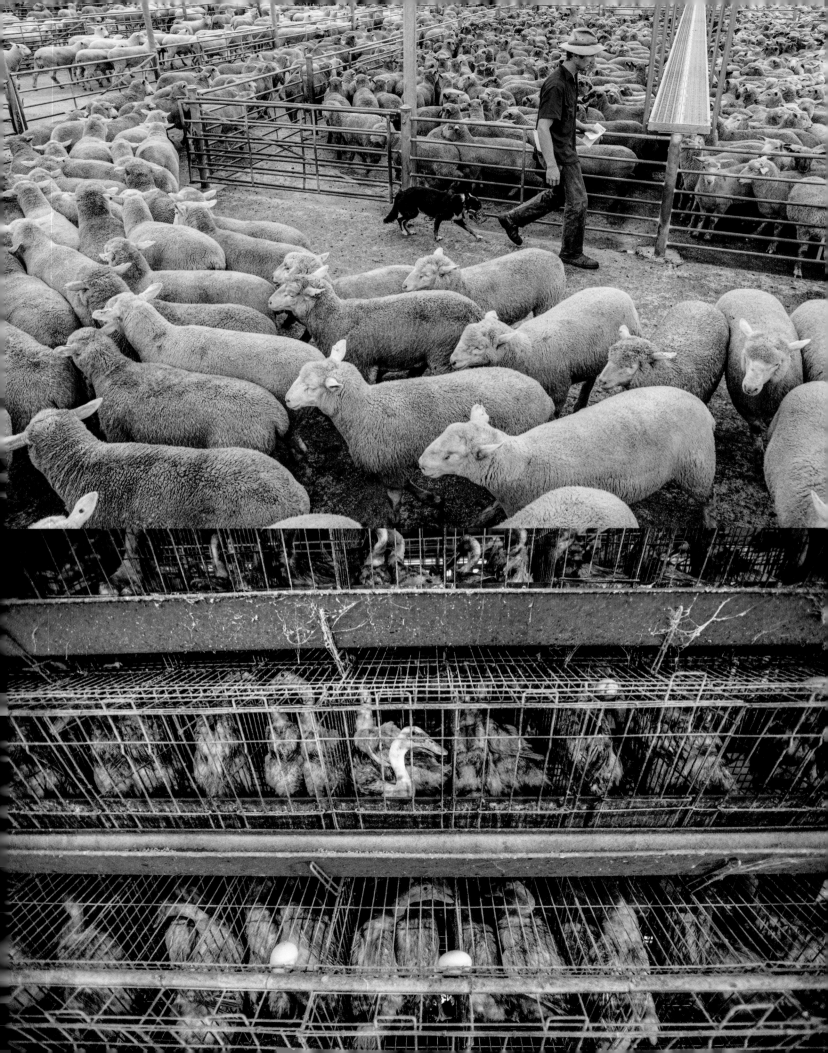

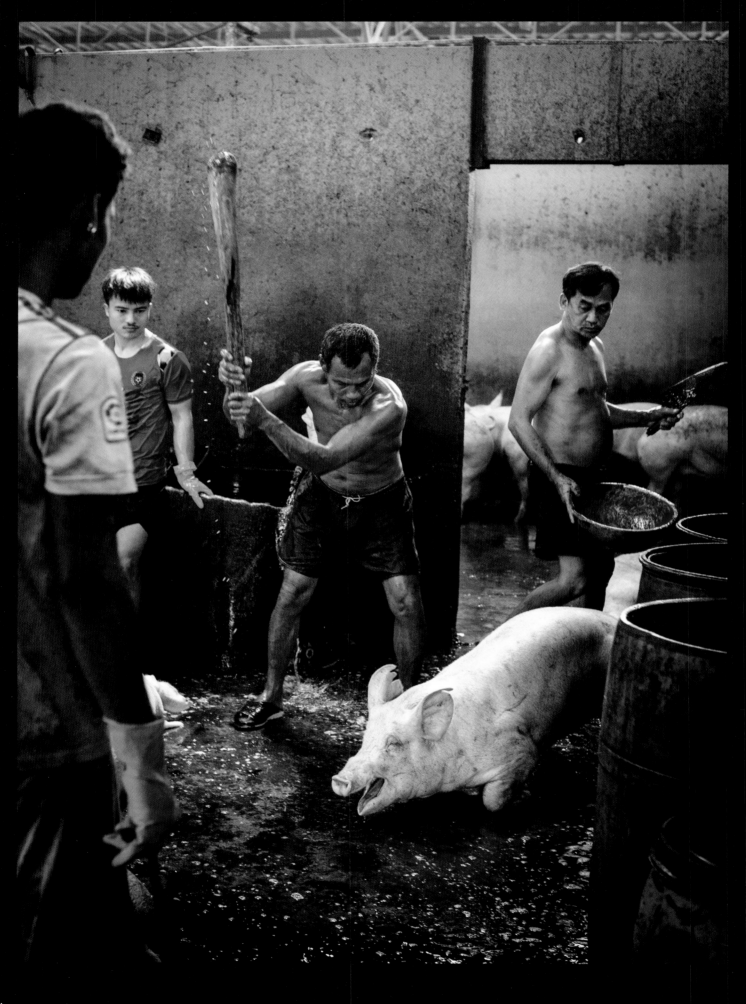

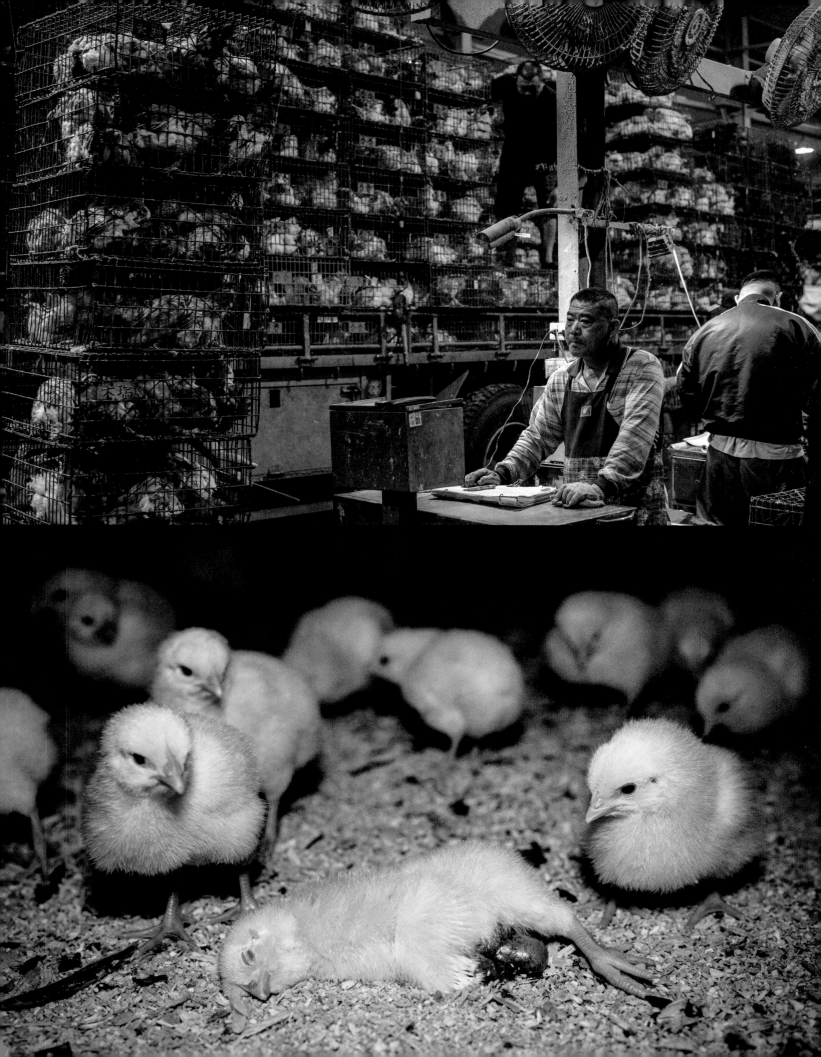

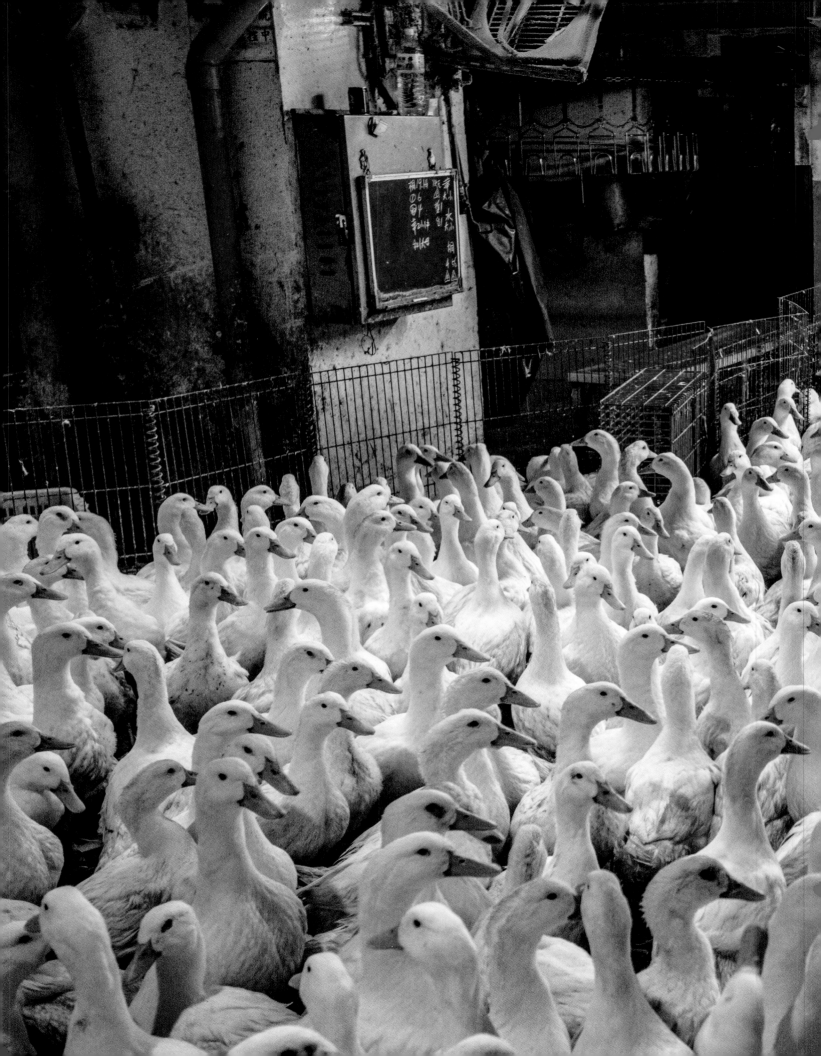

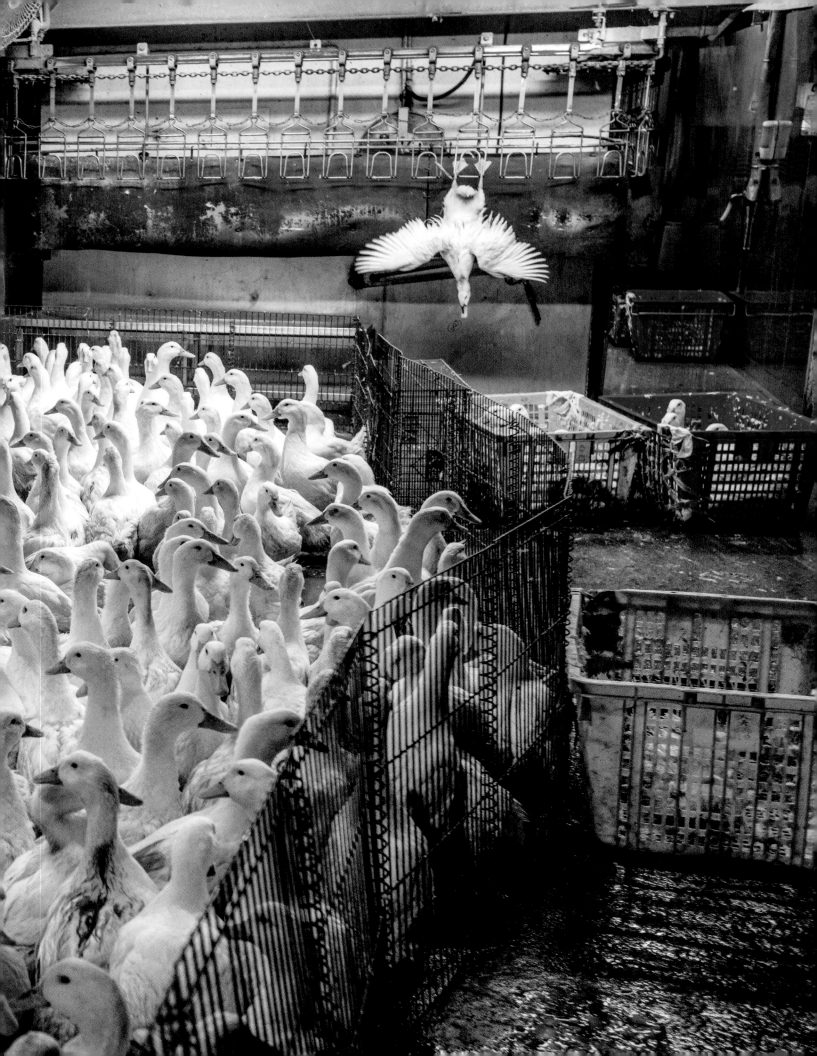

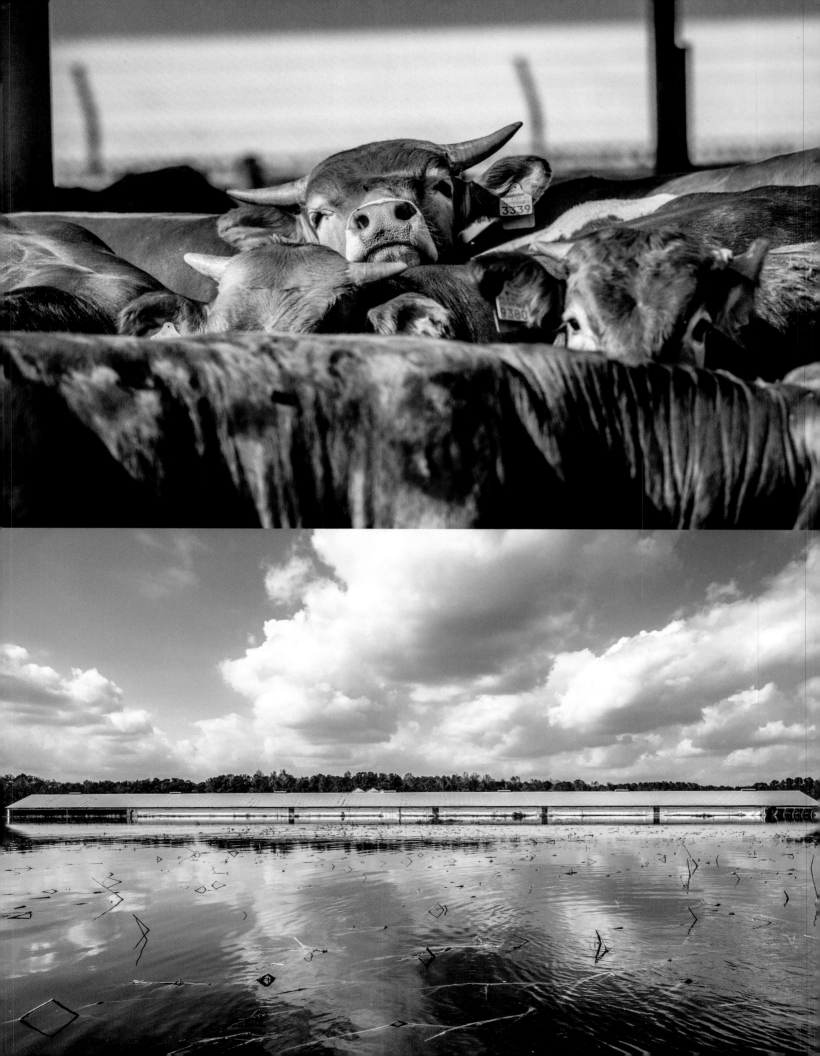

TOMMY FLYNN

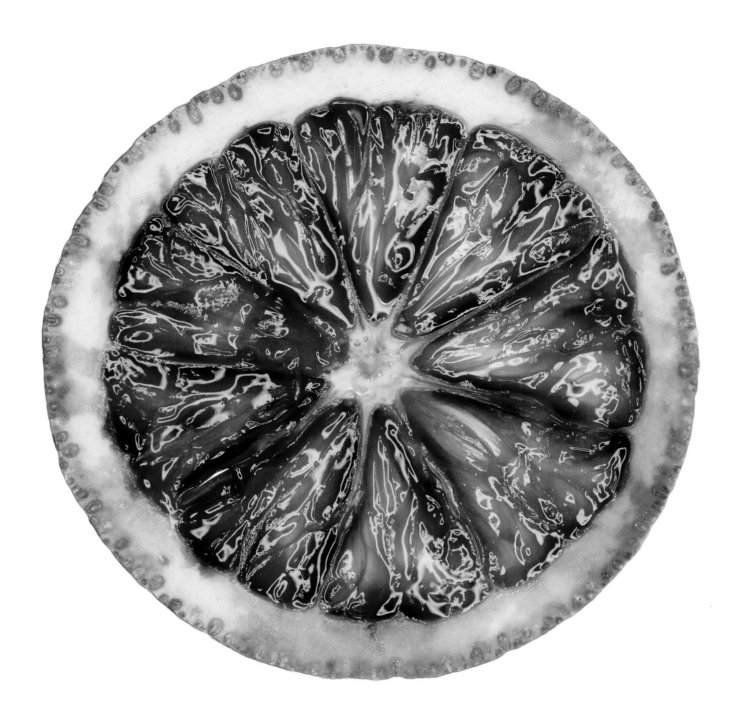

When people go vegan, they eat more fruits and vegetables.

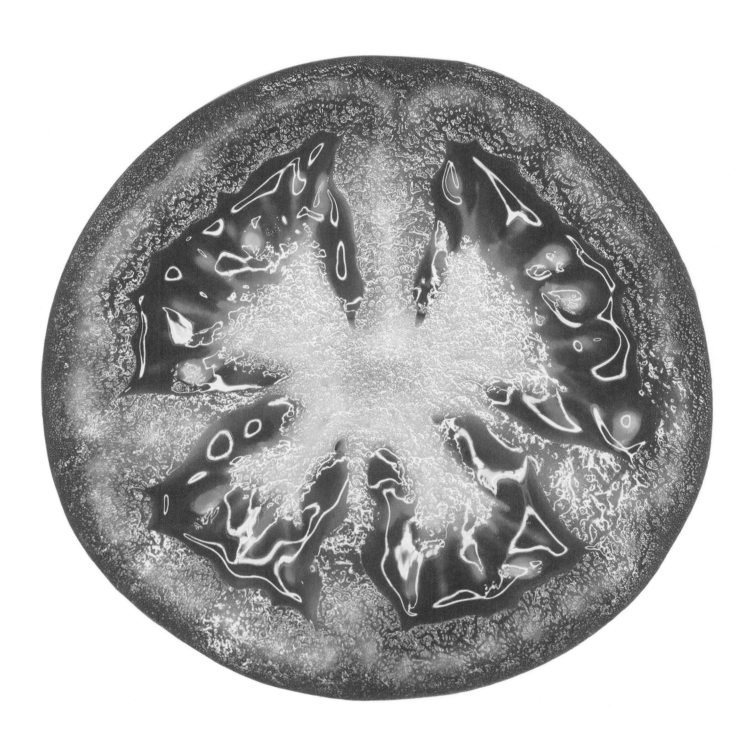

CAROLETTA

As a child, I witnessed a rabbit being slaughtered at my grandparents' farm. I remember that the sight and sounds of this little animal dying painfully was the most frightening thing I could think of. The cruelty of the act made no sense to me. I immediately stopped eating animals without ever looking back.

Being the only vegetarian in my family was not easy, especially as I was very young. At family meals, I would eat only the side dishes while everyone else was eating some type of roasted meat. Older people kept asking when this phase was going to end. Their idea of healthy eating was to fill one's body with corpses.

A few years ago, my husband went vegan for health reasons. He did this to improve his athletic performance and recovery. He inspired me to try a fully plant-based diet, and we started cooking our first vegan meals together. We began to read up on being vegan. We discovered that cows do not produce milk for humans but for their babies, and that we slaughter the young males. We learned of the millions of newly hatched male chicks that are gassed or shredded alive. We wondered why we hadn't heard about these things before.

As an artist, I knew that it was a topic I wanted to work on. So I started the illustration series "About Meat." The focus of these pieces is the distinction between edible and nonedible animals. Floral elements form the framework for offbeat, grotesque motifs. Even though I have not eaten or even touched any meat for thirty years, I like to paint it in order to draw people's attention to animal rights and to hold a mirror up to our society.

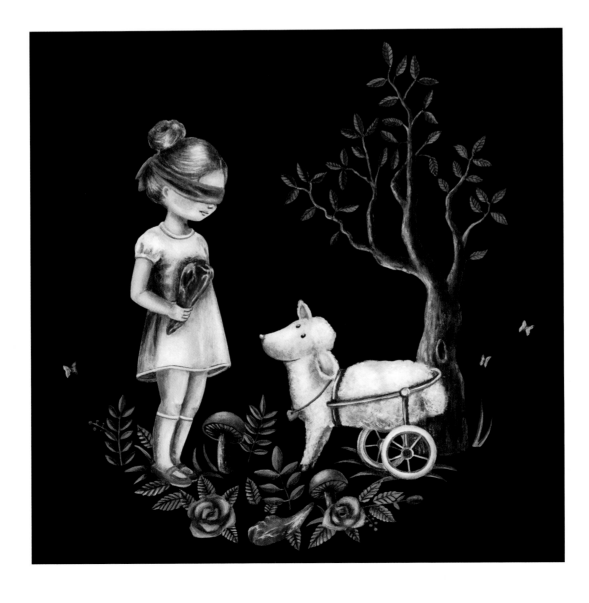

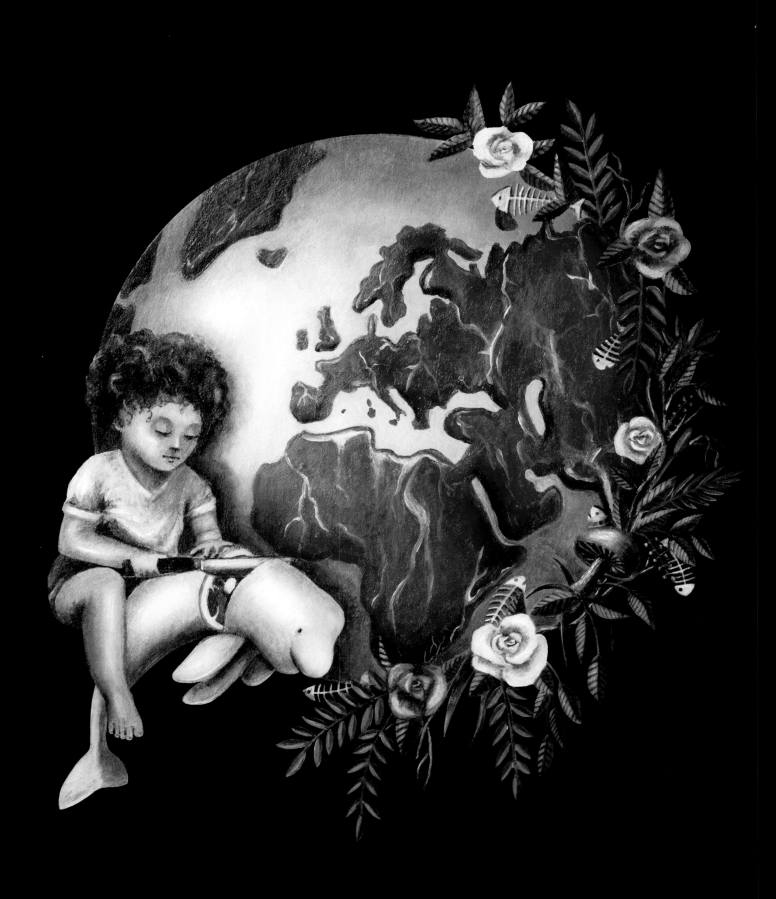

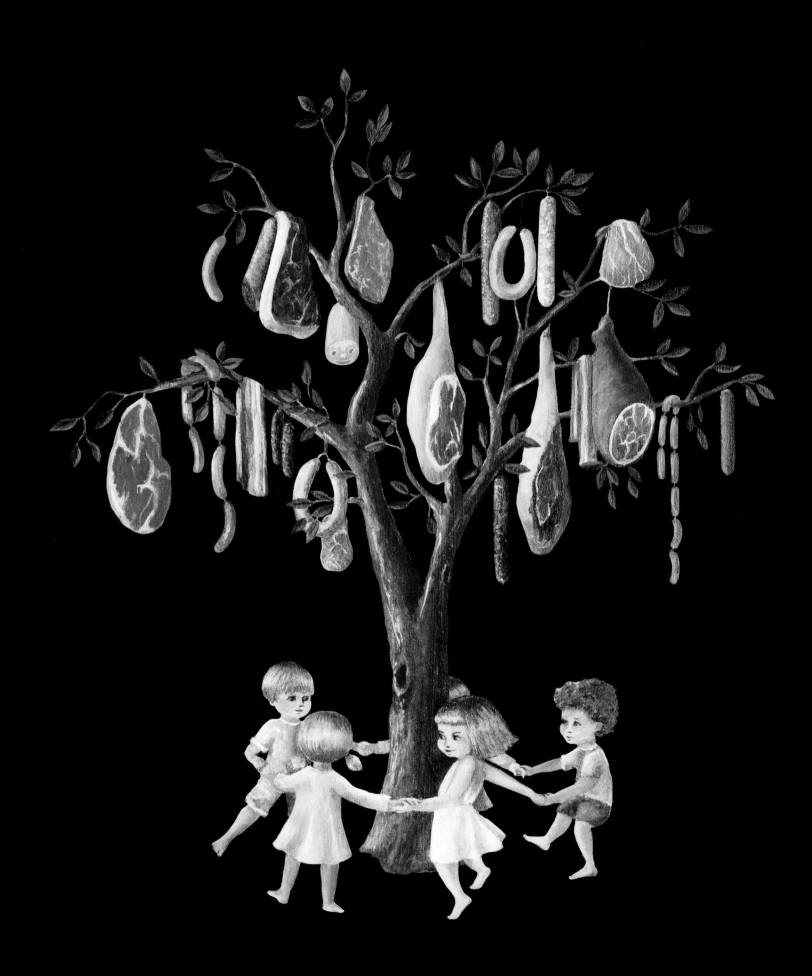

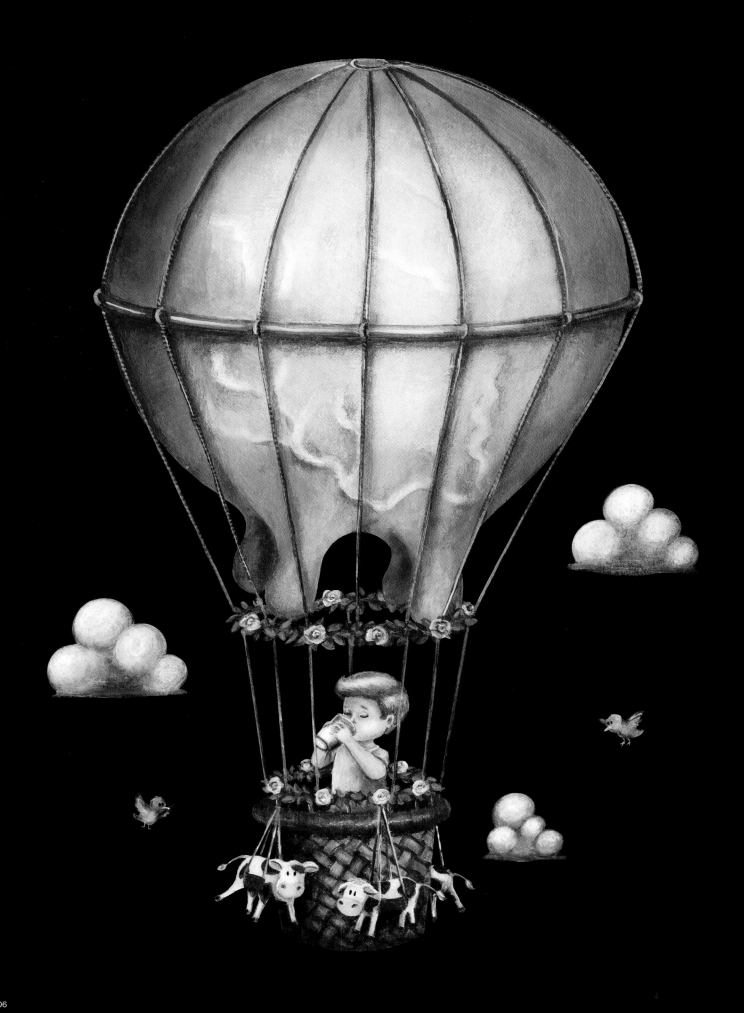

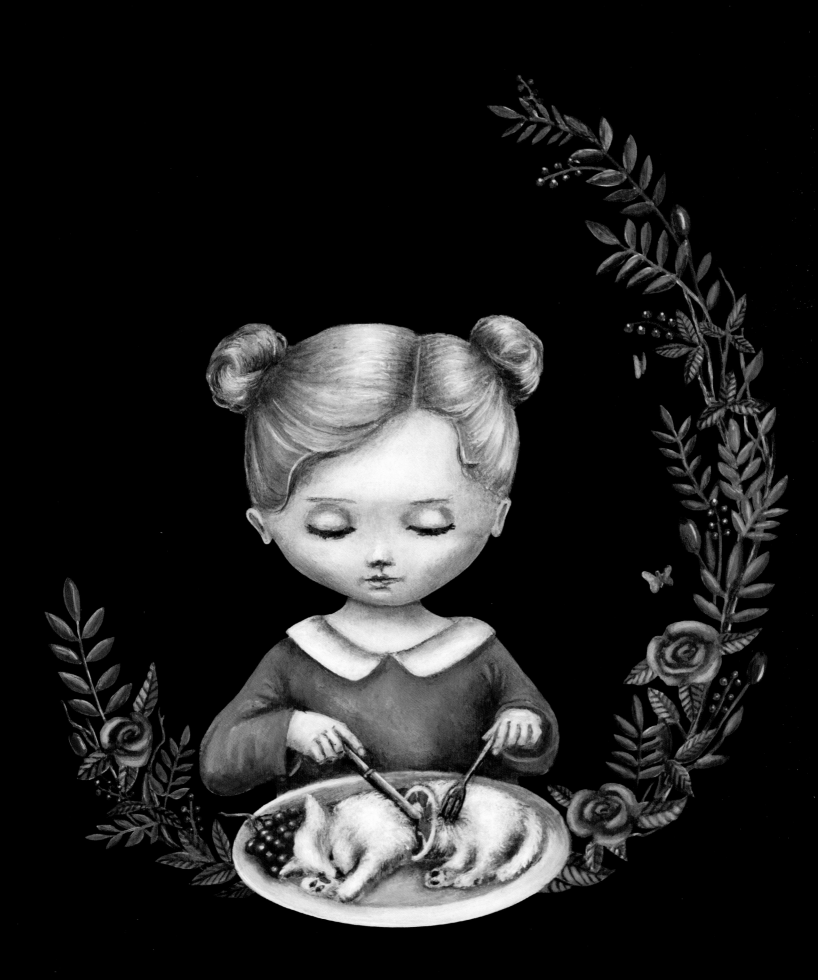

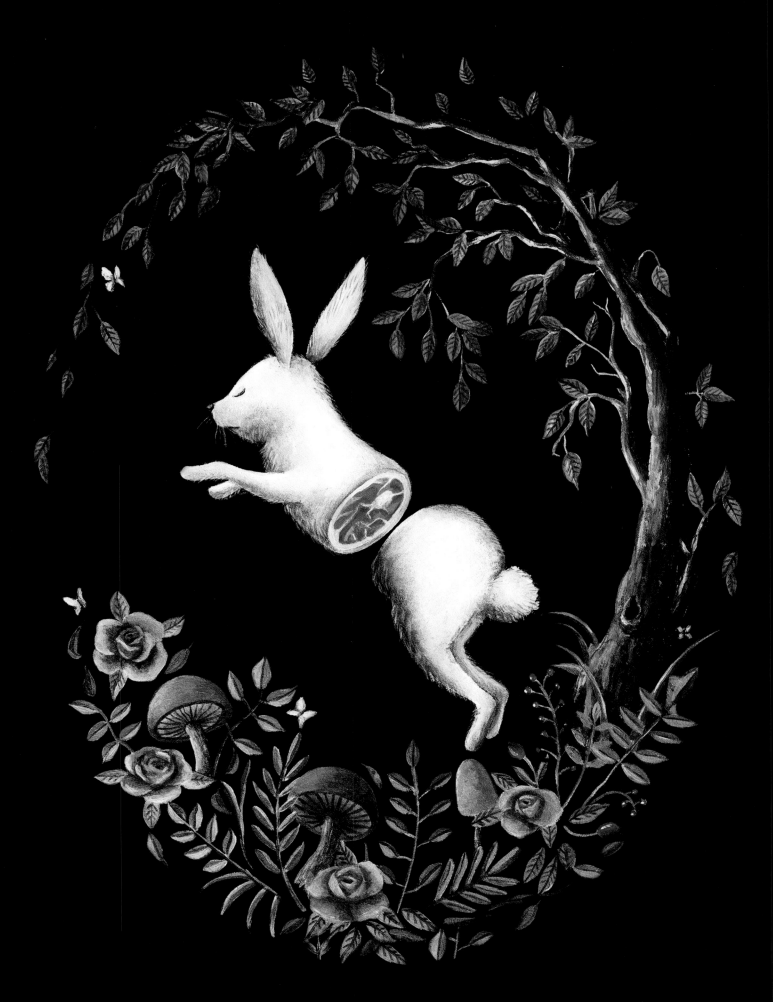

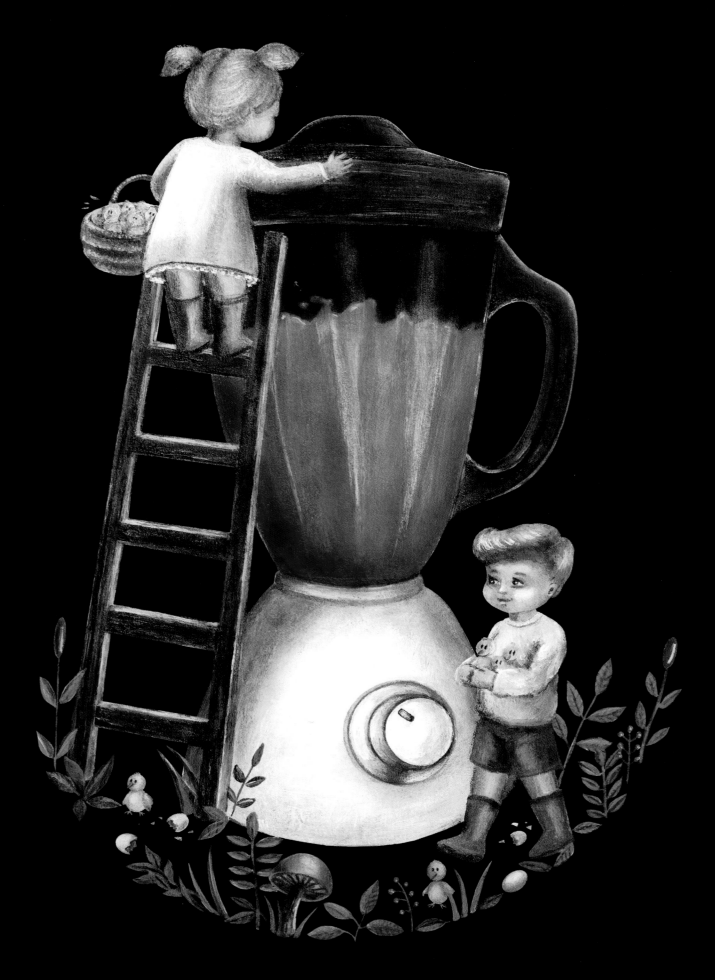

CHANTAL POULIN DUROCHER

Everything started about thirty years ago. I read the book *Diet for a New America* by John Robbins. It was not an easy read because my eyes were filled with tears most of the time. After I got to the last page, I never wanted to eat animals again. Eight years ago, I saw a Facebook post that said there is more suffering in a glass of milk than in a steak. I was surprised and shocked by that statement. I wanted to know more. There was also a video on the post. Not having the courage to watch, I asked my husband to check it out for me and I went to bed. The next morning,

we didn't put milk in our coffee. That is when we both became vegan.

I felt an urge to do something to help those poor animals. Now that I was an artist who was vegan, this theme came to dominate my work. I began to paint animals in a way that showcased their beauty, vulnerability, sensibility, and individuality. Hopefully my work will touch people's hearts and change some minds. Maybe people will realize they do not have to be a part of the exploitation, killing, and eating of these exquisite creatures.

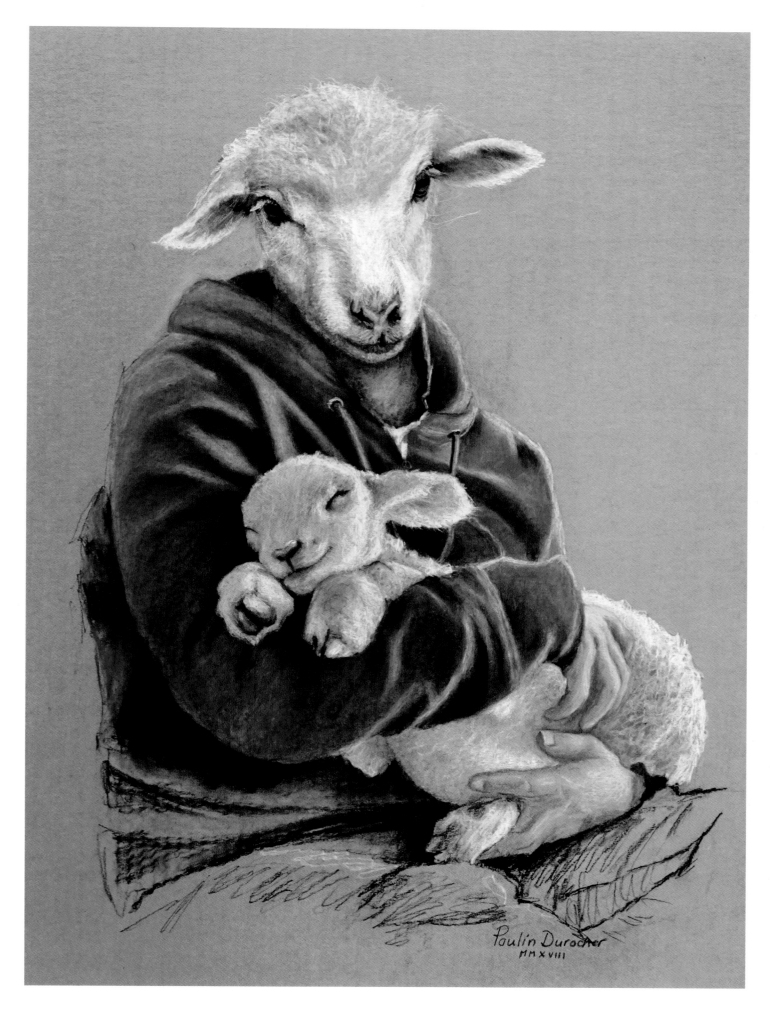

Paulin Durocher
MMXVIII

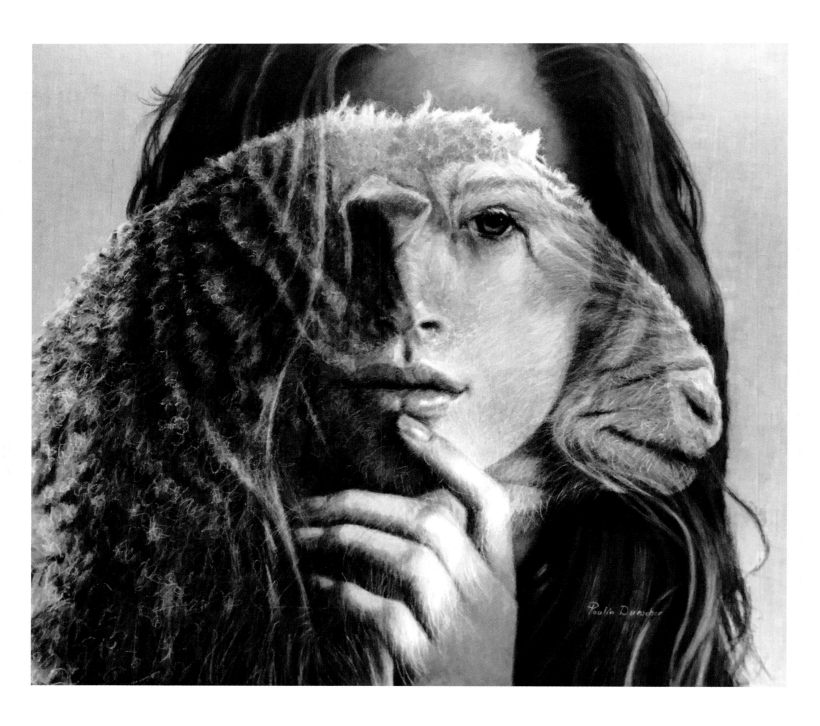

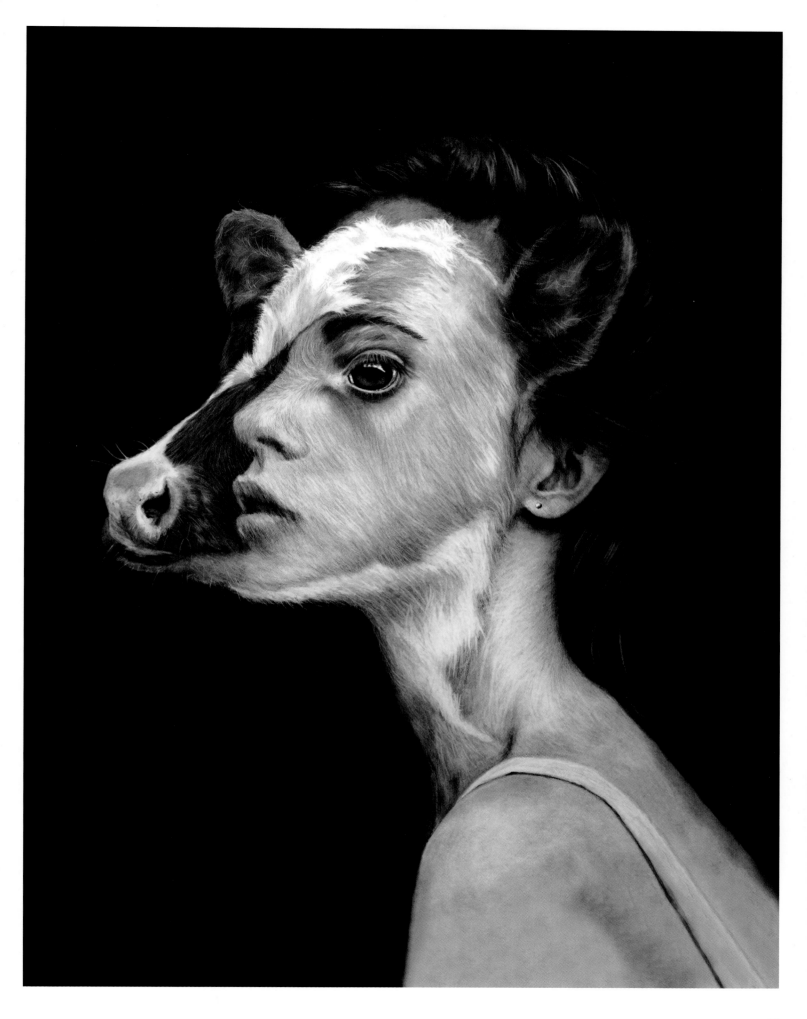

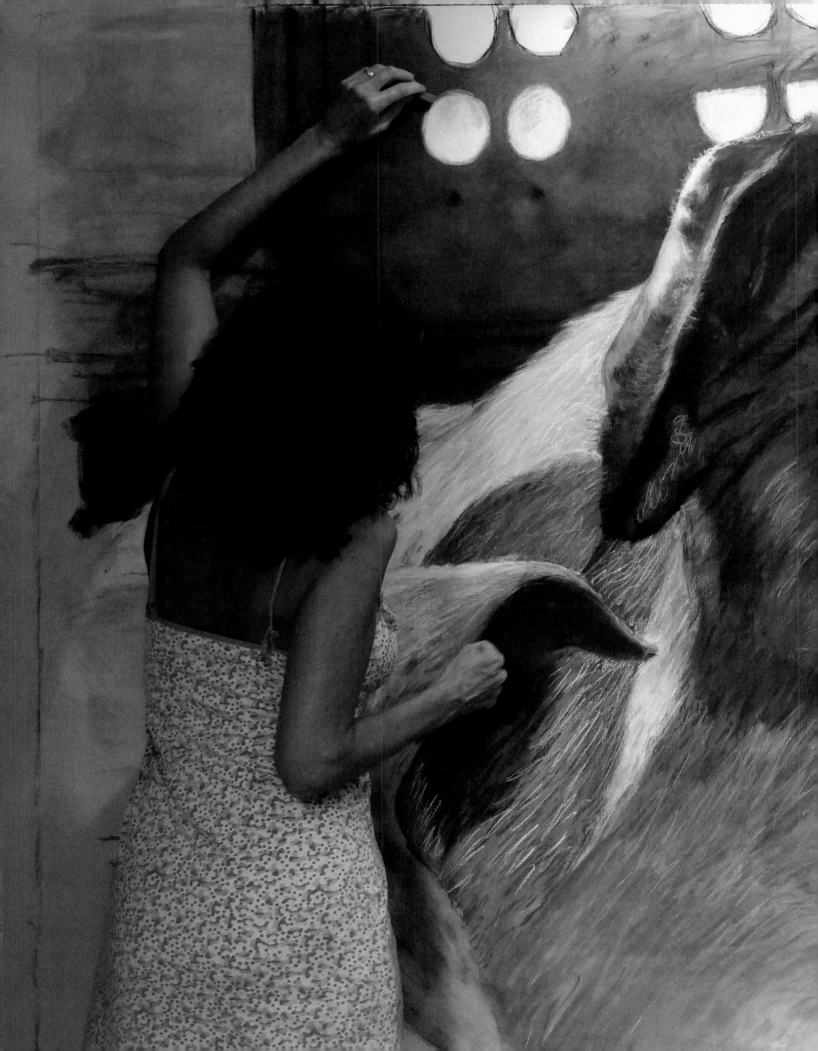

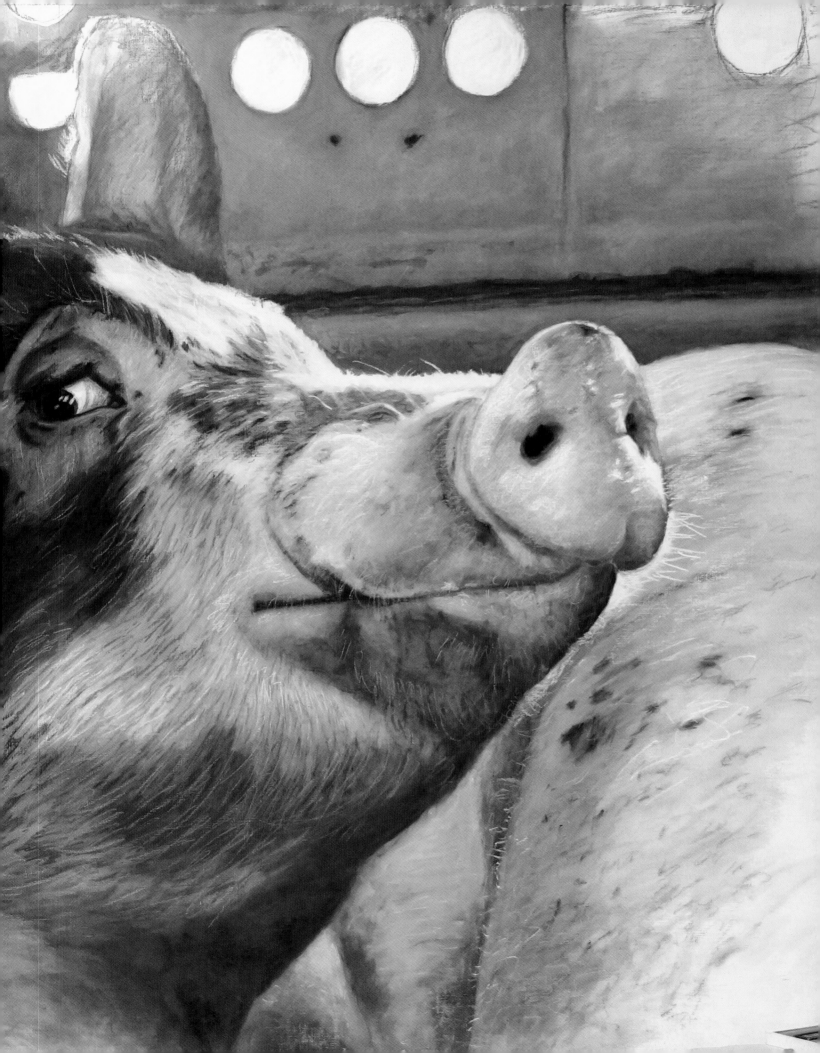

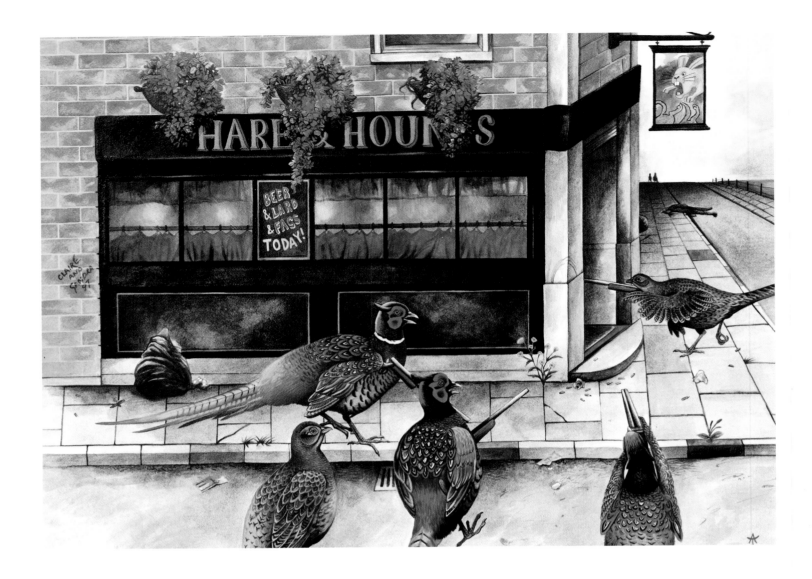

ANDREW TILSLEY

Being vegan today is weird. Even the very word is ubiquitous: in the news, on daytime chat shows, in overheard snippets of conversation; there are entire sections of supermarkets devoted to plant-based food, window displays in omnivore restaurants advertising vegan options, even vegan vending machines.

That feeling of being on the outside is getting less and less familiar. No longer do I have to worry about packing a three-course meal whenever I leave the house. I never get called a "vay-gun" anymore—as though I'm visiting from a distant star. It's literally been years since I was last asked, "So, what do you eat?" People do not seem surprised that I appear to be healthy and robust. I can't even recall when I was last responsible for triggering a defensive omnivore fit.

I can buy whatever I need, pretty much anywhere. I no longer expect new exciting foodstuffs to vanish into oblivion within a few months. My consumer concerns are more focused than they used to be: avoiding palm oil and single-use plastic, fretting about food miles and carbon footprints. I still get a buzz when I meet other vegans, but even this is now a little odd. Inevitably, I am asked how long I have been vegan. When I accurately reply "twenty-seven years," the information is usually received with a kind of awe, like people are trying to decide if I have superhero abilities or if I am some kind of living fossil.

Certainly, in the evolving world of vegan identity, I do feel like a bridge to the past; things have changed so much and so rapidly. I wonder how to account for the new prominence of veganism today, this plant-based revolution that we are experiencing. I hope that it is driven by kindness and decency—human beings simply wanting to be humane. Judging by what else is going on in many parts of the world, a revolution of compassion is needed more than ever.

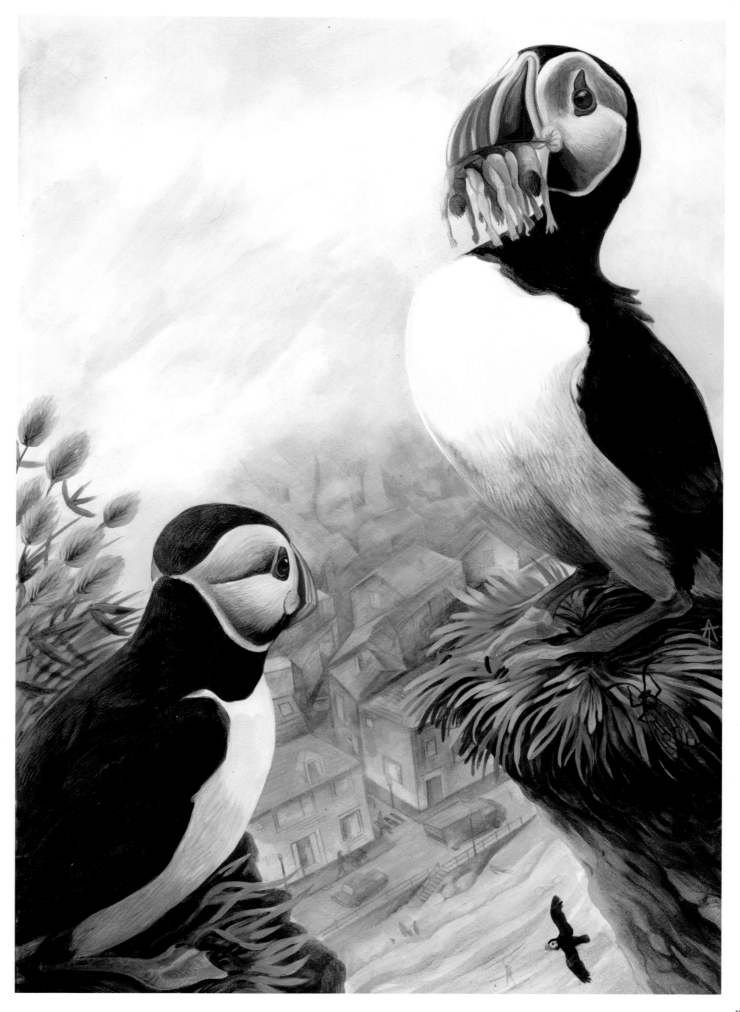

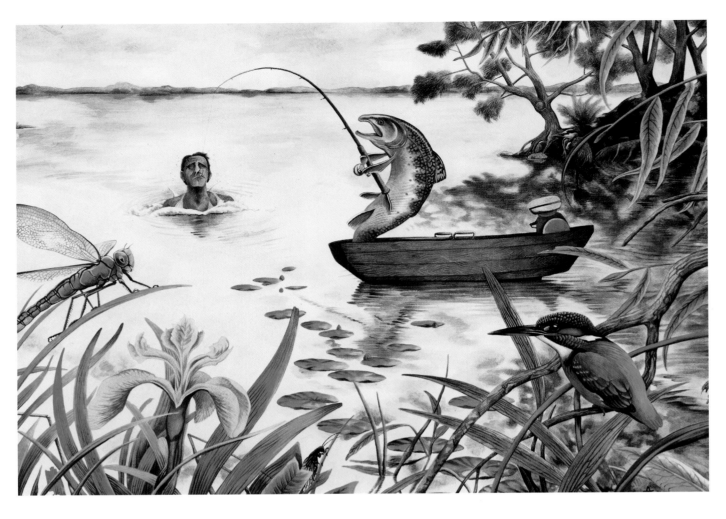

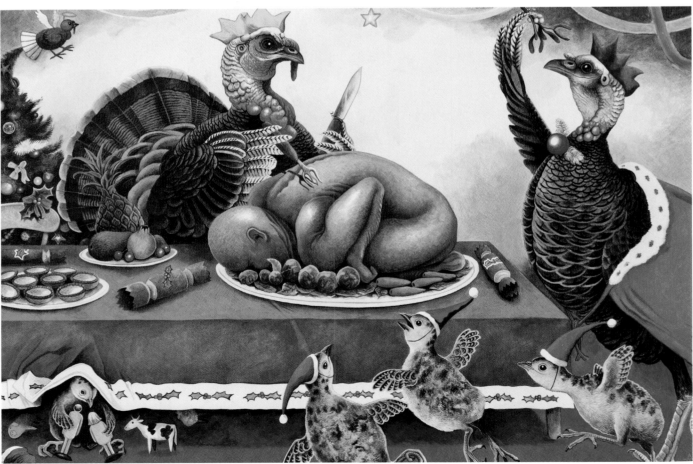

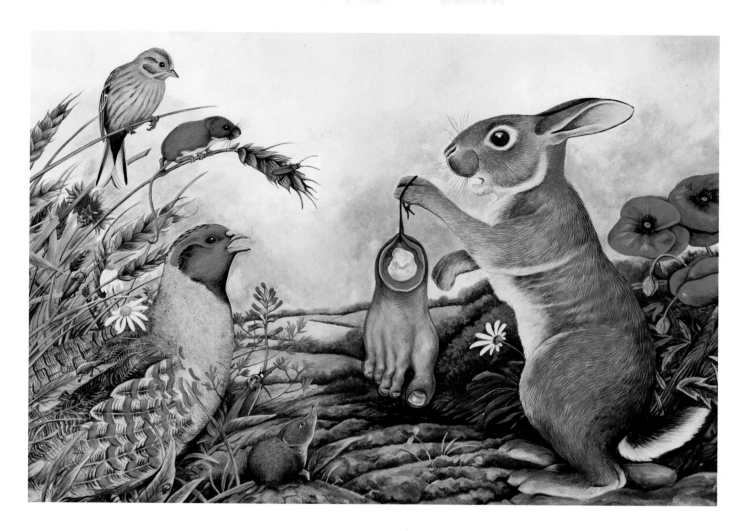

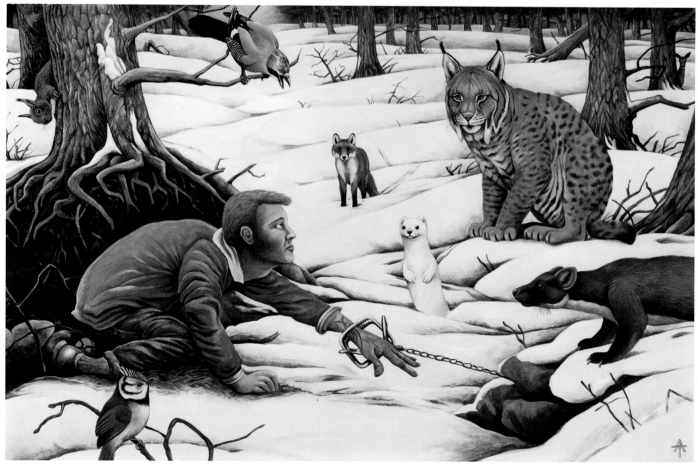

JO FREDERIKS

My art is created to shine a spotlight on the deliberately hidden plight of the helpless victims that we needlessly use and abuse for food, clothing, entertainment, and animal research. I tell their story visually. Why? Because most people are unwilling to examine the enormity of animal exploitation today, nor the ways that apathy and indifference funds this unsustainable nightmare. People generally turn a blind eye to graphic photographs or videos that document the unjustifiable violence behind our consumption of nonhuman animals. They will stop, however, to observe artworks depicting similar images. I invite you to look beyond your initial reaction to my art and be open to its message of social justice; this is where art becomes a powerful political and social tool in its ability to educate and create awareness. I hope my images move people and inspire change in their perception of animals—that they are not here for our use; that their lives belong to them and are not ours to take. Many of my works are pencil drawings, in which I show the unique expressions and characters of individuals that society reduces to commodities and belittles as "things." I also depict acts that are standard industry practices (not isolated events). I hope that my art encourages people to question their ethics and moral beliefs. We have all been indoctrinated to consume and use animals since birth. Few of us ever question the ramifications of what this violent ideology means, not just for our health and the animals, but for future generations and the sustainability of the planet. My artworks are dedicated to exposing the greatest injustice of our time and asks you, the viewer, to reject violence and demand justice for all sentient beings. That is what being vegan means.

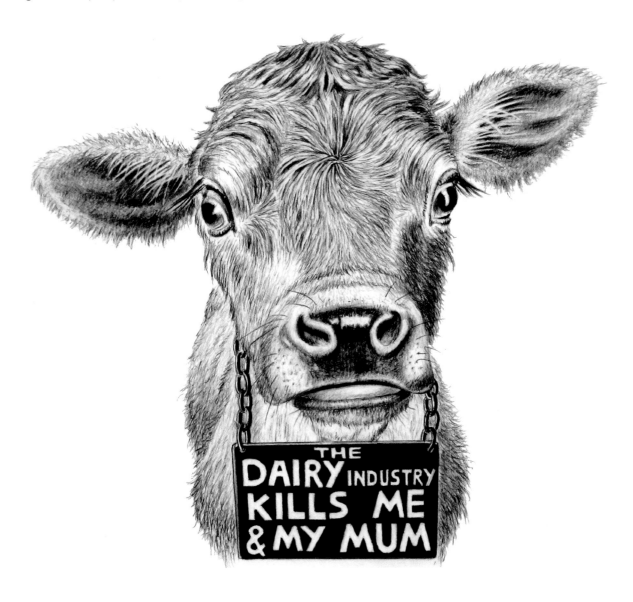

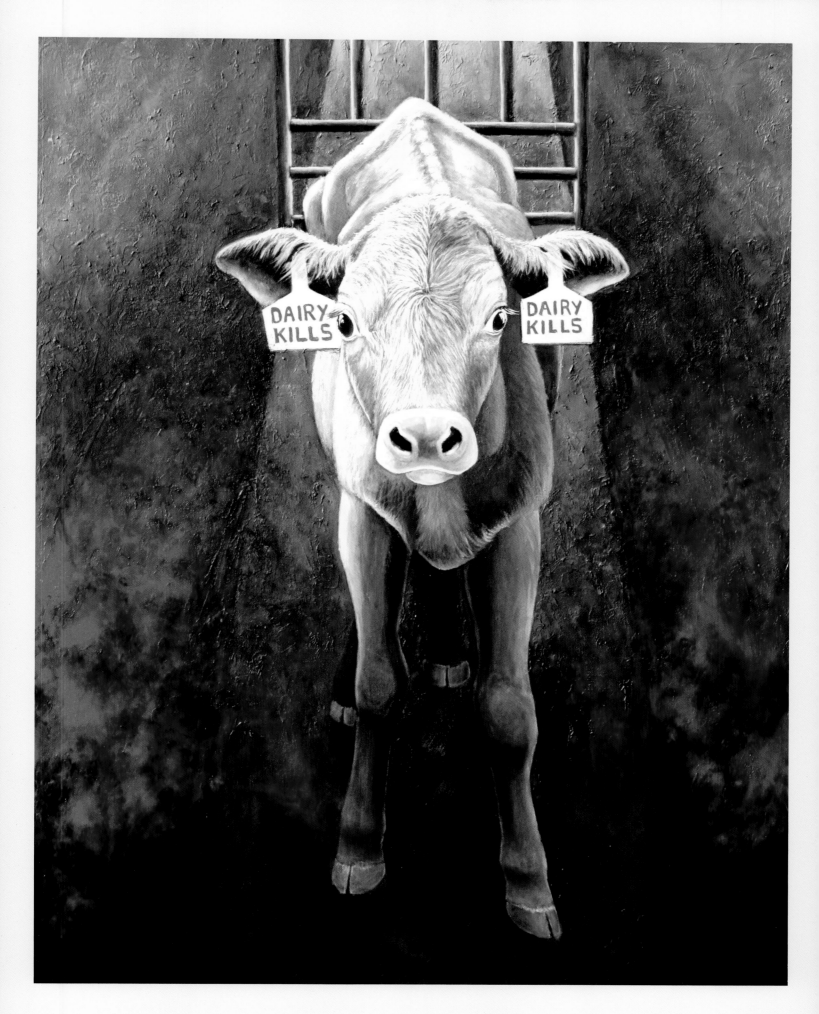

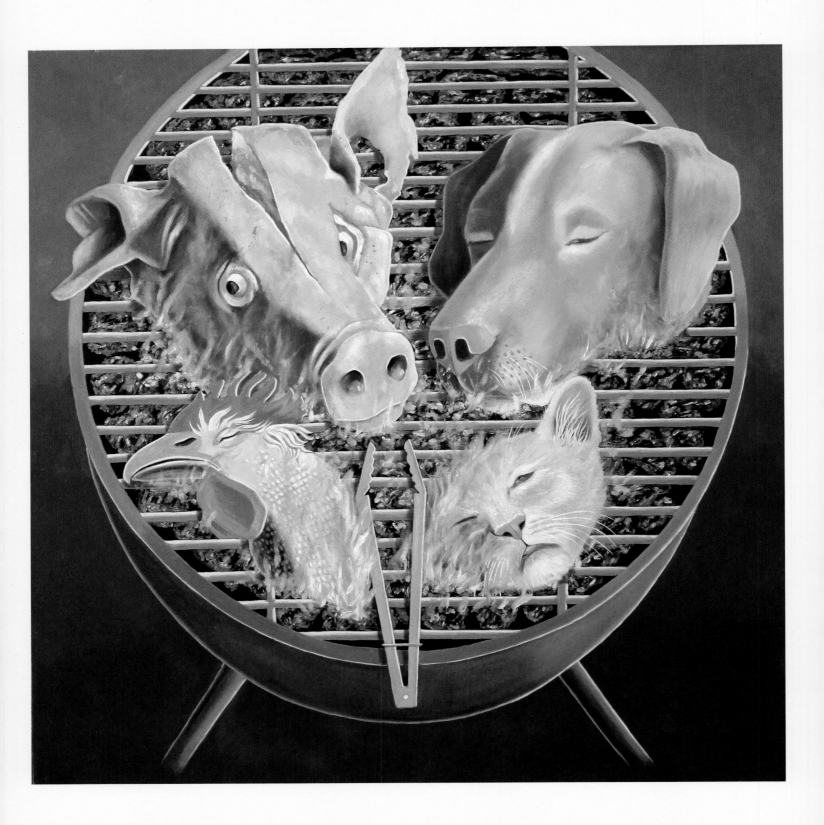

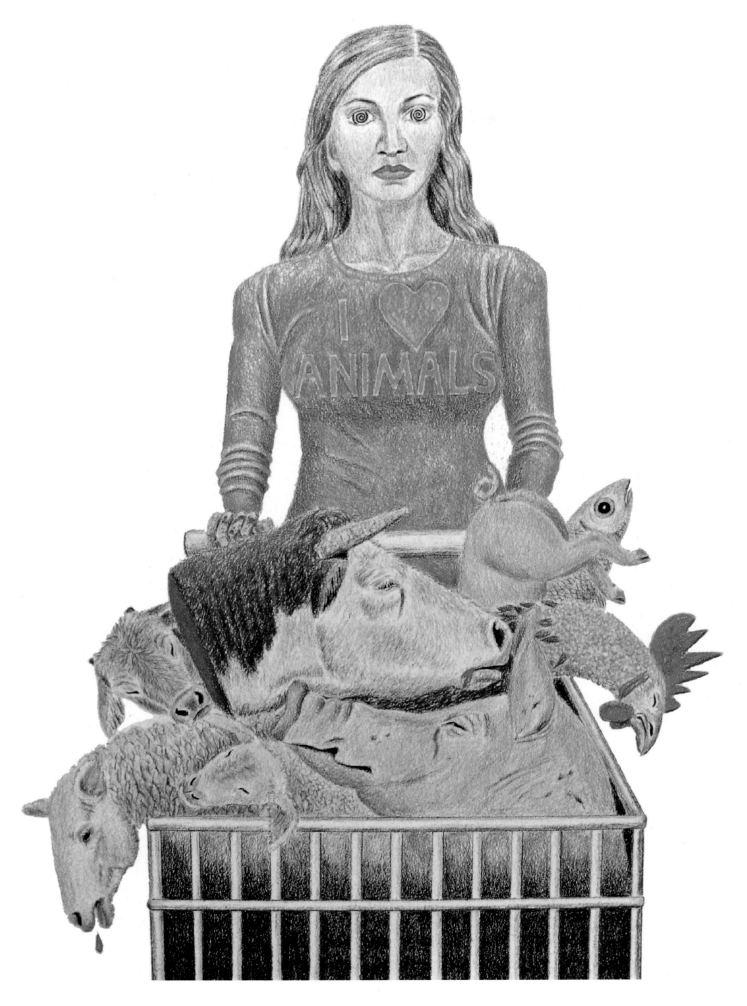

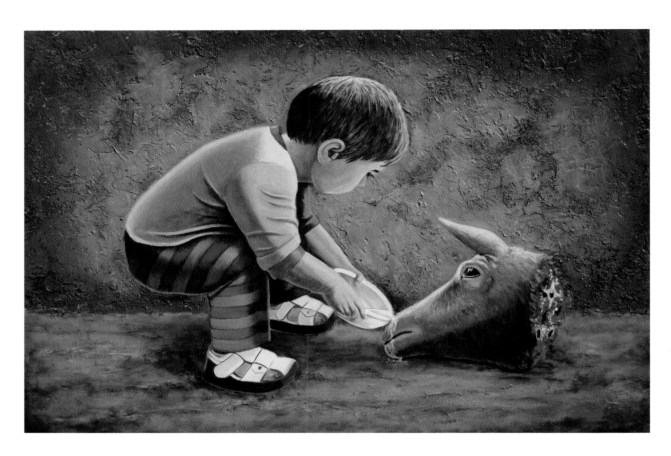

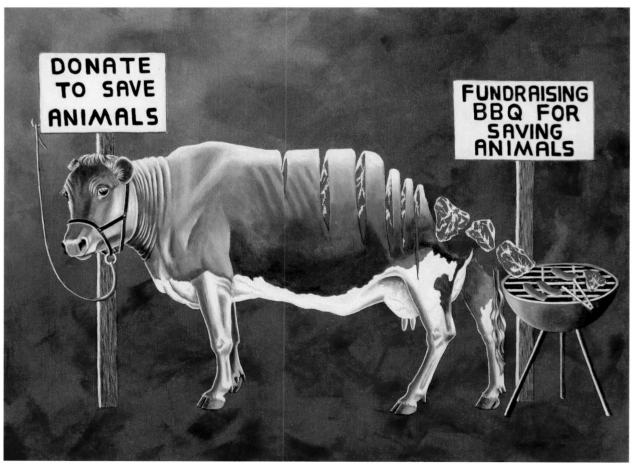

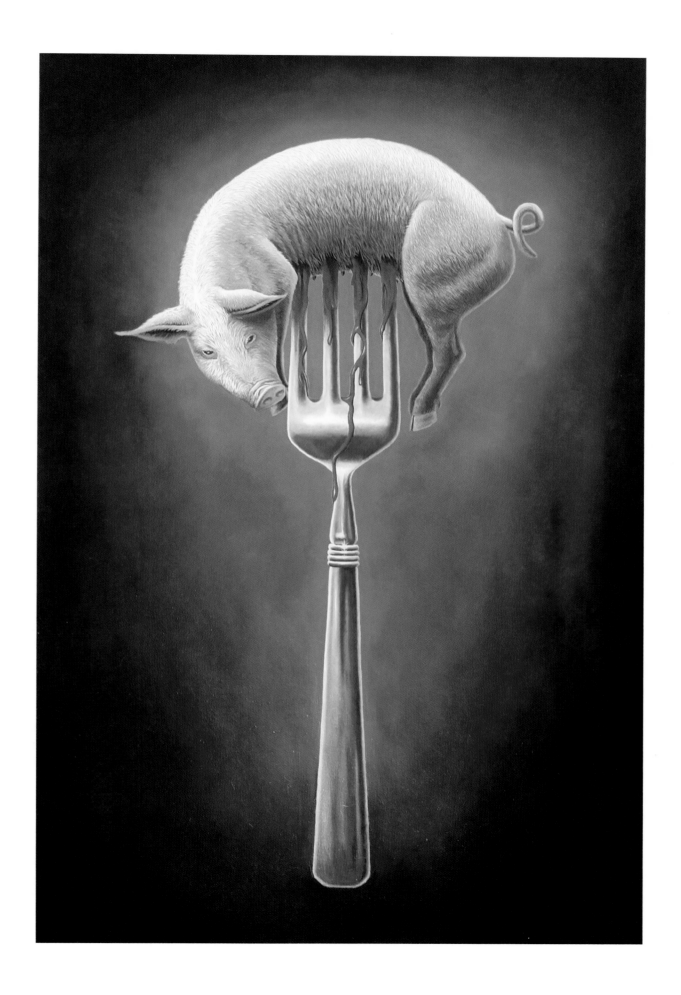

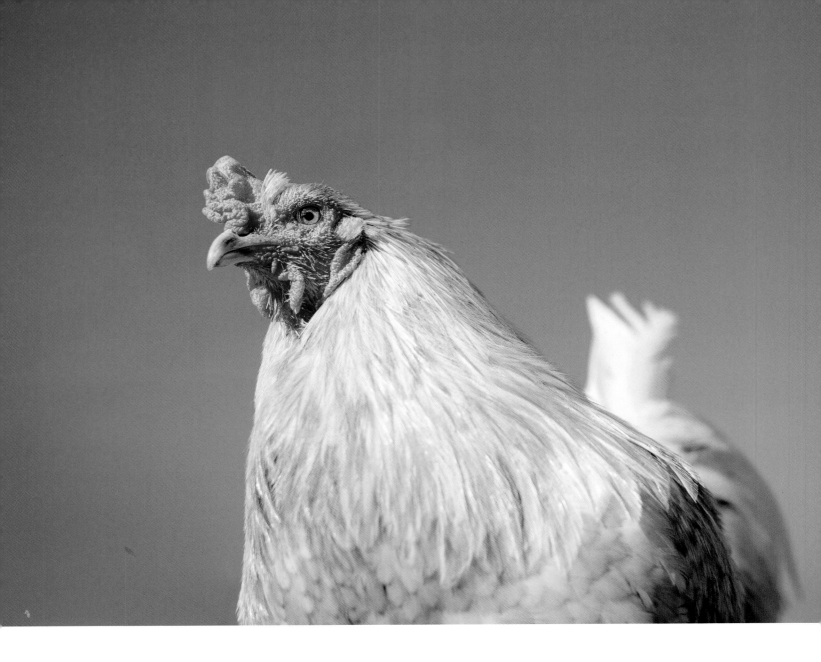

CAMERON O'STEEN

With my "Yoga Animalia" project, I want to remove the "otherness" of formerly farmed animals, to showcase them as the beautiful and complicated beings that they are. I want to highlight their voices, which are as varied as humankind's. We compare farmed animals with companion species, and while I think that this helps anyone who has not encountered such a comparison before, I also want to ensure that we discuss farmed animal species on a level equitable to humans—to remind people that we are animals too and share more in common with them than what makes us different. The cattle, chickens, pigs, turkeys, and others used by humans are as unique as each human or dog or cat. All of us love, grieve, celebrate, and want to live and thrive.

I focus on rescued farm animals living at sanctuaries, because a well-run sanctuary emanates a peaceful feeling, created by the resident animals, including the humans who help to make it function. These safe spaces allow the various species to learn and grow. It is here that I have been fortunate to meet chickens and be invited into their world, to be surrounded by sheep and feel the interconnectedness of the herd, to gambol about with goats and learn about their strong family bonds, to meditate with cattle amidst cud-chewing sessions in gently waving grasses.

Sanctuary residents can be apt teachers and loving friends, and if we human animals are calm, quiet, and observant, we can start to see their emotional, social, and cultural lives. It is my hope that we can learn to extend our compassion to all species.

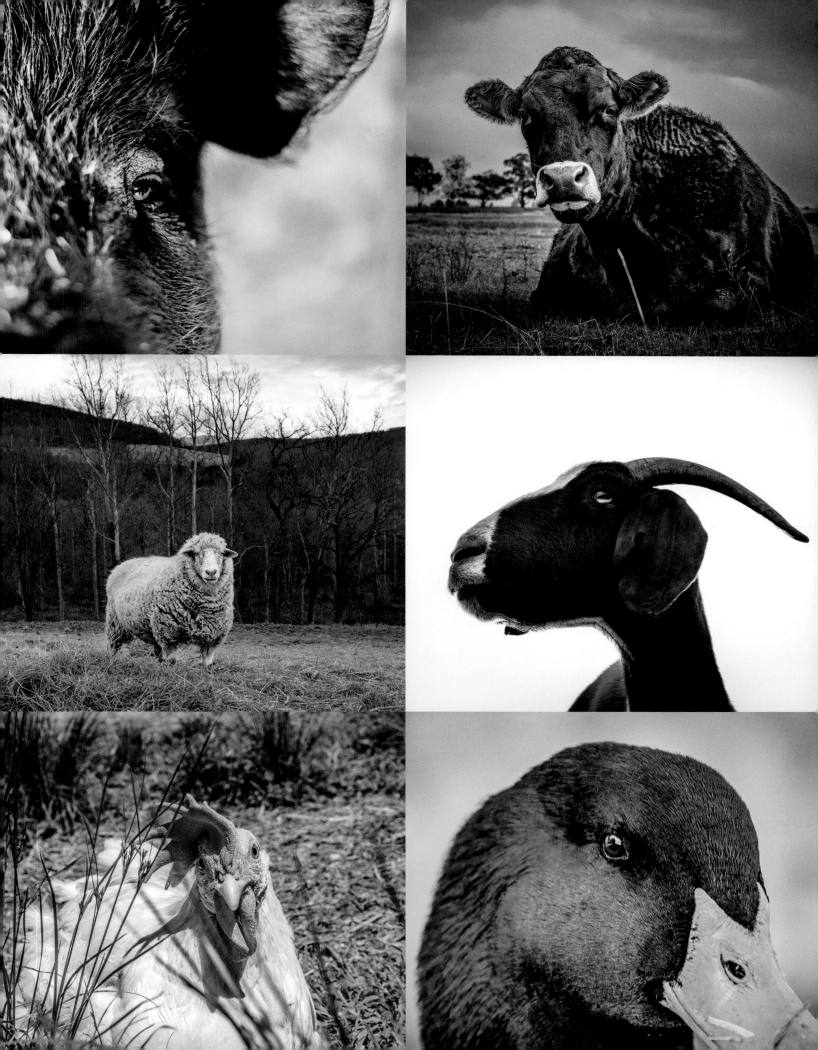

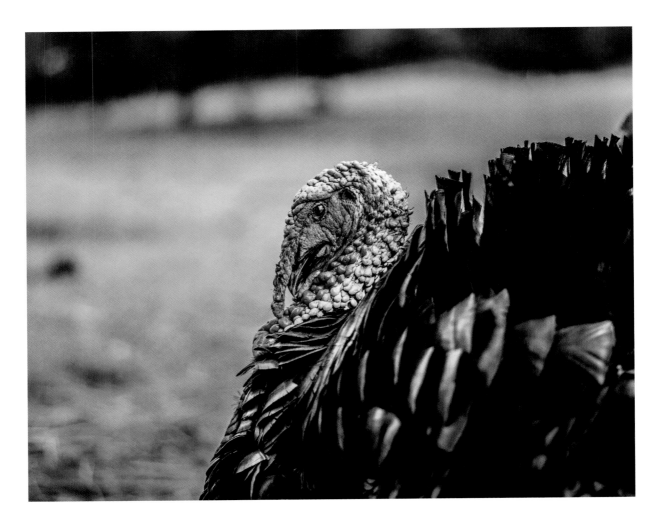

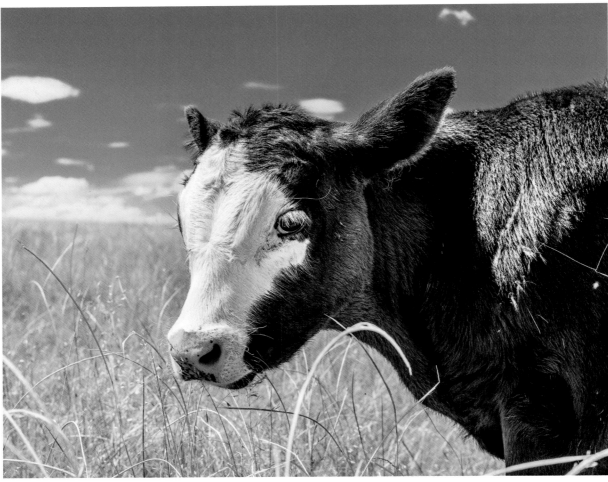

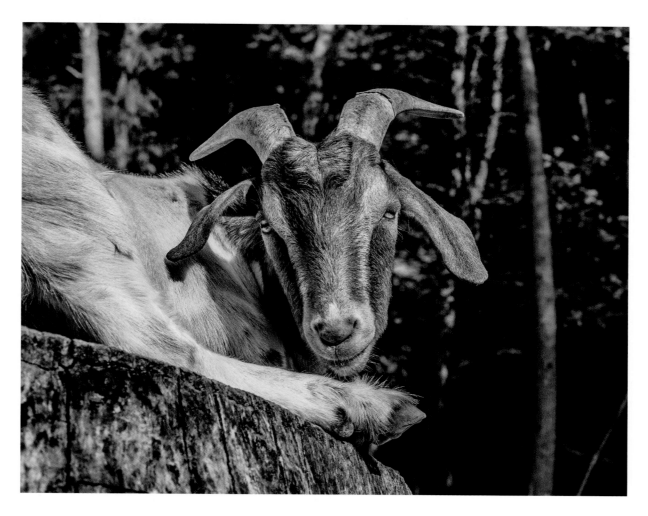

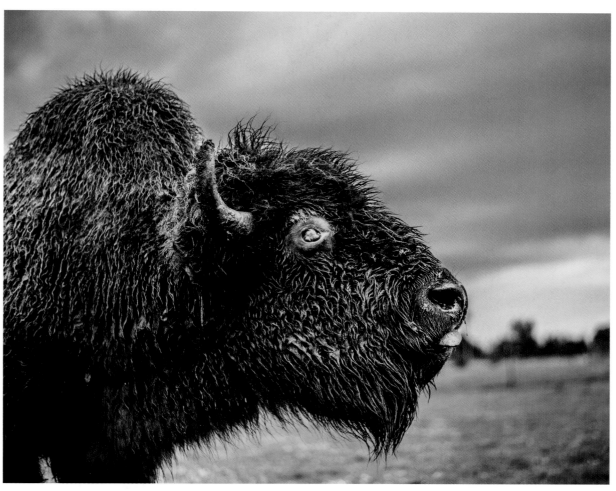

DANA ELLYN

I have been a vegetarian at heart since childhood, a committed vegetarian since 2001, and a vegan since 2004. I can remember my visceral negative reactions to the meat-based meals that I was served when growing up. I clearly recall the feeling of disgust when my knife and fork hit the bone on a breast of chicken, the realization that the "juices" flowing from my steak were blood, and that moment when I made the connection that the spare ribs my family loved to order at our favorite Chinese restaurant were, in fact, the ribs of an animal!

As I evolved from meat-eater to vegetarian to vegan, my art changed too. When I was younger, I created very safe and academic art. I give partial credit to my husband and fellow artist, Matt Sesow, for helping me to break out of the safe and predictable path that I was on. When I started to express my views on veganism through art, my paintings were very controversial and not always easy to look at. It is these risk-taking paintings that brought me much of the recognition and success I enjoy today. One of my most controversial paintings, which is titled *Baby Back Ribs*, was shown in the exhibition *Radical Fluidity: Grotesque in Art* at the Museum of 20th and 21st Century St Petersburg Art in Russia in 2018–19.

Recently I have toned down the severity of my work. I am still just as passionate about the subject, however, and I still have the desire to scream from the rooftops to make people listen about the horrors of the animal agriculture industry. But my new paintings deal more with beauty, and make the viewer think deeper to see the message I wish to convey.

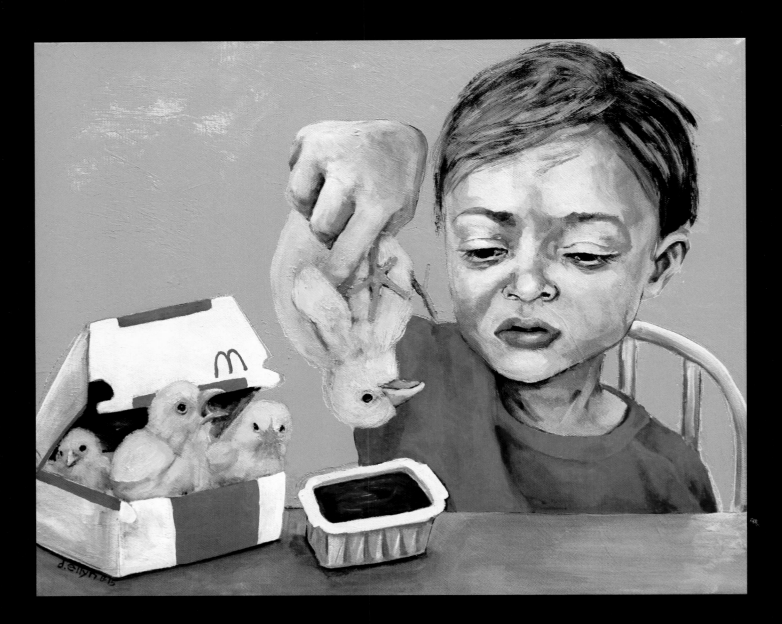

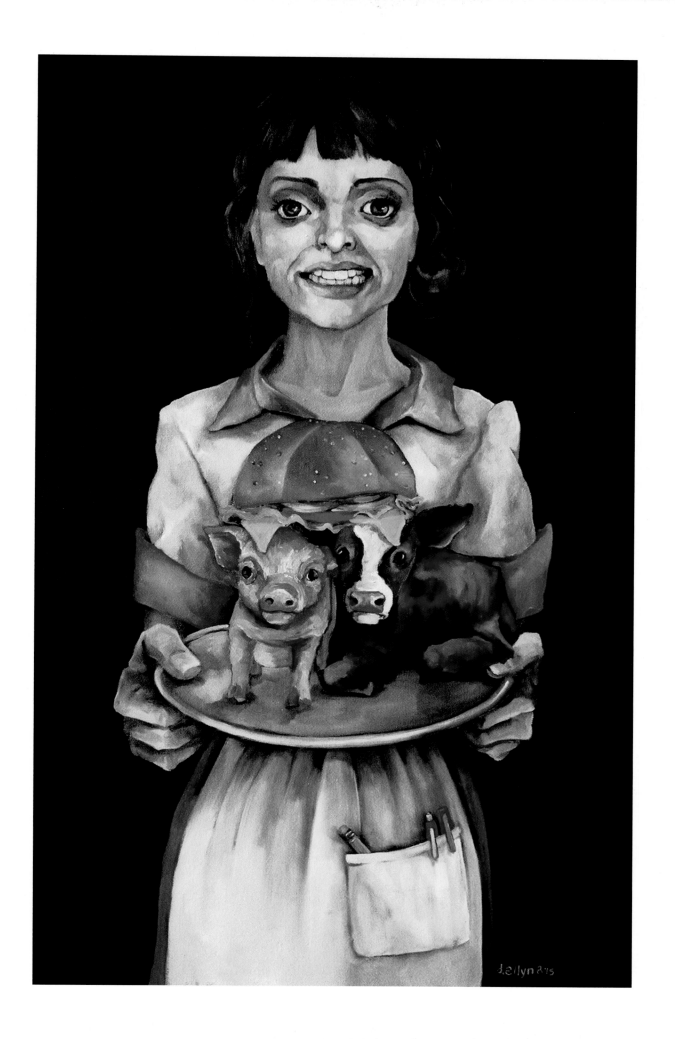

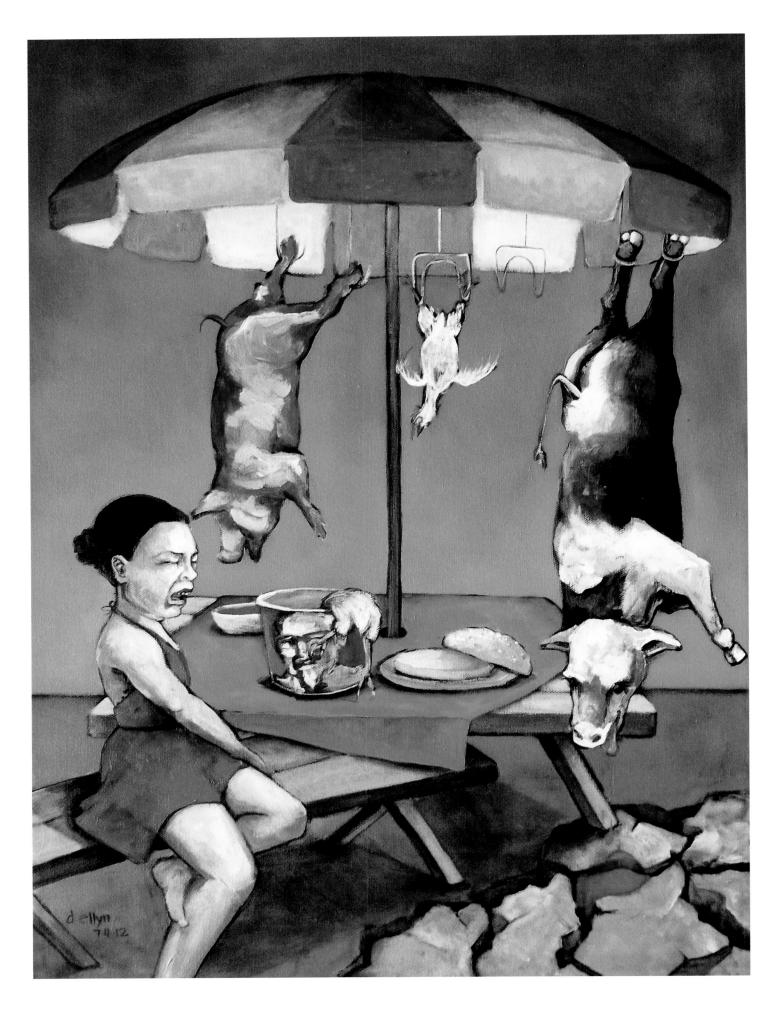

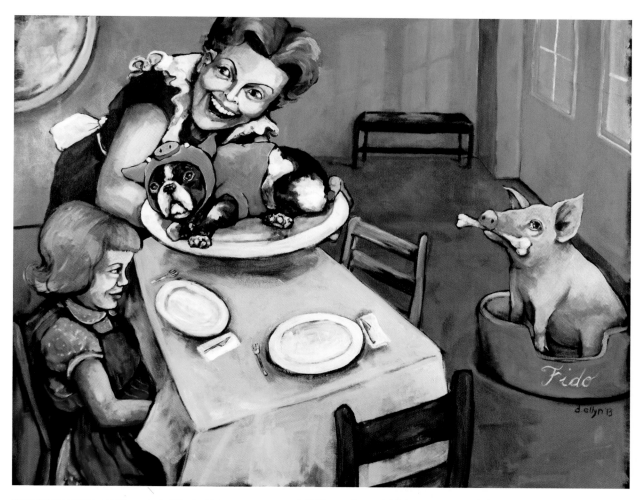

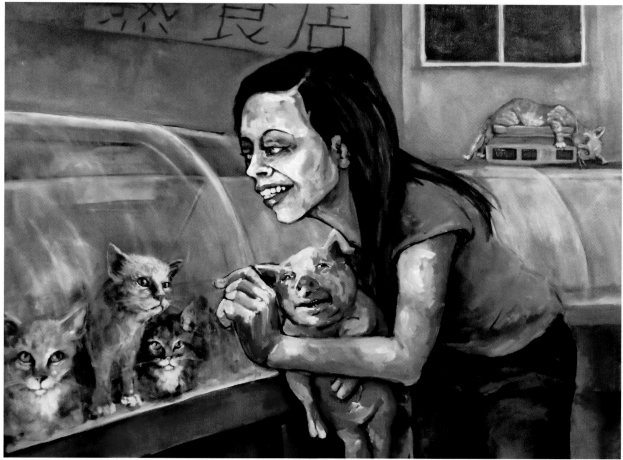

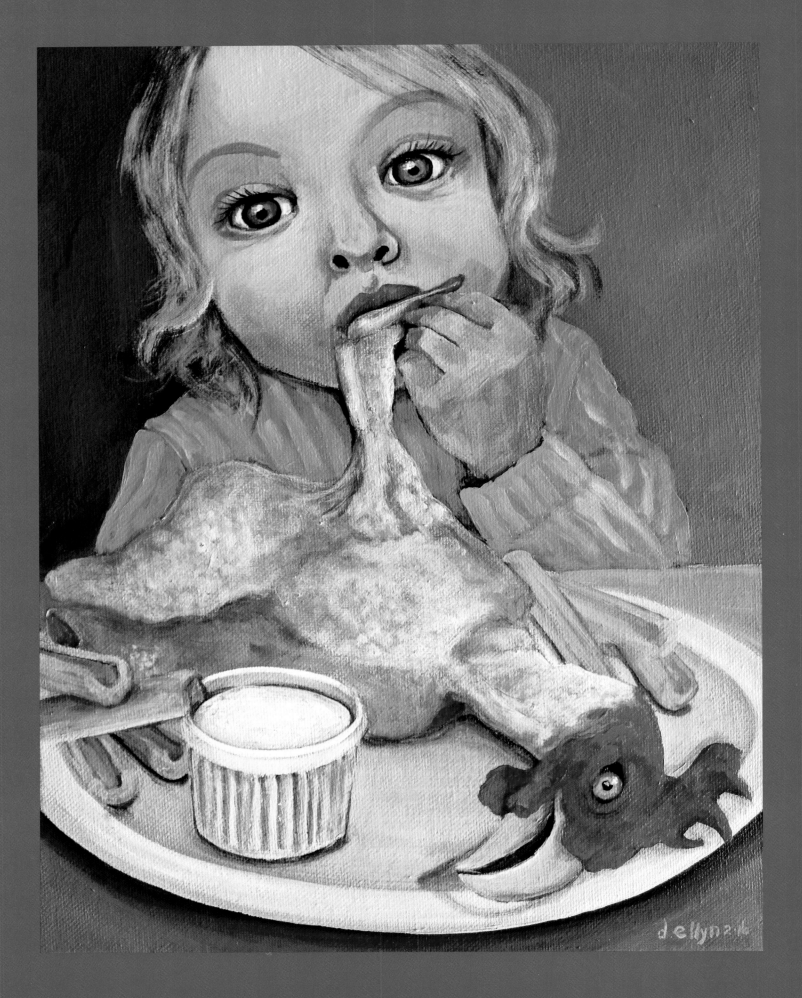

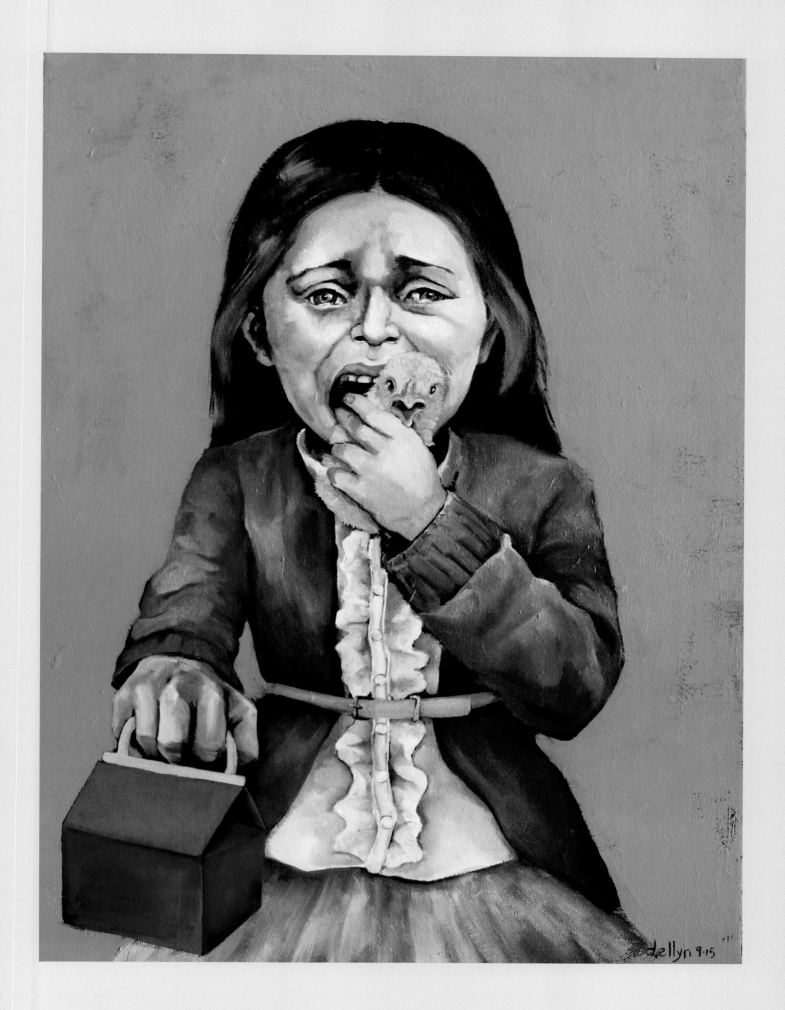

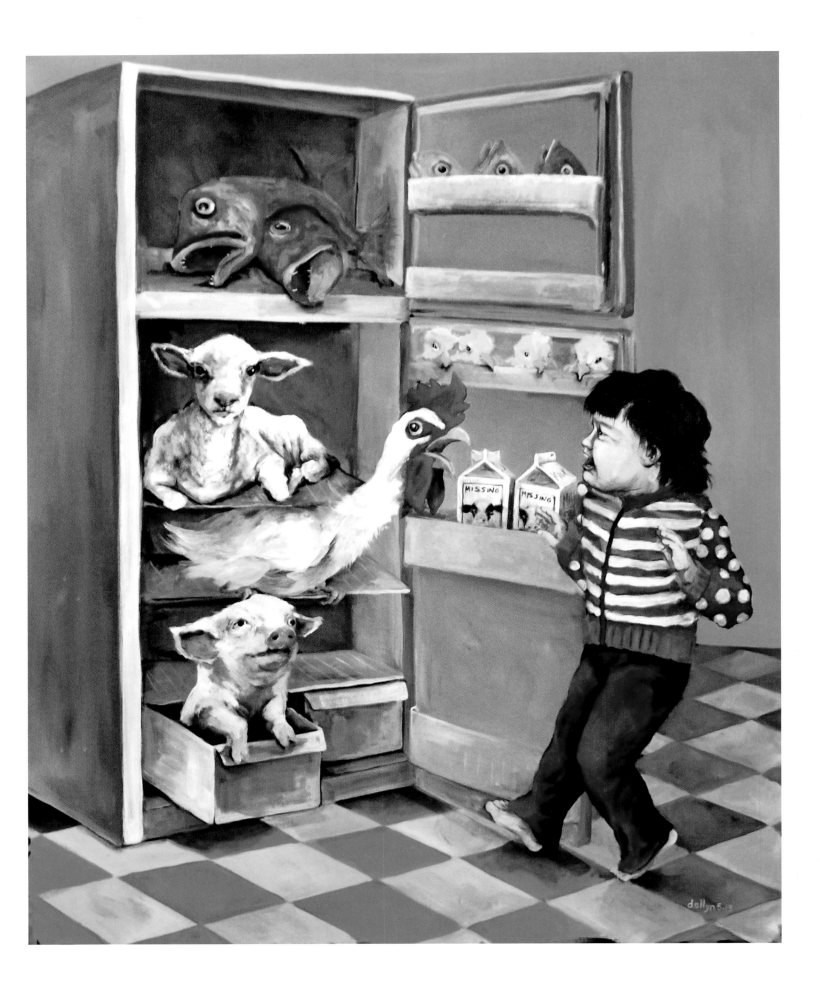

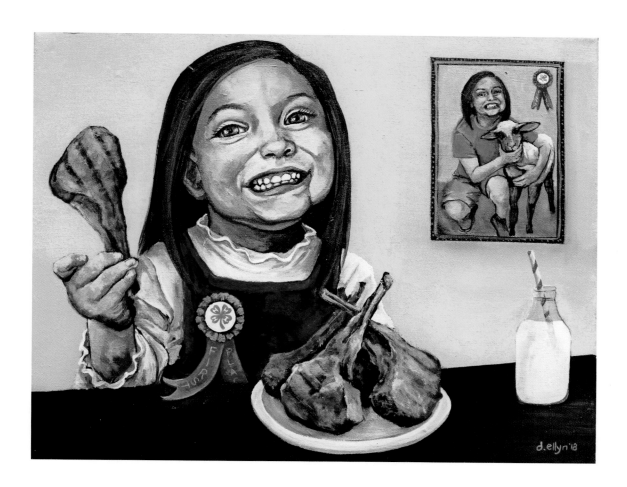

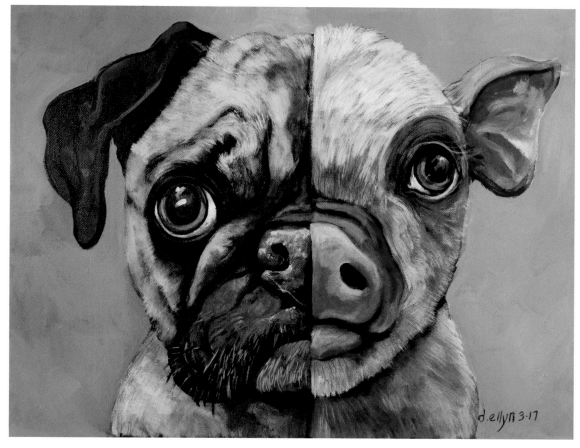

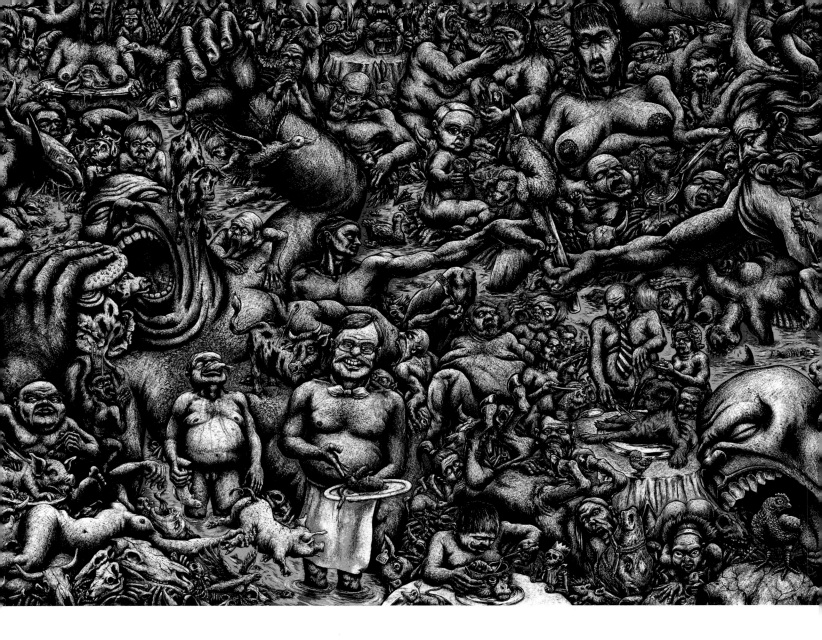

ROLAND STRALLER

I was born on July 14, 1978, and raised in Bavaria, Germany. My parents were brought up on farms, so it was normal to see animals exploited and killed for my consumption. Today, I have five relatives who are still in the factory-farming business. As a kid, I bred ten to twenty domestic rabbits each year and slaughtered them with an uncle in the autumn. Then I would proceed to eat my rabbits. I had consciously given them no names because I did not want to see them as pets. It was as if I knew that what I was doing was somehow wrong. From 1998 to 2003, I studied communication design at the Nuremberg Tech, with a focus on illustration. On May 22, 1999, after a discussion with my friend Tobias Graf, who was vegan, I could no longer justify my eating habits and I became a vegetarian overnight. Since then, this theme has come to dominate my artwork. In 2004, I finally made the leap and became vegan.

In 2006, Tobias and I founded the vegan clothing label Avenging Animals. We developed various collections and cooperated with vegan rock bands and artists. We have sold more than fifteen thousand T-shirts with vegan or animal-rights slogans. The Avenging Animals label is part of Absolute Vegan Empire (AVE), Europe's first all-vegan wholesale business. For the past ten years, I have been building AVE and its food brands as a graphic designer. Together with my wife, two children, and some animal roommates, I still live and work in the village in which I grew up, among the Bavarian milk and meat industries.

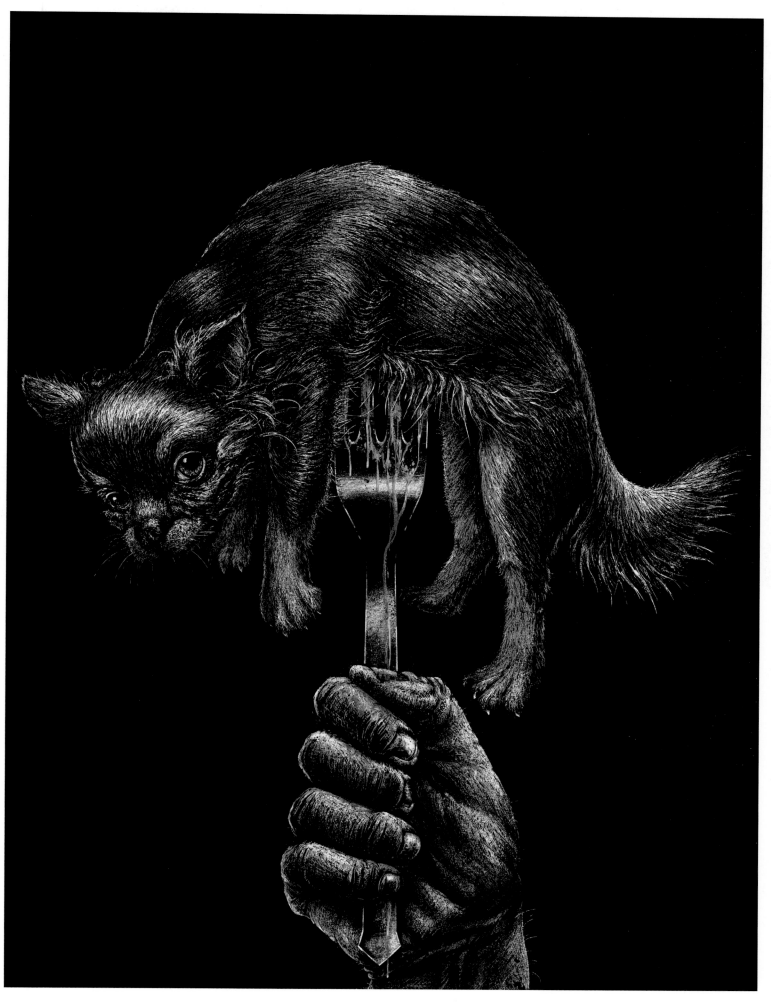

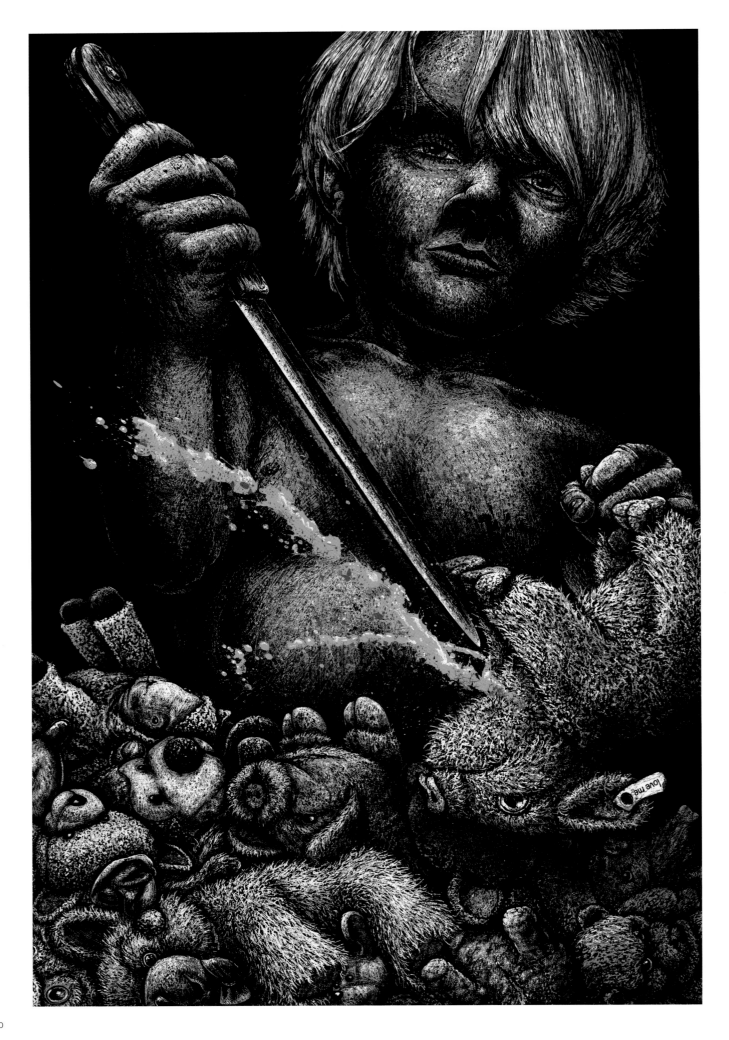

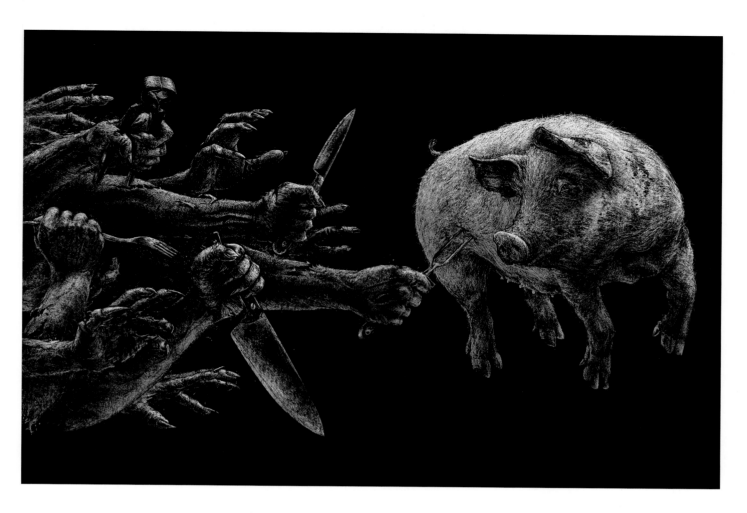

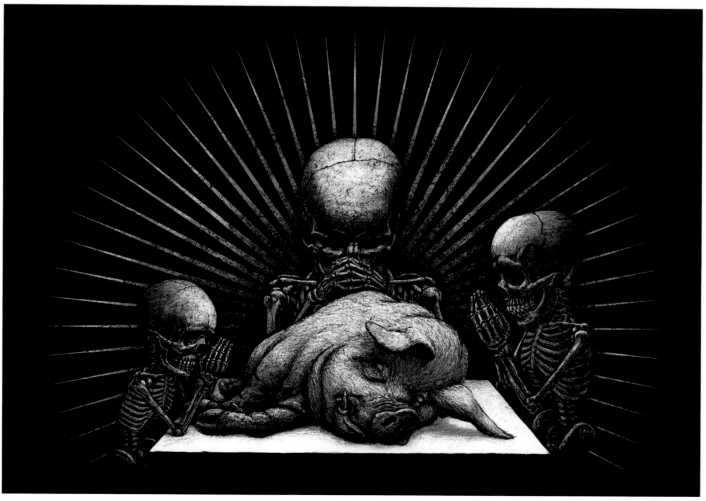

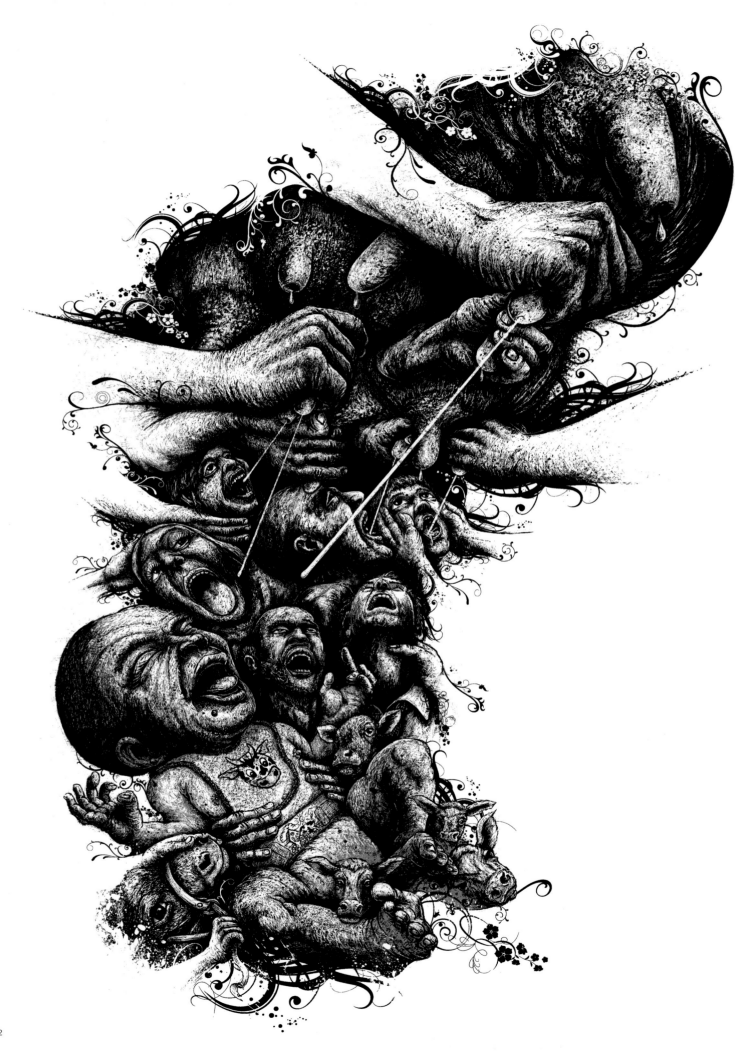

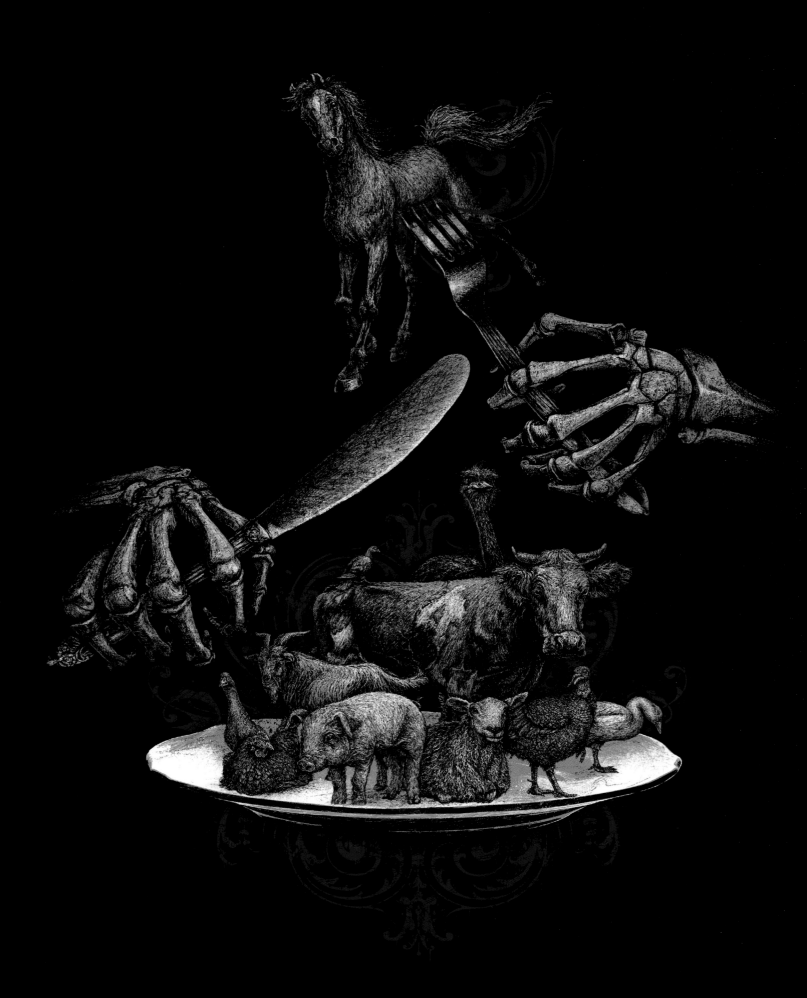

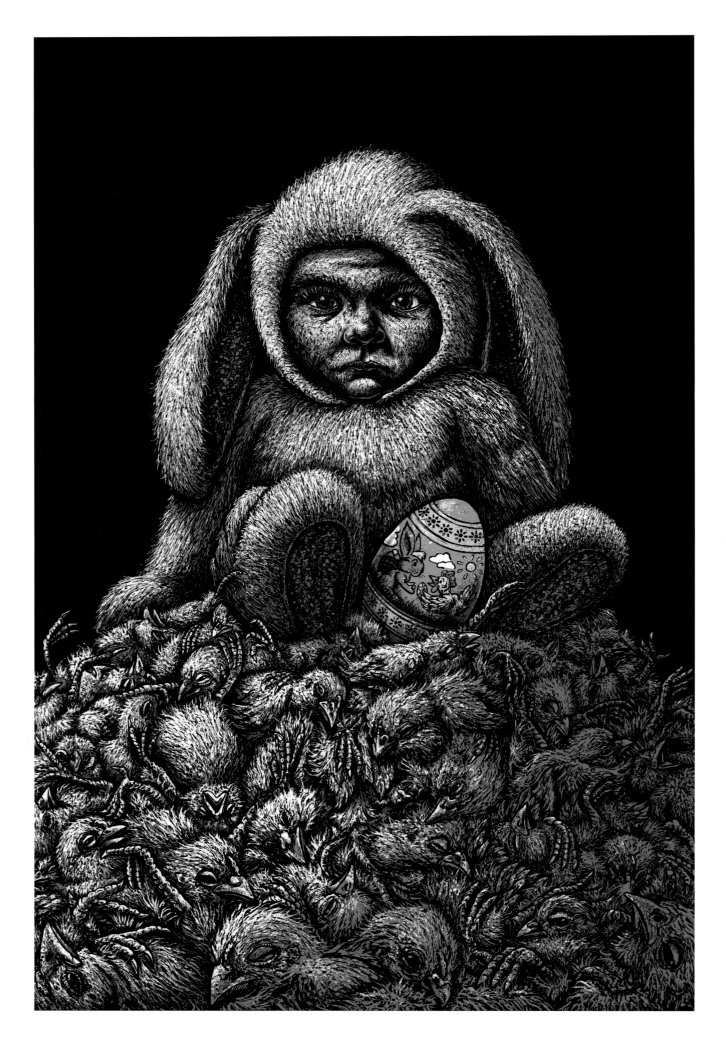

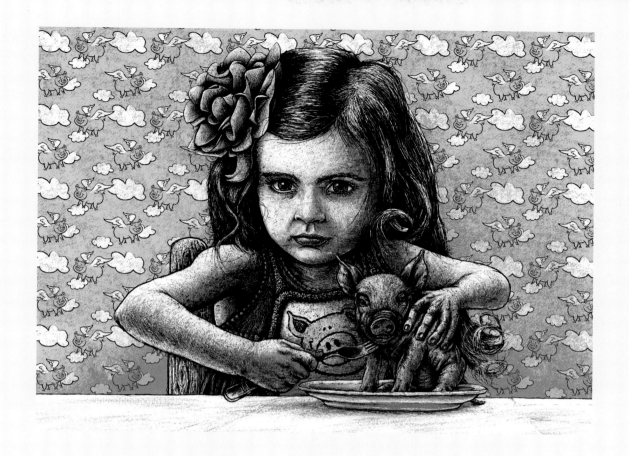

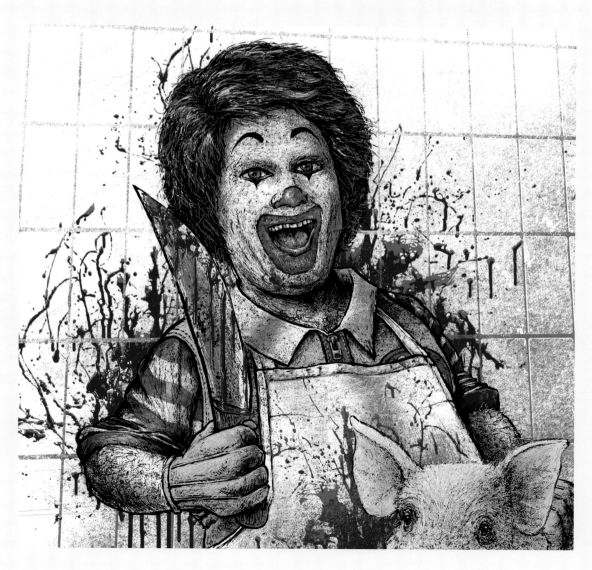

CYNICAL COYOTE

I never planned on becoming a vegan, or an artist, and especially not a vegan artist. At a young age, I briefly worked at a local, organic, "humane" farm. While it was clear the business was making an effort to be appealing, the fundamental problem of using animals as objects became more and more apparent to me over time. As a consumer of animal products, I tried to silence the guilt. No matter how nice you treat the animals before you slit their throats, you are violating them for no real reason.

I had dabbled in and enjoyed art. After learning about so many hidden atrocities, from beak trimming to brutal piglet castrations, I began to use art to vent. I am not an articulate speaker; social situations confuse me. Through art, I can craft an image about something that I have witnessed. I can visualize a message about the desperate need for animal rights. I want others to acknowledge what is happening to the animals that we eat by bringing to light the injustice they face and amplify their cries for help.

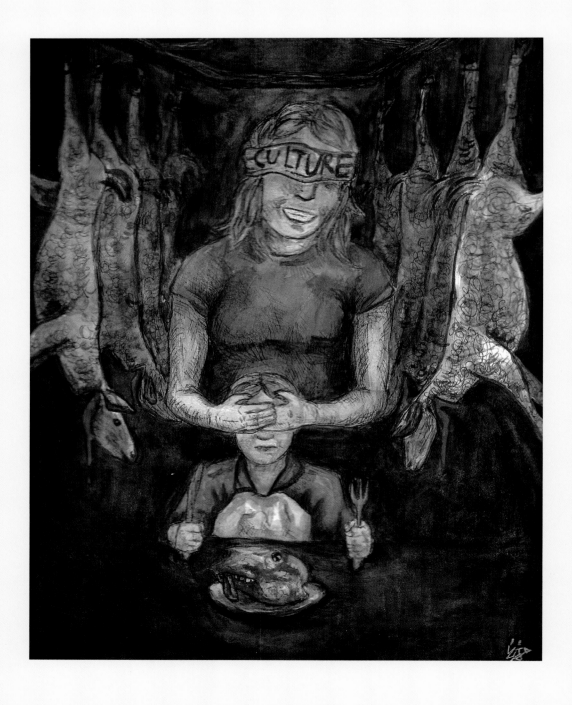

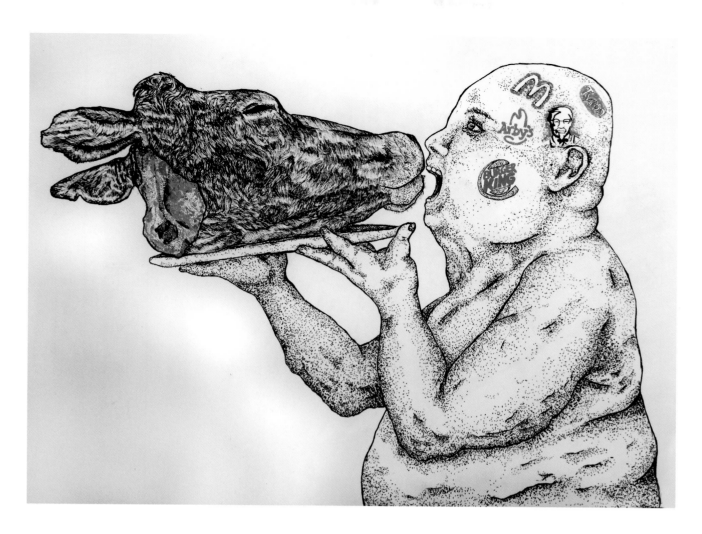

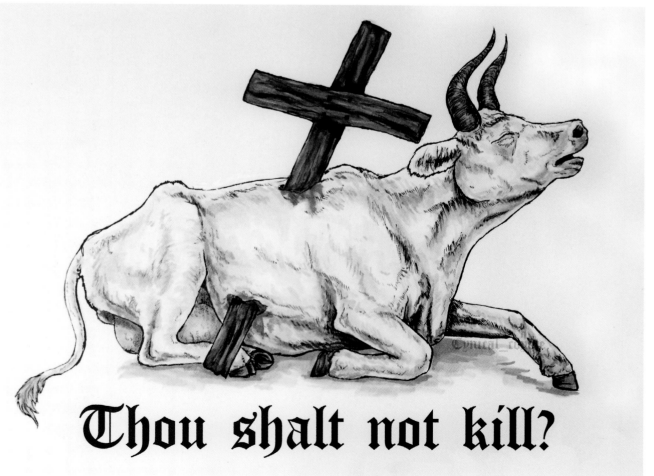

Thou shalt not kill?

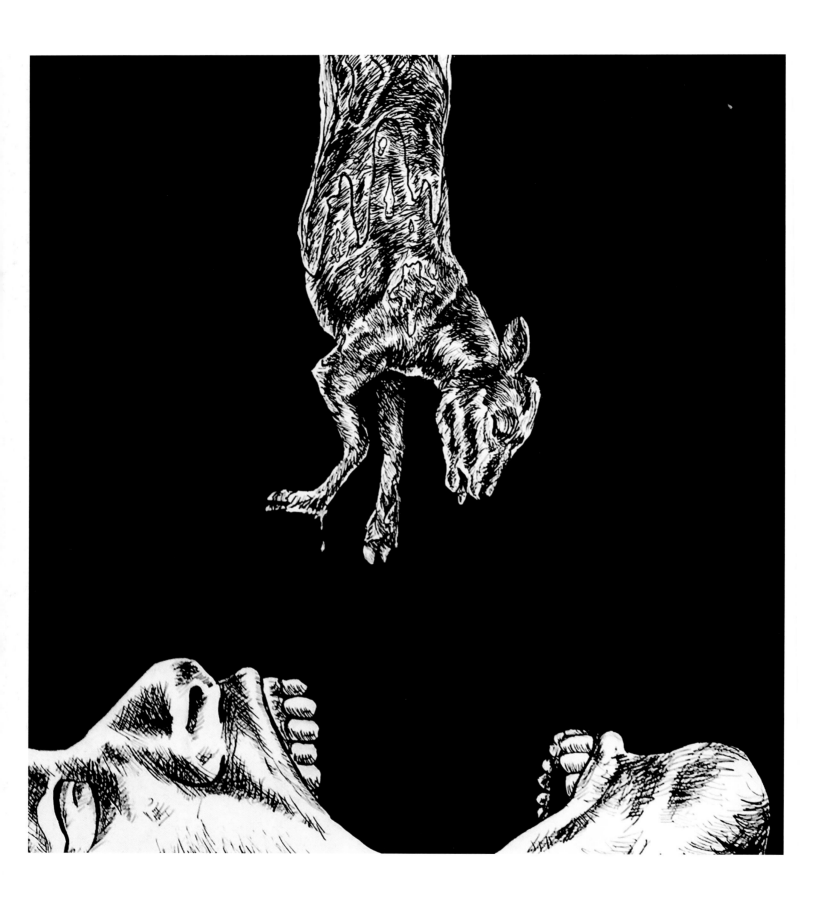

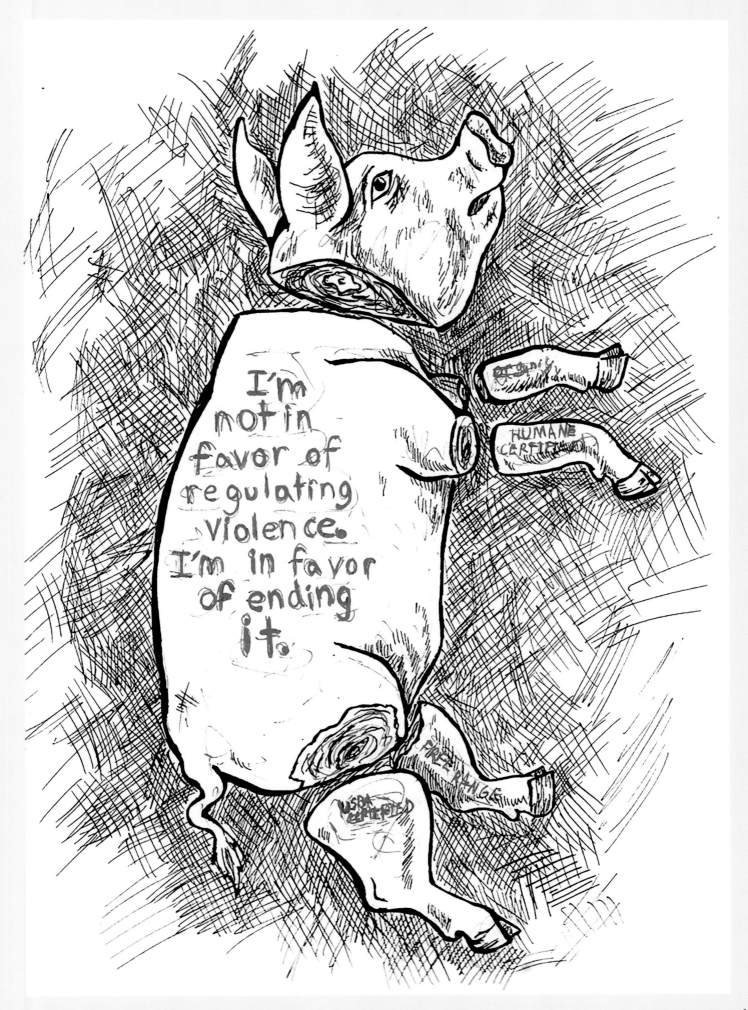

KATE LOUISE POWELL

Almost as soon as I went vegan in 2015, it started to feel like second nature to me. I wondered why I had not made the change sooner. Being vegan quickly became an important part of my identity, and I was increasingly vocal as the years went by. However, despite studying an illustration degree at the time, I initially struggled to communicate my feelings about animals through art. Tackling the subject of animal rights, animal agriculture, and animal abuse through the means of drawing felt like a daunting task, and I worried about not doing the topic justice. I was afraid that if my drawings were not up to scratch, they could trivialize the suffering and make animal rights seem "cheesy." It took me a long time to build up the self-confidence to start making art about this subject. It is something of profound importance to me, and I take great care to get the tone right.

I want to present animals in a dignified way that does not minimize their pain. I want my work to inform and challenge people, but not instantly turn the viewer away. Today I live as a freelance illustrator and as an animal-rights activist. I feel thankful that I have succeeded in combining my two biggest interests to produce work that is emotive, educational, and sometimes deliberately provocative. I use illustrations to shed light on specific acts of animal abuse and morally inconsistent human behavior, and to fuel conversations about how we perceive and treat nonhuman animals. I have only just scratched the surface of animal-rights art. Unfortunately, the ways in which we hurt those with whom we share the Earth (and therefore the topics that can be tackled by making art) are never-ending, so I see myself drawing about these things for the rest of my life.

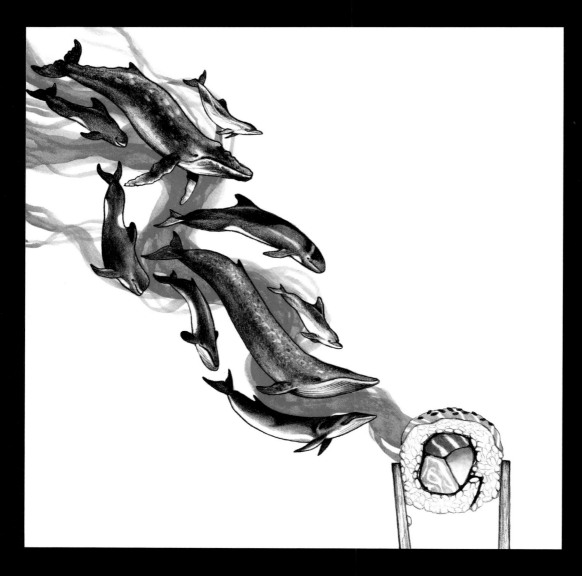

250 ANIMALS ARE KILLED EVERY SECOND

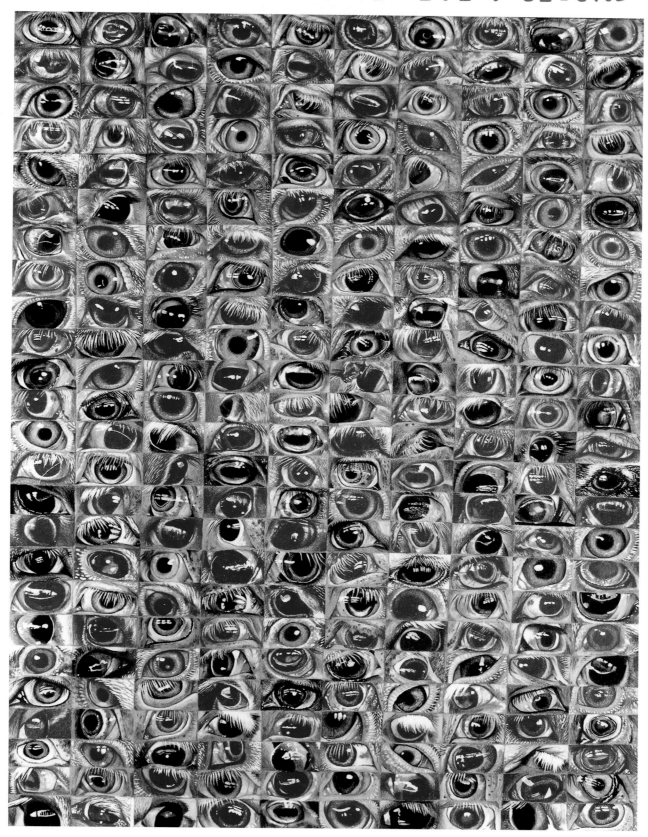

FOR FOOD CONSUMPTION IN THE UK.

Each eye here is drawn from unique photographs, taken by the
animal-rights activists Saving Me, of animals outside U.K. slaughterhouses.

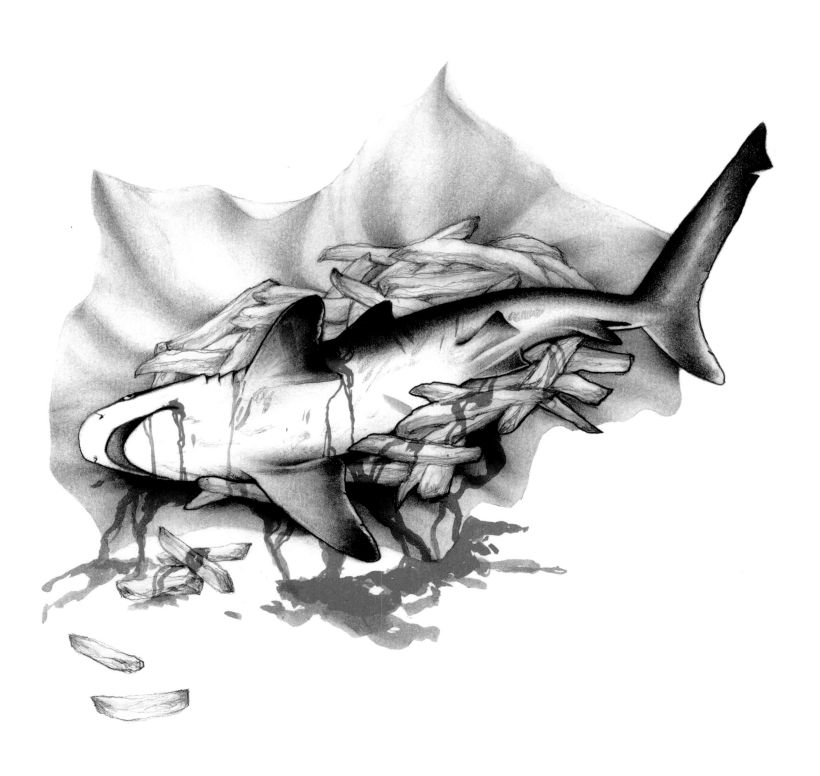

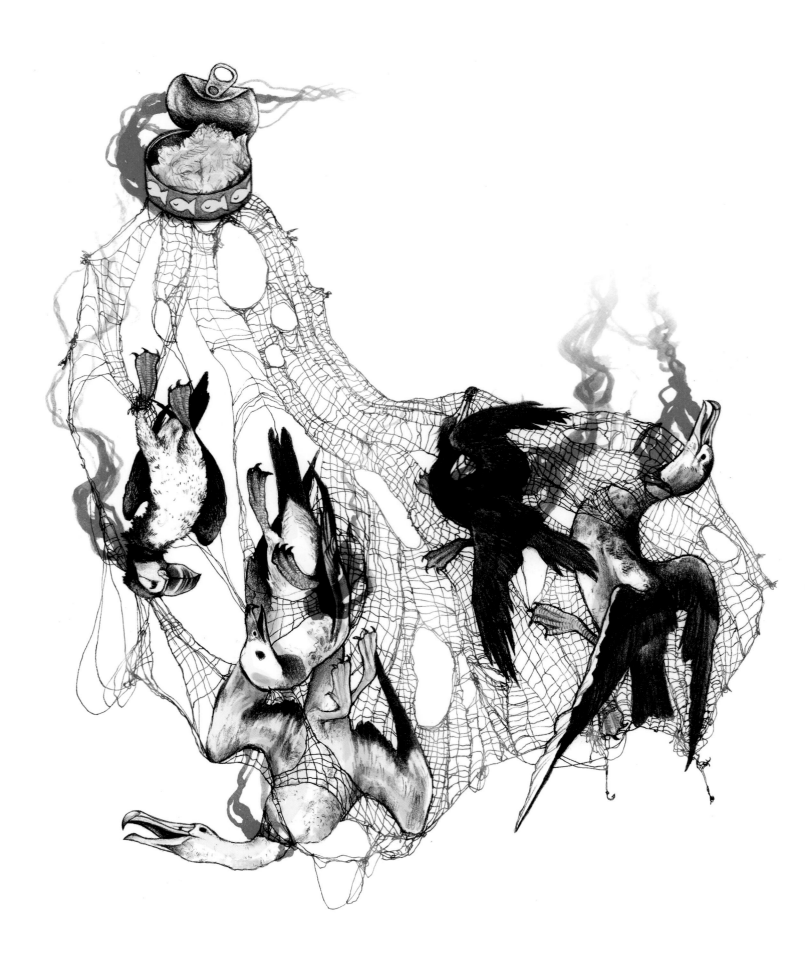

"I could never go vegan."

Almost every vegan at some point before they went vegan.

"My only regret about going vegan is that I didn't do it sooner."

Almost every vegan at some point after they went vegan.

TO PAGES 16–31

1 Jonathan Safran Foer, *Eating Animals*, New York: Little Brown, and Company, 2009

2 *New York Times*, September 19, 2018

3 *Scientific Reports* 8, article 4666 (March 2018)

4 Robert Goodland and Jeff Anhang, "Livestock and Climate Change: What if the Key Actors in Climate Change are … Cows, Pigs and Chickens?", *WorldWatch* 22, no. 6 (November / December 2009)

5 M. J. Martin, S. E. Thottathil, and T. B. Newman, "Antibiotics Overuse in Animal Agriculture: A Call to Action for Health Care Providers," *American Journal of Public Health* 105, no. 12 (December 2015)

6 *Guardian*, March 19, 2014

7 Multiple sources, including "Risk Management Evaluation for Concentrated Animal Feeding Operations," United States Environmental Protection Agency (May 2004)

8 Tom Horton, "42-Day Wonders," *Washingtonian*, September 2006

9 World Economic Forum website, 8 February 2019

10 *Guardian*, April 17, 2018; and *New York Times*, August 9, 2019

11 Vegan Peace website, 2015

12 Sergio Margulis, "Causes of Deforestation of the Brazilian Amazon," *World Bank Working Paper* 22 (2003)

13 United Nations Framework Convention on Climate Change (UNFCCC), European Commission, Food and Agriculture Organization of the United Nations (UNFAO)

14 Think Differently About Sheep website

15 Washington Post, August 4, 2018

16 US Department of Agriculture via IndexMundi, 2020

17 United Egg Producers via *New York Times*, August 15, 2010

18 *Washington Post*, October 29, 2013

19 World Health Organization, "Q&A on the carcinogenicity of the consumption of red meat and processed meat" (October 2015)

20 United Egg Producers via *Washington Post*, June 10, 2016

21 *New York Times*, August 28, 2019

PICTURE CREDITS

Tommy Kane
1, 4, 5, 10–31, 161, 163, 164
All works are untitled and copyright © 2022 Tommy Kane

Helen Barker
Copyright © 2022 Helen Barker
32 *The Macerated*, 2019 mixed media, dimensions variable
33 *The Seven Billion*, 2019 mixed media, dimensions variable

Melinda Hegedus
Copyright © 2022 Melinda Hegedus
34 *Deer Hunter*
35 *The Butcher* (top) *Fresh Flesh 1* (bottom)
36 *Hypocrite* (top) *Namaste* (bottom)
37 *Stuffing* (top) *Thanksgiving* (bottom)
38 *Chophouse* (top) *I'm Not Loving It* (bottom)
39 *Foie Gras*
164 *Vegetables Ewww*

Philip McCulloch-Downs
Copyright © 2022 Philip McCulloch-Downs
40 *Behind Closed Doors*, 2017, acrylic paint on canvas board, 21 × 29.7
41 *Broiler: Portrait of a Life*, 2017, acrylic paint on canvas board, 29.7 × 21
42 *See How They Grow*, 2015, acrylic paint on canvas board, 21 × 29.7 (top) *Dæge*, 2018, acrylic paint on canvas board, 21 × 29.7 (bottom)
43 *Meat*, 2017, acrylic paint on canvas board, 21 × 29.7 (top) *Weanling*, 2019, acrylic paint on canvas board, 21 × 29.7 (bottom)
44 *Life Sentence: The Invisible*

Faces of Dairy, 2015, acrylic paint on canvas board, 29.7 × 21
45 *Marketing Myths #1*, 2018, acrylic paint on canvas board, 21 × 29.7 (top) *Nurture / Nature*, 2019, acrylic paint on canvas board, 29.7 × 21 (bottom)
46 *One in a Million*, 2015, acrylic paint on canvas board, 21 × 29.7 (top) *Best of British*, 2016, acrylic paint on canvas board, 21 × 29.7 (bottom)
47 *The Ghost Camera*, 2014, acrylic paint on canvas board, 29.7 × 21
48 *Caged*, 2014, acrylic paint on canvas board, 29.7 × 21
49 *One of Us*, 2015, acrylic paint on canvas board, 29.7 × 21
159 *Consumer*, 2016, black ink on card, 29.7 × 21
161 *Cold Blood*, 2017, acrylic paint on canvas board, 29.7 × 21

Rob MacInnis
Copyright © 2022 Rob MacInnis
50–1 *Judique* (top) *PEI* (bottom)
52 *Untitled #4*
53 *Farm Family #3*
54 *Farm Family #2*
55 *Farm Family #1*
56–7 *Untitled #1*

Milk DoNg Comics
Copyright © 2022 Milk DoNg Comics
58 *Finless Shark: Hey Human, Give Me Back My Fins*, 2018, pencil sketch, 29.7 × 21
59 *FattyLiver Goose: Hey Human, Why You Fill Me Up*, 2018, pencil sketch, 29.7 × 21
160 *Human Limb: Hey Human, If You Were Us*, 2017, pencil sketch and Photoshop, 21 × 29.7

Dan Piraro
Copyright © 2022 Dan Piraro
60 *Guilty Cows*, 2005
61 *Left Buttocks*, 2005 (top left) *Feeling Lucky*, 2006 (top right) *True or False*, 2007 (bottom left) *Clogs the Arteries*, 2005 (bottom right)
62 *Don't Serve Your Kind*, 2015 (top left) *New Heifer*, 2012 (top right) *Jerk Says*, 2004 (bottom left) *Director's Cut*, 2010 (bottom right)
63 *Pilgrims*, 2002
162 *Come to Me Sooner,* 2011

Sue Coe
Copyright © 2022 Sue Coe and courtesy Galerie St. Etienne, New York
64 *Modern Man Followed by the Ghosts of His Past*, 1990 Private collection
65 *Feed Lot*, 1991
66 *Mulesing: Cutting Off the Vaginal Folds with no Anesthetic*, 2004 (top) *Meat Flies*, 1991 (bottom)
67 *Number 6652*, 1989
68 *Butcher*, 2011 Private collection
69 *You Consume Their Terror*, 2011 Private collection
70 *Cruel*, 2011
71 *Got Milk?*, 2011
162 *Egg Machines*, 1991 Private collection

Jane Lewis
Copyright © 2022 Jane Lewis
72 *Beauty and the Human Beast*
73 *Pig Dragged to Slaughter* (top) *Tagged & Fettered* (bottom)
74 *ByCatch, A Marine Atrocity (top) Shorn & Scarred* (bottom)
75 *Plucked Geese*
76 *Pig in Hell* (top) *Game Birds* (bottom)
77 *Chicken & Egg* (top) *Chicks & Eggs* (bottom)
78 *Worked to the Bone*
79 *Led by the Nose*

Hartmut Kiewert
Copyright © 2022 Hartmut Kiewert
82 *Colorful Stairs*, 2017, oil on canvas, 120 × 150
83 *Why Not?*, 2012, oil on canvas, 145 × 194
84 *Lazy Afternoon II*, 2017, oil on canvas, 120 × 150 (top) *Marking II*, 2017, oil on canvas, 120 × 150 (bottom)
85 *Brothers from Different Mothers*, 2016, oil on canvas, 145 × 195 (top) *Lazy Afternoon*, 2015, oil on canvas, 190 × 250 (bottom)
86 *Bench*, 2015, oil on canvas, 190 × 250
87 *Picnic III*, 2019, oil on canvas, 120 × 150
88–9 *Mall II*, 2016, oil on canvas, 250 × 400

Jo-Anne McArthur
Copyright © 2022 Jo-Anne McArthur
90 *Dairy and Veal Farm, Canada*, 2014
91 *Rabbit Slaughter, Spain*, 2010
92 *Broiler Chickens*, Mexico, 2018 (top) *Slaughterhouse*, Turkey, 2018 (bottom)
93 *Sheep Saleyard, Ballarat, Australia*, 2013 (top) *Duck Farm*, Taiwan, 2019 (bottom)
94 *Pig Slaughterhouse, Thailand*, 2019
95 *Poultry Slaughterhouse Taiwan*, 2019 (top) *Broiler Chicks*, Mexico, 2018 (bottom)
96–7 *Duck Slaughterhouse Taiwan*, 2019
98 *Feedlot*, Israel, 2018 (top) *Hurricane Florence Floods*, North Carolina farms, USA, 2018 (bottom)
99 *Turkish Border*, Turkey, 2018

Tommy Flynn
100 *Blood Orange*
101 *Tomato*

Caroletta
102 *The Easter Lamb*
103 *About Meat*
104 *Red Planet*
105 *The Meat Tree*
106 *Bobby Ballast*
107 *MEOW*
108 *Jump Apart*
109 *The Smoothie Makers*

Chantal Poulin Durocher
110 *I Am Not a Nugget*, 2018, charcoal on raw linen, 152.4 × 177.8
111 *Please Don't Kill My Baby*, 2018, pastel on cardboard, 91.4 × 60.9
112 *Think Occasionally,* 2019, charcoal on raw linen, 101.6 × 127
113 *We Are the Same*, 2018, charcoal on Fabriano paper, 203.2 × 152.4
114–15 *Where Are They Bringing Me?,* 2015, oil on canvas, 152.4 × 182.9

Andrew Tilsley
116 *Shooting Party*, 2018
117 *Puffins*, 2018
118 *Peaceful Pastime*, 2018 (top)
 A Vegetarian at Christmas, 2018 (bottom)
119 *Lucky Rabbit's Foot*, 2018 (top)
 Non-Target Species, 2018 (bottom)
160 *Liberated*, 2018

Jo Frederiks
120 *Innocence Condemned*
121 *The Death of Innocence*, pen and ink
122 *Why Love One and Eat the Other?*, pen and ink
123 *Blind to the Hypocrisy*
124 *Both Are Victims* (top)
 RSPCA, Hypocrisy is Our Mission (bottom)
125 *Forkgetting the Right to Life*

Cameron O'Steen
126 *Yoga Animalia: Galline – Aldrick, Big Al, Harvest Home Animal Sanctuary*
127 *Yoga Animalia: Porcine – Laverne, Ching Farm Rescue and Sanctuary* (top left)
 Yoga Animalia: Bovine – Brahma, PreetiRang Sanctuary (top right)
 Yoga Animalia: Ovine – Yin, Indraloka Animal Sanctuary (centre left)
 Yoga Animalia: Caprine – Joey, Farm Sanctuary (centre right)
 Yoga Animalia: Galline – Alfalfa, Piedmont Farm Animal Refuge (bottom left)
 Yoga Animalia: Anatine – Google, Harvest Home Sanctuary (bottom right)
128 *Yoga Animalia: Meleagrine – Charles Wildwood Farm Sanctuary* (top)
 Yoga Animalia: Bovine – Elliot, Peaceful Prairie (bottom)
129 *Yoga Animalia: Caprine – Benny, Uplands PEAK Sanctuary* (top)
 Yoga Animalia: Bovine – Helen, Lighthouse Farm Sanctuary (bottom)

Dana Ellyn
130 *Teaching Moment*, 2015, oil on canvas, 40.6 × 50.8
131 *Bacon Cheeseburger*, 2015, oil on canvas, 73.7 × 45.7
132 *Independence (From Meat) Day*, 2012, acrylic on canvas, 61 × 45.7
133 *Outsmarted By Your Food*, 2013, acrylic on canvas, 63.5 × 78.7 (top)
 Deli, 2013, acrylic on canvas, 76.2 × 101.6 (bottom)
134 *Chicken Wings*, 2016, acrylic on canvas, 35.6 × 27.9
135 *Unhappy Meal*, 2015, oil on canvas, 61 × 45.7
136 *What's In Your Fridge (Meet Your Meat)*, 2013, oil on canvas, 91.4 × 76.2
137 *Mary Had A Little Lamb (Then She Ate Him)*, 2018, acrylic on canvas, 35.6 × 45.7 (top)
 Pup. Pig., 2017, acrylic on canvas, 35.6 × 45.7 (bottom)

Roland Straller
138 *Bloody Hell*, 2011, digital drawing
139 *Carnism*, 2012, digital drawing
140 *Stecher*, 2011, digital drawing
141 *Toninho*, 2016, digital drawing (top)
 Schwein 59, 2013, digital drawing (bottom)
142 *Milchijieper*, 2011, digital drawing
143 *All Souls Day*, 2016, digital drawing
144 *Day Old Chick*, 2011, digital drawing
145 *Paula*, 2013, digital drawing (top)
 McDwahrheit, 2017, digital drawing (bottom)
161 *Calimanesti*, 2012, digital drawing

Cynical Coyote
146 *CULTure*, pen and ink
147 *Gluttony*, pen and ink (top)
 Thou Shalt Not Kill?, pen and ink (bottom)
148 *Selfish*, pen and ink
149 *Humane*, pen and ink

Kate Louise Powell
150 *Whales*
151 *250*
152 *Sharks*
153 *Seabirds*

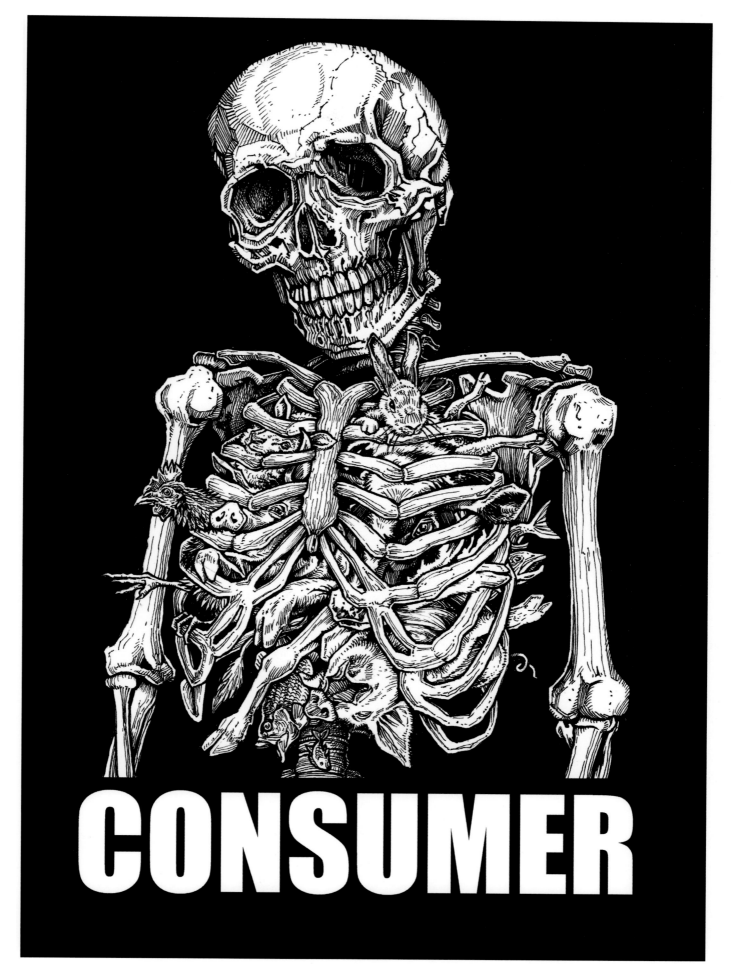

Philip McCulloch-Downs

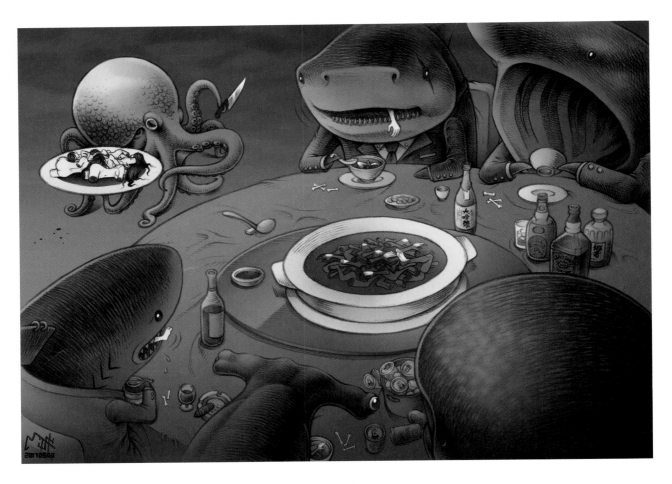

Milk DoNg Comics

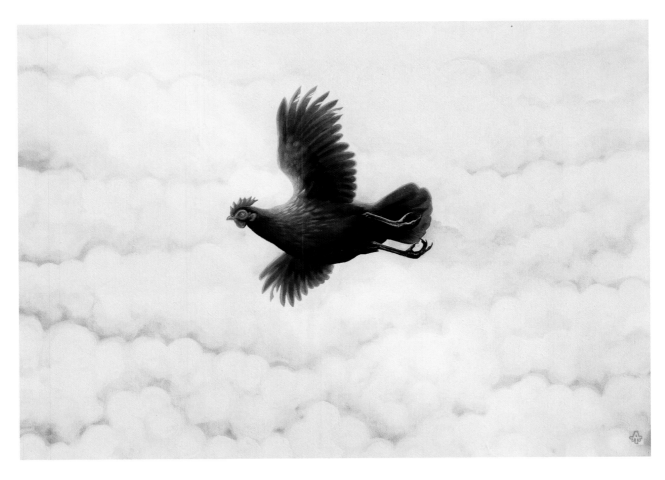

Andrew Tilsley

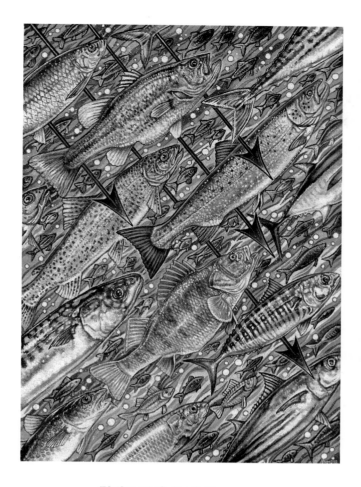

Philip McCulloch-Downs

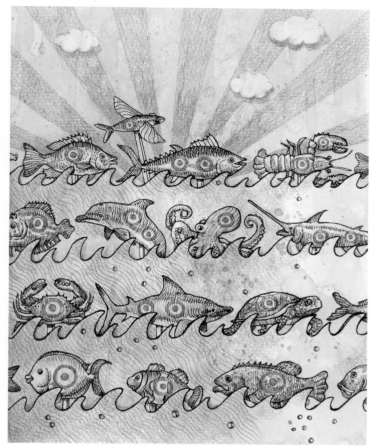

Tommy Kane

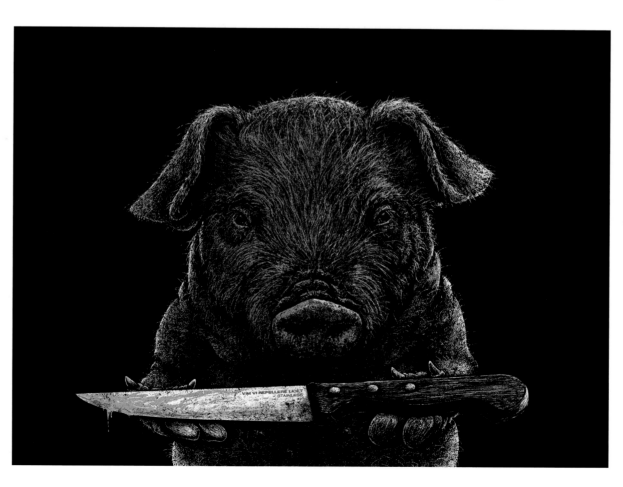

Roland Straller

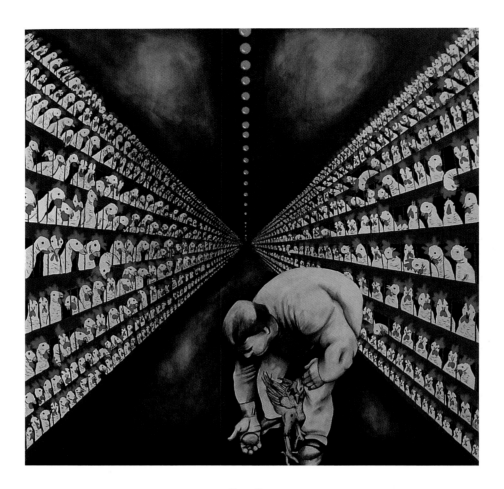

Sue Coe

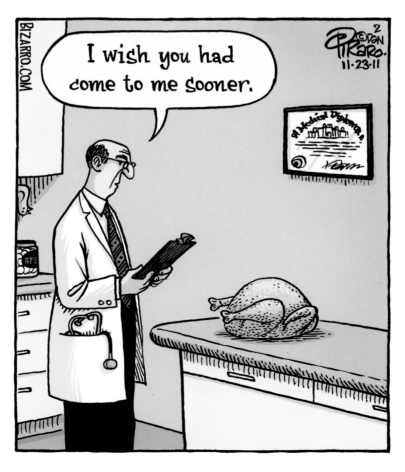

Dan Piraro

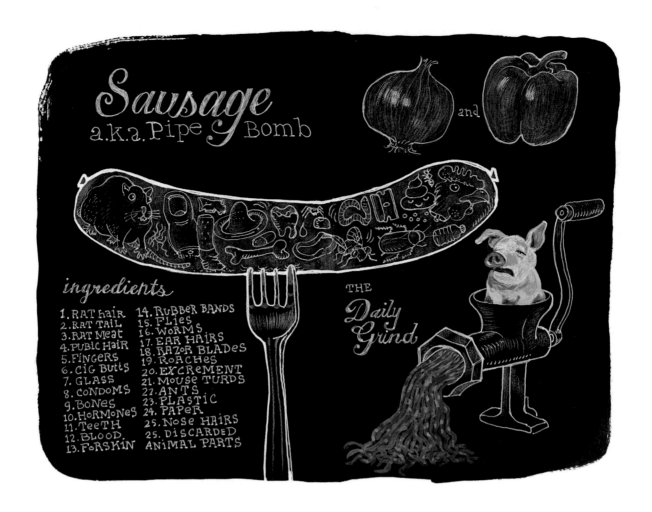

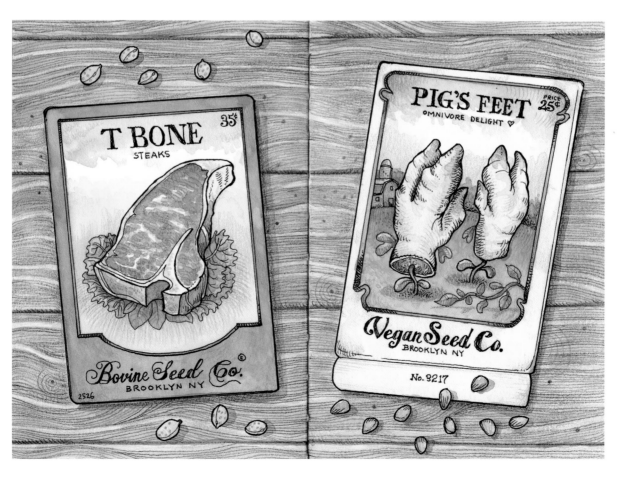

Tommy Kane

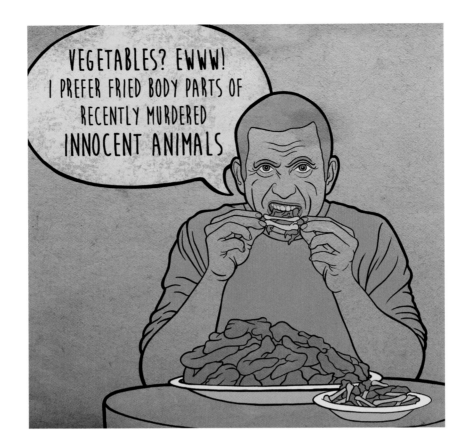

Melinda Hegedus

ISBN 978-1-912122-30-1

Designed by Tommy Kane and Sylvia Ugga
Cover art by Jo Frederiks
Back cover art by Chantal Poulin Durocher, Rob MacInnis,
Tommy Kane, and Caroletta
Production manager: Sarah McLaughlin

Typefaces: Century Gothic, American Typewriter, Darleston, Suisse Int'l
Printed and bound by GPS Group

The use in the art in this book of particular brand or character imagery
has not been approved by relevant owners / licensees of such brand /
character rights. Such use in the book is for artistic and political purposes
and there is no commercial or other connection between those involved
in this book and such owners / licensees of those brand / character rights.